The *New* Creative Artist

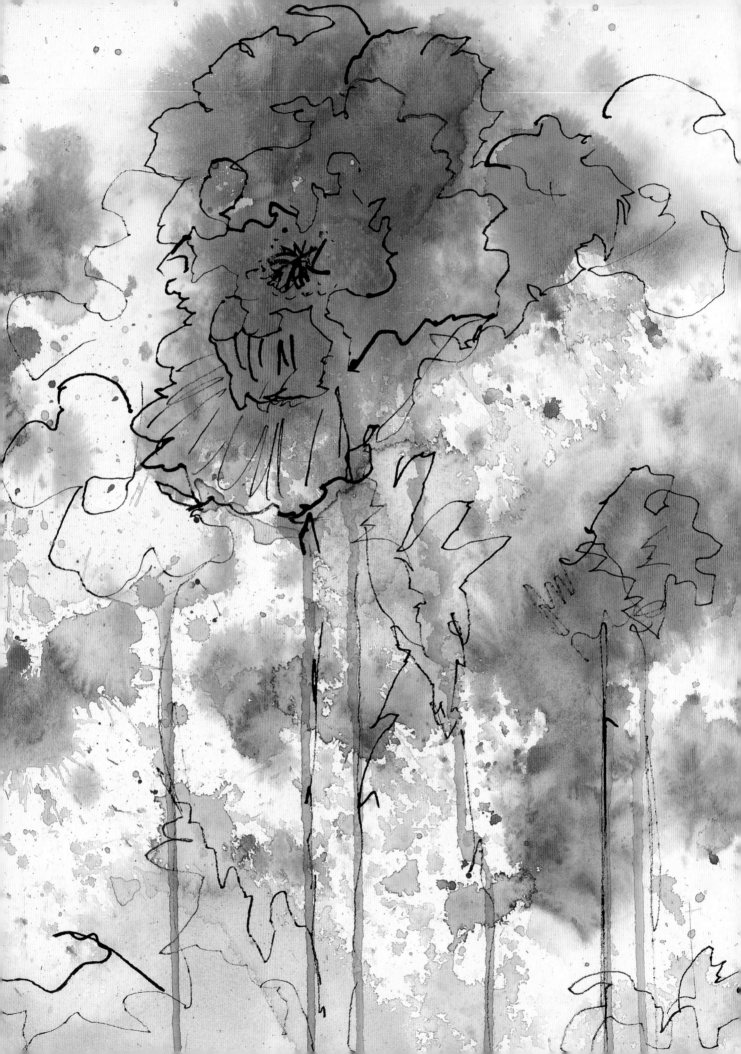

the *New* Creative Artist

a GUIDE to DEVELOPING your CREATIVE SPIRIT

Nita Leland

NORTH LIGHT BOOKS
CINCINNATI, OHIO
www.artistsnetwork.com

About the Author

*N*ita Leland began painting in watercolor in 1970 and now teaches workshops in color, creativity, collage and design throughout the United States and Canada. She's the author of three best-selling art-instruction books for North Light: *Exploring Color, The Creative Artist* and *Creative Collage Techniques* and has contributed articles to *Watercolor Magic, Watercolor, The Artist's Magazine, American Artist* and many other art publications. She is the author and publisher of *Exploring Color Coloring Book,* a workbook for artists. Leland is the designer and manufacturer of the Nita Leland™ Color Scheme Selector, as well as a freelance consultant to manufacturers of art materials. She is the featured artist in a video series, "Exploring Color Workshop," a color course for artists and teachers. Visit her website at www.nitaleland.com or email her at nita@nitaleland.com.

The New Creative Artist. Copyright © 2006 by Nita Leland. Manufactured in China. All rights reserved. No part of this book may be reproduced in any form or by any electronic or mechanical means including information storage and retrieval systems without permission in writing from the publisher, except by a reviewer who may quote brief passages in a review. Published by North Light Books, an imprint of F+W Publications, Inc., 4700 East Galbraith Road, Cincinnati, Ohio, 45236. (800) 289-0963. First edition.

fw F+W PUBLICATIONS, INC.

Portions of this book appeared in *The Creative Artist: A Fine Artist's Guide to Expanding Your Creativity and Achieving Your Artistic Potential,* © 1990 by Nita Leland.

Other fine North Light Books are available from your local bookstore, art supply store or direct from the publisher.

16 15 14 13 12 10 9 8 7 6

DISTRIBUTED IN CANADA BY FRASER DIRECT
100 Armstrong Avenue
Georgetown, ON, Canada L7G 5S4
Tel: (905) 877-4411

DISTRIBUTED IN THE U.K. AND EUROPE BY DAVID & CHARLES
Brunel House, Newton Abbot, Devon, TQ12 4PU, England
Tel: (+44) 1626 323200, Fax: (+44) 1626 323319
Email: postmaster@davidandcharles.co.uk

DISTRIBUTED IN AUSTRALIA BY CAPRICORN LINK
P.O. Box 704, S. Windsor NSW, 2756 Australia
Tel: (02) 4577-3555

Library of Congress Cataloging in Publication Data
Leland, Nita.
 The new creative artist : a guide to developing your creative spirit / Nita Leland.—
1st ed.
 p. cm.
 Includes bibliographical references and index.
 ISBN-13: 978-1-58180-756-1 (hardcover with wire-o binding : alk. paper)
 ISBN-10: 1-58180-756-2 (hardcover with wire-o binding : alk. paper)
 1. Art--Psychology. 2. Creation (Literary, artistic, etc.) I. Title.
 N71.L372 2006
 701'.15--dc22
 2006007415

Edited by Christina Xenos and Stefanie Laufersweiler
Designed by Wendy Dunning
Production art by Kathy Bergstrom
Production coordinated by Mark Griffin and Matt Wagner

The permissions on pages 172–173 constitute an extension of this copyright page.

Metric Conversion Chart

To convert	to	multiply by
Inches	Centimeters	2.54
Centimeters	Inches	0.4
Feet	Centimeters	30.5
Centimeters	Feet	0.03
Yards	Meters	0.9
Meters	Yards	1.1
Sq. Inches	Sq. Centimeters	6.45
Sq. Centimeters	Sq. Inches	0.16

Art on cover:
Little Pieces of Land 23 · Cheryl McClure · Acrylic on canvas · 30" x 30" (76cm x 76cm)

Art on page 2:
Splash · Nita Leland · Watercolor, pen and ink · 14" x 10" (36cm x 25cm)

If you
are
· a beginner who
wishes
to be a creative artist
· an artist who desires to
be more creative
· a creative artist
who is blocked
This book is
dedicated
to
you.

Begin

Acknowledgments

My sincere thanks to all who encouraged, supported and helped me throughout the creation of this book: to David Lewis, who suggested after *Exploring Color* was published in 1985 that I write another book; to Greg Albert, who was my editor on *The Creative Artist* published in 1990; to Rachel Rubin Wolf, who planted the idea to revise the book; and to my editors Jamie Markle and Christina Xenos, who convinced me to do it, and Stefanie Laufersweiler, who came on the scene with enthusiasm and fresh ideas. Thanks to designer Wendy Dunning, layout artist Kathy Bergstrom and production coordinators Mark Griffin and Matt Wagner for doing a great job.

Special thanks to Sylvia Dugan for helping me keep track of the pieces; to Ann Bain for the beautiful dedication calligraphy; and to my students at Hithergreen Senior Center for putting up with me during the final stages of the book. Thanks to Graphics Terminal color lab for a great job on the slides and transparencies, to the folks at Dayton Visual Arts Center for lending a hand at the last minute, and to George Bussinger, Jr. of McCallister's Art Store for helping out when I needed supplies. A million thanks to the generous artists whose paintings, drawings and crafts enhance these pages.

And, finally, thanks to my family and Stephie and Virginia for their love, friendship and support no matter what. A big hug for Jenna… just because. And, thanks always and forever to R.G.L.

Table of CONTENTS

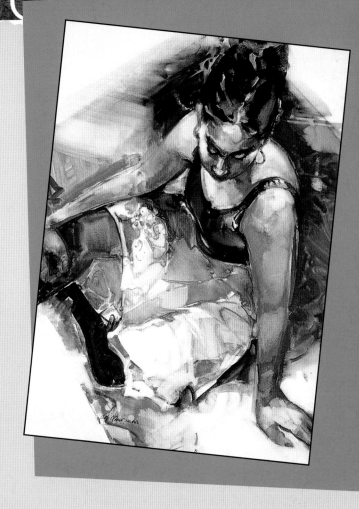

Activity Guide

CHAPTER 6
Abstraction:
Off the Beaten Path

CHAPTER 7
Experimentation:
Exploring New Territory

CHAPTER 8
Adventure: Developing
Your Creative Spirit

☞ *Activity* ☜
Draw With Both Hands

Make a drawing of one or two flowers using pencils in both hands. Use real or artificial flowers. Keep both hands moving simultaneously, either side-by-side or following the shapes of petals and leaves on opposite edges. Lift the pencils to move to another shape and keep drawing until the flower is complete. Do this exercise whenever you have a spare moment. It's a great way to jump-start your creative right brain.

Two-Handed Drawing

Are you surprised to see that your non-dominant hand is able to draw? Drawing with a pencil in each hand creates spontaneous line quality. You might make more interesting drawings with your non-dominant hand than with the one you usually draw with.

Creative people are curious, flexible, persistent and independent, with a tremendous spirit of adventure and a love of play. Creative people trust their intuition and listen to their hearts. Creativity and intuition are both within you, but you must awaken your creative spirit. Pay attention. Trust yourself. Develop and strengthen these traits in yourself and reach your creative potential. This book will show you how.

YOU WERE BORN TO CREATE

Don't be taken in by the myth that only a chosen few are truly creative. Almost anyone can become a creative artist. The late Edgar A. Whitney, America's oft-quoted teacher of watercolor, said, "No door is closed to a stubborn scholar." What it takes is desire and determination, plus practice, patience and perseverance, the same qualities that lead to success in any creative endeavor.

Academic training is useful, but not essential. Many creative folks in visual arts and crafts are self-taught, energized by the desire to create and a willingness to take chances. Creative people relish the discovery of ideas, new directions and challenges, and the belief that there is another wonderful adventure just around the corner. Every human being has creative powers. You were born to create. Appreciate your inborn potential. Unleash your creative

"Creativity is a celebration of one's grandeur, one's sense of making anything possible. Creativity is a celebration of life— my celebration of life. It is a bold statement: I am here! I love life! I love me! I can be anything! I can do anything!"

Joseph Zinker, therapist, painter, sculptor and poet

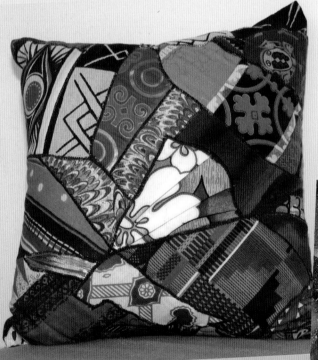

Crazy Quilt Pillow · Frances Turner · Hand-sewn mud cloth from South Africa · 10" x 10" x 5" (25cm x 25cm x 13cm)

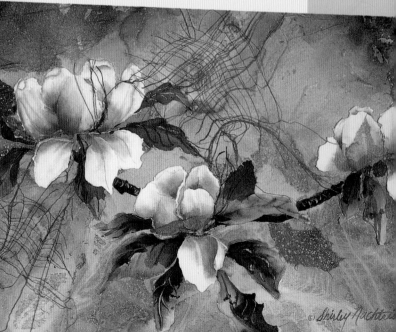

Envy Magnolia · Shirley Eley Nachtrieb · Watermedia collage ·11" x 15" (28cm x 38cm)

energy and let it flow. Relish the possibilities.

WHAT YOU BELIEVE YOU CAN BE IS WHAT YOU WILL BECOME

Every artist started out as a beginner. Your level of skill right now doesn't matter. You'll learn. Learning and doing cultivate creativity. Don't be afraid. Even if you're not an artist, you're probably doing many creative things already—sewing, woodworking, gardening, scrapbooking, even raising children, for example. It's no great leap from such activities to creative art. All you need is desire and a willingness to learn and practice new skills. Mastering art skills is like learning to drive—repeating a series of movements one by one until you can do them all at the same time. If you can learn to park a car, you can learn to make a painting or weave a cloth.

Let go of self-fulfilling prophecies that you have no talent. Henri Matisse said: "It would be a mistake to ascribe this creative power to an inborn talent. In art, the genuine creator is not just a gifted being, but a man who has succeeded in arranging for their appointed end, a complex of activities, of which the work is the outcome. The artist begins with a vision—a creative operation requiring an effort. Creativity takes courage."

PRACTICE, PATIENCE AND PERSEVERANCE PAY OFF

All this doesn't happen in a flash. Psychologist A. H. Maslow writes in *The Farther Reaches of Human Nature*: "Apparently one impression that we are making… is that creativeness consists of lightning striking you on the

Untitled from "Chair Series" · Mel Meyer, S.M. · Acrylic on canvas · 60" x 60" (152cm x 152cm)

head in one great glorious moment. The fact that the people who create are good workers tends to be lost."

That's good news. Creativity isn't magic. It's achievable. So don't wait for a bolt from the blue. Find out what works for you; then get going.

This is a hands-on book of activities for stimulating creative thinking and doing. It taps into many different aspects of creativity, from theory to technique to practical exercises for developing creativity in art and daily life. In this revised edition, you will find a wealth of new material—many new activities and illustrations, plus an added chapter that explores the different means of expression in art and craft.

This book will help you inch around—and sometimes leap over—roadblocks and strengthen your creativity as you exercise your skills. This isn't work—it's play. Engage your sense of humor. Have a good time doing the exercises and trying new things.

Whatever complications you may have to overcome, start with small victories over circumstances. Art can transform your life, but be patient and take it one step at a time.

Off to a Running Start

You don't need exotic materials to create. The humble pencil is everyone's best friend—a simple, familiar tool. Begin with a ream of copy paper and a pencil. Use your paper freely and without fear. You're not necessarily making art here; you're seeking your creative spirit.

MAKE EXPERIMENTING FUN

Play with a variety of different media, colors and tools. Do this with a minimum of expense by having a swap meet with friends to trade art and craft supplies. Nearly everyone has an accumulation of usable materials collecting dust somewhere. One or two new toys may be just what you need to stimulate your creative growth.

Another way to experiment is to invite a group for a painters' or crafters' potluck. Ask each person to bring different media, papers and tools to share. Specify items that relate to a variety of arts and crafts; for example, a few watercolors and brushes, some rubber stamps and inks, quilt fabrics, colored pencils, oil pastels and cropping tools for scrapbooks. Switch

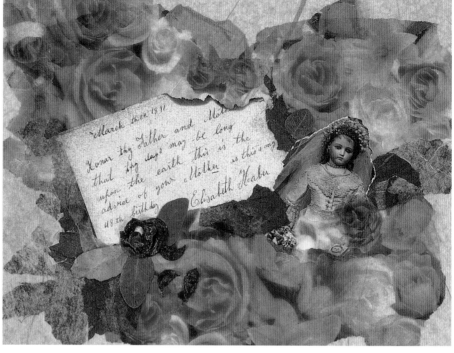

media and tools several times during the session. Pass a 16" × 20" (41cm × 51cm) illustration board around and let everyone have a hand in the same piece, using various materials. You'll have a great time, especially if your friends all have a good sense of humor.

GATHER YOUR TREASURES

You'll need a variety of objects for creativity projects. Make a treasure chest out of a shoebox or milk crate. Collect small objects for sketching: shells, fibers, nuts, leaves, buttons, driftwood, stones, weeds, nails, keys. Ask your family and friends to contribute surprises to your collection. Use these items in scrapbooks and collages, too.

Keep a scrap box for art papers, wrapping papers, photos, magazine pictures, bits of newspaper, pieces of fabric, string, old paintings and drawings. You'll use these odds and ends in some of your activities.

Creativity Starts at Home

Sometimes you only need to look around the house for great source materials. I used printed wrapping tissue for the background of this collage about my grandmother, with an eye-catching image of an antique doll appropriate to her childhood. The text is a scanned page written by her mother in her autograph book. I singed the edges of the copy and aged the paper with a watercolor wash of Burnt Sienna.

Autograph · Nita Leland · Mixed-media collage · 8½" x 11" (22cm x 28cm)

Don't Let Materials Intimidate You

Take a fresh sheet of paper. Step on it. Fold it or crumple it. Let the cat walk on it. Brush it off and draw something on it. Scribble, scratch and rub marks on the paper. Isn't that easy? Relax and think of every new support as you would a plain old piece of paper. It is just a piece of paper!

☞ Activity ☜
Make a Job Jar

As you read through this book, you'll find many ideas for projects. To keep them from getting away from you, make a job jar from a cookie jar or a large bowl. On slips of paper, note activities from this book you would like to try. Drop in any ideas, subjects or techniques that look intriguing in magazines, arts-and-crafts stores and exhibitions. When you need a jump-start, pull out a job at random and work with what you find.

Your Travel Log

Go out right now and buy a sketchbook—your travel companion on an exciting journey into creativity. Spiral-bound, hardcover, loose-leaf, big or small: There are a lot of acceptable books in stores that sell stationery and school or office supplies. With your sketchbook-journal keep a couple of sharpened no. 2 pencils and a pen (a ballpoint or inexpensive cartridge pen is fine). Spend at least fifteen minutes a day with your sketchbook.

ABOUT LISTS

Throughout this book you'll often find references to making or consulting lists. Lists have three important functions that develop your creativity: They challenge you to think, help you to focus on your ideas, and generate more ideas and creative alternatives.

Lists in this book have a long-term purpose; they aren't just temporary reminders jotted down on scrap paper. Lists help you organize your ideas so you can find them when you need them. Capture your ideas while they're fresh; write them on your lists so you don't lose them. Your sketchbook-journal is a good place to store your ideas for future reference. What good is an idea if you don't remember where you put it? Review your lists often and add to them continually to energize your creative spirit.

Be Creative on the Run

Put a few items in a small pouch or a child's lunch box to keep in your car. Use this basic creativity kit to make small sketches or torn-paper collages while you're waiting for your kids' car pool or sitting in a traffic jam:

* 5" x 7" (13cm x 18cm) sketchbook
* set of six to eight colored markers
* 2B pencil
* white plastic eraser
* .05 Pigma Micron pen
* glue stick
* small pack of origami paper
* bits of found paper (like ticket stubs)

☞ Activity ☜
Fill a Sketchbook-Journal Page in a Jiffy

Fill a page in your sketchbook-journal in fifteen minutes. Don't necessarily make a picture. With your pencil or pen, write, draw or scribble anything that comes to mind. Use different-colored pens to reflect your changing moods. You might:

* Write notes to yourself.
* Make lists of ideas and creative projects.
* Add to your list of books to read.
* List music you enjoy.
* Copy inspirational quotes.
* Doodle and draw.
* Sketch on location.
* Plan projects.
* Work out some of the activities suggested in this book.

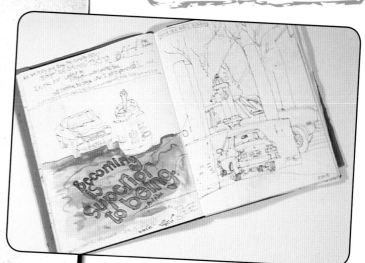

A Must-Have for Every Artist

A well-used sketchbook-journal is a creative person's best friend. Get your idea down before it slips away. Mistakes don't matter. I learned three simple rules from my friend Brian Zampier, an avid sketcher whose sketchbook is shown: Never erase; never tear out a page; date every entry.

Prepare for Your Journey

Provide yourself with a special art space where you're relatively free from interruption. An art studio would be great, but you can make art almost anywhere. As a mother of four, I began painting and drawing at the kitchen table. This proved to be impossible with busy, hungry helpers all around me, so I moved my workspace to a card table in my bedroom. It was a bit cramped, but at least I didn't have to wash peanut butter off my brushes. Now I have a wonderful, well-equipped studio with full-spectrum lighting, but I still think some of my most creative thinking was done at that little card table.

Establish an atmosphere that energizes you. Some creative people flourish in confusion; others need to be free from interruption. Many prepare themselves for work by exercising to stimulate circulation; others meditate to quiet the chatter of the outer world.

Listening to music as preparation or background for your work brings you into a creative mood. According to Kurt Leland, author of *Music and the Soul*, music affects us at physical, emotional, intellectual and spiritual levels. Choose one type of music to calm down, another to reach a higher energy level, depending on the artwork you're doing. Leland suggests making playlists of the music that moves you and recording your favorites on CDs. When you need inspiration, play rhythms and melodies that release your creative spirit.

Make time for your creative activity. Schedule it on your calendar and work other activities around it. Start with fifteen minutes a day. Even this short time will help you improve your skills. As you gain confidence, you will feel less guilty about "wasting time" with your art. Trust me: you're not.

Creativity needs to be exercised to grow strong. Allow some warmup time each day to stimulate your creative flow. A pianist does keyboard exercises. A gymnast stretches. An artist needs to loosen up, too. It takes a few minutes to shift from the real world into a creative mode. When you finish for the day, write a note reminding yourself of what you plan to do next. This helps you to remember today's great idea when you get back to work tomorrow.

Know Thy Creative Self

Creativity is a journey of self-discovery. Begin the trip by asking yourself:

* What do I most love to do?
* What is my best creative environment?
* What is my most productive time of day?
* What motivates me to undertake a creative challenge?

☞ Activity ☜
Get Going With Whatever You've Got

Scribble, doodle, draw or splash paint. Don't be concerned about making a painting or a finished product. Use markers or colored pencils, a child's crayons, watercolors or chalk. Tear up colored magazine pages and arrange a few pieces in a small collage. Just about anything you play with will get your creative energy buzzing. You don't need art materials to get started; you just need to get started.

My Resulting Watercolor

I lightly spritzed an 11" x 8 ½" (28cm x 22cm) piece of cold-press watercolor paper with water and with the corner of my flat brush touched color to different areas of the paper: Brown Madder first, then Raw Sienna and Indigo. The colors crept into areas where the paper was wet, and I encouraged some blending by tilting the paper. I let it dry, then did light spritzing and flicked in some spatter and made lines with a thin rigger. Again, the wet areas on the paper moved the paint.

Set Your Priorities and Follow Your Dream

John Lennon said, "Life is what happens to you while you're busy making other plans." Nevertheless, if you set goals, you'll be more successful at achieving the creative life you dream of. It's simple, really, but it does take a degree of commitment on your part.

FOSTER A HEALTHY BODY AND MIND

Your first priority is to take care of yourself. Get enough rest, eat properly, exercise and attend to your spiritual needs. You may insist that you're too busy and you have obligations to others that make this impossible, but, believe me, you're absolutely no good for others if you aren't taking proper care of yourself. And you can't develop your creative spirit if you're a physical and emotional wreck.

MAKE CREATIVITY A PART OF EVERYDAY LIVING

Your next priority is to live every moment of every day as creatively as you possibly can. When creative thinking becomes your natural response to daily activity, it's easier to be creative in your art. Creative living brings energy and awareness to art that can't be drawn from any other source.

Every time you do something you haven't done before, you're being creative. This may be as simple as putting jam on your waffles instead of syrup. From the time you get up in the morning until you go to bed you have myriad opportunities to make small changes in your life that add spice and sparkle to your day. This attitude, carried over into your creative work, makes you even more aware of the possibilities of change. Change is the stimulus to creativity. Habit is the enemy.

> ☞ *Activity* ☜
> ## Boost Creativity in Your Everyday Actions
>
> Keep a complete record in your sketchbook of all your activities for the next seven days. Go over each item and think of a more creative way of doing that activity. Here are some examples: Drive a different route to work. Wear a scarf instead of a necklace with your outfit. Add a new plant to your garden. Tweak a recipe with a different spice. You'll soon become aware of many opportunities for exercising your natural creativity throughout the day. Stop taking things for granted. Try new things on a regular basis. You'll be amazed at how creative you can be when you stop to think about it.

GET ORGANIZED

My workshop students groan when I tell them they need to organize their studios and their living spaces. But many tell me later that doing this helped them to break creative blocks that had stifled them for long periods of time. Hardly anyone can work in chaos. The frustration of trying to find in your studio a certain tool or notes for a project usually results in your walking out with nothing accomplished. Take time to bring order to your environment and your creative mind will appreciate the freedom from clutter.

GET GOING

This book is intended to help you develop your creative spirit in life and art through sensitivity, awareness and determination, whatever your art or craft may be. In each chapter I suggest activities to help you develop these traits. You make the creativity happen by doing the activities. Pick the ones you like and do them right away. I encourage you to read chapter one for a better understanding of the creative process, but you may dip into the text almost anywhere and find something to work on that will help you become more creative.

Take a creative trip starting today. Explore new territory. Enjoy the familiar highways and byways as you go along, but investigate new paths as well. Instead of crashing into roadblocks, look for interesting detours around them. Curiosity and a willingness to experiment make an exciting journey.

Enjoy the trip, not just the destination. Before you arrive, you will already be thinking about your next creative adventure.

Are you worried about inspiration? Sigmund Freud stated, "When inspiration does not come to me, I go to meet it." Don't wait for inspiration. It will come as you work.

Getting started is the hard part. As poet James Russell Lowell said, "In creating, the only hard thing is to begin."

Don't just think about it.
Don't just talk about it.
Do it.

1 CREATIVITY:
A Joyride

Lexis at 13 · Cathy Jeffers · Fiber art · 30" x 17" (76cm x 43cm) · Collection of Elaine McGuire

You probably take for granted the many creative things you do every day. Planning a party, organizing a business event, designing a newsletter, decorating a room, even choosing the clothes you wear are all endeavors that reward you with feelings of accomplishment. When you feel really good about something you've done, it's because you've done it creatively. **You have always been creative.** The creative process is universal, regardless of product or result. Expanding your creativity in any area will improve your creative thinking in all.

Thinking you have no talent can be a self-fulfilling prophecy. "Argue for your limitations and sure enough, they're yours," says author Richard Bach in *Illusions*. So true! A positive attitude accelerates your development as a creative person. Believe in yourself. Release and regulate the flow of your inborn creative energy to reach your artistic potential.

"People who want to be creative, who deeply value such a characteristic in themselves, are more likely to make themselves creative and keep themselves that way....
Creativity concerns what we do with our abilities. Any normal person can be creative in terms of whatever abilities he or she has or can acquire."

D.N. Perkins
The Mind's Best Work

Road Trip · Robert L. Barnum · Watercolor · 21" x 15" (53cm x 38cm)

You Can Get There From Here

Creative adventure is both exhilarating and demanding. Creativity doesn't just happen—you make it happen. Changing daily routines is one way to access creativity. When was the last time you used a new ingredient in an old recipe? Walked through a nearby garden? Sketched at a park? Designed a quilt? Ate dinner by candlelight? Get started by taking a class, reading a book or visiting a craft workshop or artist's studio. Pace your creative growth by taking a few short steps, then a big creative leap.

Creativity also requires flexibility and a willingness to change. It takes courage and positive thinking. Make up your mind to go for it. Choose to give your creative art priority over other things. You can do it. You can do collage or weaving or woodcarving, or paint with watercolor and pastels. You can learn drawing and design. You can become a master gardener. You owe it to yourself to make your creative development a top priority.

STEERING YOUR CREATIVE GROWTH

Here's what you need to do to spark your creative fire:

Emphasize the joy of creating, rather than the achievement of results. Artist/teacher Robert Henri said, "What we need is more sense of the wonder of life and less of the business of making a picture."

Develop your skills. Skills build confidence, so work to improve your drawing or refine your painting or craft techniques. As Edgar Whitney said, "The discipline endured is the mastery achieved." You will improve with practice. While you're working, notice the good things you've done. Don't dwell on your mistakes. Set achievable goals: a confident line, effective use of values, interesting shapes, exciting texture.

Expand your horizons. Gather knowledge to help you get started and to break creative blocks. Visit galleries, museums, art and craft fairs and hobby shows. Read books and magazines. Take workshops. Use your senses. Experience stimulates your memory and imagination.

Trust your intuition. Pay attention to the inner voice that tells you when something feels right. Much of your creative problem-solving occurs at an unconscious level. If you persist in ignoring your intuition, you may find yourself stuck in a permanent holding pattern instead of taking the risks that lead to creative growth.

Notice the Beauty in the Everyday
Color is the catalyst that makes this piece memorable. The things you see every day, like a tree in your backyard, can become beautiful works of art. But first you have to notice them.

Winter Beech · David R. Daniels · Watercolor · 36" x 60" (91cm x 152cm)

Make creative thinking a part of your daily life. Ask questions. Vary routines. Do the unexpected. Creativity becomes more accessible when you learn to act more impulsively in your everyday life. Change starts your creative juices flowing and makes you more observant of what's going on around you.

Smash creative blocks. Change the problem or sneak up on it from a different direction. Try something fresh—a new way with an old theme, a different point of view, an unusual tool.

Give Yourself License to Create

Children don't need permission to be creative, but sometimes adults feel creative behavior isn't dignified or acceptable for them. "Act your age" puts a damper on any attempt to loosen up and have some creative fun. Put that out of your mind right now and place your feet firmly on a creative path. Age has nothing to do with it. One of my most successful students began painting at age 72. She was still painting nearly every day and selling most of her paintings when she died at 94. It's never too late to create.

BECOME LIKE A CHILD AGAIN

Children quickly notice anything new and unusual; they explore it, then rush off to another adventure. Children have few doubts about themselves as inventors, storytellers and image-makers. To a small child anything seems possible. Do you remember the creative things you did when you were small? You made a clubhouse out of a box, cut paper dolls from cardboard, invented games and stories. The world was your playground. And it still is.

To tap into that natural creative spirit, recapture your childlike enthusiasm for everything around you. Work with the reckless delight of a child. Researchers note that the childlike and playful attitude of many creative people is accompanied by an amazing flow of enthusiasm and energy.

"We do not stop playing because we grow old; we grow old because we stop playing."

George Bernard Shaw

THE CREATIVE ADULT

As an adult, you have many personal resources to draw upon in addition to a child's playful attitude. Your hopes and dreams, as well as your perceptions of the world around you, come through in your work and make it unique. Creative expression is not just a means of getting attention, although some have approached art that way. Think of art as a way of connecting, of sharing your insights with others.

☞ *Activity* ☜
Rediscover Yourself With Collage

On illustration or poster board, start an autobiographical collage. Include memories of yourself as a child, your perception of yourself now, and your hopes for the future. Include things you like and things you hate. Adhere photos and magazine pictures with white glue or acrylic soft gel. Draw or paint on your collage, and include real objects if they're not too big. Use crayons, colored pencils, watercolors, ink—whatever you like. There is no right or wrong way to place the pieces. When you fill up one sheet, begin another. Use your collages as reference files for creative imagery.

☞ *Activity* ☜
Revisit the Kid Inside

Recover some of the creative energy you enjoyed when you were young. Work and play with the delight of a child. Call up the youngster inside you by using materials you've long since abandoned—crayons, finger paints, chalk, construction paper—or by drawing while lying on the floor. Go ahead; it'll feel good to act like a kid again! Draw with markers or crayons, using your non-dominant hand. Draw a cartoon showing what you want to be when you grow up.

A Lifetime of Ideas

This partially completed autobiographical collage contains photos, sketches and magazine clippings of places I've been, things I love, and a few activities I enjoy. Several of the pictures have already inspired paintings.

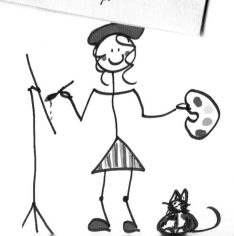

Creativity Can Be Learned

At one time the consensus was that creativity is an inborn characteristic of a few lucky people. If you weren't born with it, forget it. In the twentieth century, theories of creativity recognized the creative potential of every human being. What's more, they asserted that you can increase your level of creativity with a little effort.

THE FIVE LEVELS OF CREATIVITY

I.A. Taylor defined five levels of creativity in "The Nature of Creative Process." (P. Smith, ed. *Creativity*. New York: Hastings House, 1959.) With motivation, anyone can attain the first four levels of creativity.

1 The first level incorporates the *primitive and intuitive* expression found in children and in adults who have not been trained in art. There is an innocent quality to primitive art, but also directness and sensitivity. The naive artist creates for the joy of it.

2 The second level of creativity is the *academic and technical* level. At this level the artist learns skills and techniques, developing a proficiency that allows creative expression in myriad ways. The academic artist adds power to expression through mastery of craft.

3 Heralding the level of *invention*, many artists experiment with their craft and explore different ways of using familiar tools and media. Breaking rules is the order of the day, challenging the boundaries of academic tradition and becoming increasingly adventurous and experimental. Inventors use academic tradition and skills as a stepping-stone into new frontiers.

Level One: Primitive and Intuitive

My daughter's marker drawing at the age of 8 shows the intuitive creativity typical of the first level of expression. It bears a remarkable similarity to prehistoric drawings found in France that this child had never seen.

Hippokantlerralogniff · Kathleen Leland Norman · Marker on illustration board · 12" x 16" (30cm x 41cm)

Level Two: Academic and Technical

Skillful use of traditional media and techniques indicates the second level of creativity. Egg tempera is a demanding medium, handled masterfully in this painting.

Vessels of Time · Julie Ford Oliver · Egg tempera · 15" x 22" (38cm x 56cm)

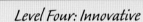

4 At the level of *innovation* the artist becomes highly original. Out-of-the-ordinary materials and methods are introduced. The innovative artist breaks boundaries. Academic foundation remains the substructure of unconscious thought guiding these creative efforts.

5 The fifth level of creativity is characterized as *genius*. Certain individuals' ideas and accomplishments in art and science defy explanation. Genius is arguably the one unexplainable, and perhaps unattainable, level, something that an individual may be born with. Some experts nevertheless contend that genius is a combination of exceptional genetics and environment.

Level Four: Innovative

An innovative artist, Stolzenberger uses unlikely materials such as bones, beads and feathers to make distinctive creative art.

Artifacts from Feast of the Hunter's Moon · Sharon Stolzenberger · Paper, watercolor, muskrat skull, porcupine quills, bone buttons, turkey feathers, wax-covered cord and beads · 30" x 22" (76cm x 56cm)

Level Three: Inventive

The inventive artist finds unusual ways to manipulate ordinary materials. Betts has invented a technique she calls "aqua-gami," comprising constructions of folded watercolor-painted papers.

Swirl Pools · Judi Betts · Watercolor collage aqua-gami · 22" x 30" (56cm x 76cm) · Collection of Thyrsie and Mark Cahoon

The Mechanics of Creativity

Psychologists who study creativity have concluded that creative thinking involves a process that an individual can consciously set in motion. Understanding this process is key to creative problem-solving.

THE FIVE STEPS OF THE CREATIVE PROCESS

There are definite steps in the creative process. Sometimes you work systematically through a creative project over a long period of time and other times you get instantaneous results, but, regardless of the timing, the process is virtually the same.

Let's examine the five stages of the creative process—identification of the problem, preparation, incubation, breakthrough and resolution—to see how they work:

1 The creative process begins with *identification* of the problem to be solved: planning a quilt, designing a landscape or learning a new painting medium. Nothing creative will happen until you identify what you want to do.

2 A *preparation* phase follows, during which you evaluate possible solutions. At this stage you research possibilities, considering what you've done previously with similar problems or what others have done. You make sketches, plan color schemes, and establish boundaries for your creative activity. This is the thinking stage of the project.

3 In the *incubation* stage, you put the project on the shelf for a while. Your unconscious mind sorts and assimilates the information you accumulated in the preparation phase,

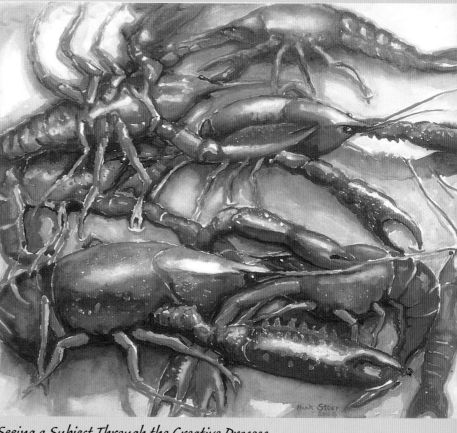

Seeing a Subject Through the Creative Process

How does a "mudbug" become an attention-getting painting? The artist sees the subject as it filters through conscious and unconscious processes during the incubation stage of creation to become this striking image captured on paper.

Louisiana Mudbugs · Dr. Hank Stoer · Watercolor · 17½" x 20½" (44cm x 52cm)

much like a computer sorts a database. This stage may take only minutes, while you set up to work or take a coffee break. Then again, it may take a much longer time for a fully realized solution to surface.

4 *Breakthrough* is the fourth stage in the creative process, when the solution becomes immediately apparent. This is not inspiration, but the result of your earlier thinking—although it sometimes seems amazing when the insight suddenly comes through.

5 Once the breakthrough has occurred, a *resolution* step completes the process. You're ready to try your solution and see how it works. The creative process has helped solve your problem.

Think about a recent problem-solving event you experienced and examine closely the way you solved the problem. You will discover that each step in the creative process contributed to your solution.

Equipping Your Creativity Toolbox

Awareness is a major key to creativity. Notice your surroundings; pay attention to changes in your environment; consciously acknowledge your intuitive urges or gut feelings about choices you're making. The gift of creativity is yours, but you must grasp it fiercely and affirm, "I am a creative artist" over and over again. You have the right to be creative.

Think positively about your creative self at all times. Start with creative goals that are doable. You're freer to create when you're not bound to unrealistic expectations. You have a great deal in common with other creative souls, and creativity tools abound to help you on your journey.

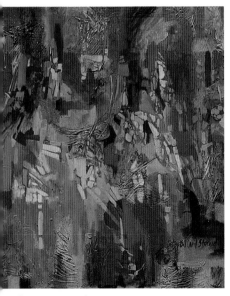

The Fruits of Creative Problem-Solving

Pushing boundaries is Stroud's trademark in her colorful abstract artwork. She dazzles with color and gesture as the painting develops from intuitive beginnings through creative problem-solving processes like those described on this page.

Moonwalk · Betsy Dillard Stroud · Acrylic on canvas · 5' x 5' (2m x 2m)

THINKING TOOLS FOR CREATIVE PEOPLE

In *Sparks of Genius* Robert and Michèle Root-Bernstein assert, "At the level of creative imagination everyone thinks alike." Everything begins with feeling, followed by understanding. When you see a problem, you intuit a solution, and then prove it. Intuition is the still, small voice that says, "Try this." In analyzing the work of creative people, the Root-Bernsteins describe thirteen important ways to look at a problem to prompt your creative voice to chime in:

1 Paying attention to your senses

2 Seeing in your mind's eye

3 Reducing to essentials

4 Seeing natural patterns and structure

5 Combining simple elements in new patterns

6 Seeing similarities in different things

7 Feeling a preverbal sensation in your body

8 Feeling a part of the process

9 Visualizing in dimensions of space or time

10 Using tools 1–9 above to create something

11 Pushing boundaries to see what happens

12 Changing a thing into something that works

13 Integrating several of these thinking tools

Many activities throughout this book address one or more of these problem-solving strategies. Each tool makes an important contribution to the complex experience of creativity. You may be more evolved in some areas than others. Open your eyes to possibilities and work on the tools you think need development.

Imagine That!

When you look out at the snow and wish you were walking on the beach, you're imagining. Everybody has imagination. And, as Albert Einstein said, "Imagination is more important than knowledge."

Imagination is the picture in your mind of something that isn't there. The creative artist takes those pictures out of the mind and makes them visible—sometimes literally, sometimes symbolically. Poet Wallace Stevens describes imagination as "the power of the mind over the possibilities of things." You have the power to free your imagination.

Do you see figures in the shapes of moving clouds? When I was a little girl, I used to imagine a pair of Spanish dancers in an old oak tree near my bedroom window; when the wind blew, they danced for me. Look for people and animals in old stone walls; find images among shells washed up on the beach; see what the patterns on fences and weather-beaten boards suggest to you. Ordinary objects have extraordinary patterns and textures that excite your imagination.

Some people have difficulty seeing pictures in their mind's eye. Don't expect to see complete images. If you have trouble seeing pictures, play word games and make marks that stimulate imagery. Many words sug-gest symbolic images easily represent-ed by marks rather than pictures.

Let yourself daydream some-times. Empty your mind of thoughts that rush through at every waking moment. When distracting clutter surfaces, let it go. Allow spontane-ous images to come and go. Capture one in a quick sketch. These images express connections with your inner self. That's what creativity is about.

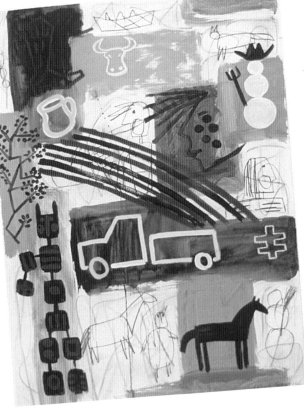

Symbols That Speak

The objects in this painting are pictographic sym-bols rather than realistic representations. Smith calls them autobiographical writings and orga-nizes them into a thematic composition highly suggestive of memories of childhood.

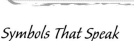

Boot • Jaune Quick-to-See Smith • Acrylic and pastel on paper • 30" x 22" (76cm x 56cm) • Photography by F. A. Ambrose, Albuquerque

☞ Activity ☜
Visualize the Unexpected

Find a quiet place where you'll be free from interruptions for a few minutes. Close your eyes. Practice visualizing things in new and unusual juxtapositions. The unex-pected gives you little shocks that sharpen awareness and enhance creative thinking. Visualize common objects in odd combinations or unusual places. A lemon with an umbrella. An igloo on the beach. A palm tree and a penguin. This isn't a picture-making exercise; it's a way of stretching your creative muscles, like a jogger stretches before running. Occasionally, a visual idea that presents itself will have creative pos-sibilities. When that happens, sketch it out and play with it for a while.

Discover Your Themes

*I*n *Fire in the Crucible,* John Briggs highlights the importance to creative people of a commitment to themes that begins in childhood and continues throughout adult life. Each of us possesses a singular interest in specific ideas, although we may not be aware of their importance to us. Some typical themes are the relationships of human beings to each other, to animals or to the environment; the phenomena of nature and science, metaphysics or religion.

A theme may suddenly surface and pique your curiosity, raising fascinating questions that activate your creativity. If you're not open to it, you may lose your theme in the shuffle of daily activity. Whatever direction your life takes, your underlying themes remain. Discover and explore your themes to open the way for rich creative development.

One of my themes developed from an early fascination with birds in the fields and woods in my neighborhood. This theme has endless variations: freedom (flight), beauty (color, feathers, wings), spaciousness (the sky), power (birds of prey), motion (flight), direction (upward), survival (hunting).

You can expand and interpret any such theme in realistic or abstract art and craft, developed in series or individually.

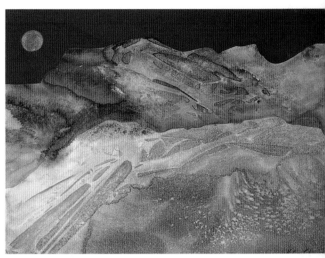

Emergence of Recurring Themes

Recurring themes of wave-like forms and a solitary disk have frequently appeared unbidden in my realistic and abstract work. This piece began as a spontaneous watercolor pouring with no subject in mind. As I developed it, I felt intuitively directed to shape the mountains and incorporate the moon in the painting. Six months after I completed the painting I saw this scene on Red Mountain Pass in Colorado. I may have mentally stored this image on previous trips, triggering an unconscious response to the organic shapes that appeared in my pouring.

Lunarscape · Nita Leland · Watercolor and gouache · 15" x 20" (38cm x 51cm) · Private collection

☞ *Activity* ☜
Run With One Theme

Search your autobiographical collage (from the activity on page 19) for your themes. Are there repeated images of people? Buildings? Water? Animals? Do you notice connections between themes—animals and natural surroundings, people and cities? When you recognize a theme, explore it. Are the people isolated in the city or part of the hustle-and-bustle? Are the animals in a domestic setting, prowling a wild habitat, or endangered by an environmental hazard? Look beneath the surface of an image to find out why this theme is important to you.

Choose one theme from your collage and develop it in a new collage. Make an expressive statement by emphasizing this theme. Scrapbookers show the importance of themes when they organize myriad photos and memorabilia. Without a theme, the pages would be chaos. Make a scrapbook collage using three or four photographs, from landscapes to florals to family pictures. Start with a background paper that ties in with your theme. Embellish the pages with words, handwritten or printed in fancy fonts from your computer. Decorate your page with scrolls and patterns.

Family Connections

Grouping photos with a theme adds poignancy to your page. I scanned and printed old photos of my grandmother's brothers at different ages, then adhered them to a background of antique newspaper fragments and decorative paper. Is it a scrapbook page or a collage? Both!

The Haber Boys · Nita Leland · Mixed media collage · 10" x 13" (25cm x 33cm)

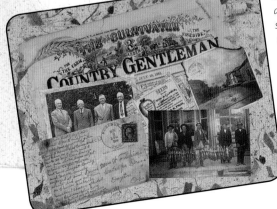

Make Connections

When your viewers look at your work, they bring along their past experiences and prejudices, perceiving more than a simple image. They react intellectually to how you have made your work—your techniques and materials. Their senses respond to the way it looks and feels. But at a deeper level, they respond to the expressive content of the piece: to what you're saying. You express visually something related to human experience that is inexpressible in words. You make connections.

The source of these connections is yourself, so in order to be creative you must get in touch with yourself. The fountain of creativity begins with the stream of unconscious thought flowing inside you. Open the floodgate and creative ideas come rushing out.

Investigate the possibilities of cross-fertilization—combining things that have nothing in common—to come up with a whole new concept. It may be nothing more than an unusual juxtaposition of two dissimilar things, leading from a treatment for one disease to a cure for a different condition. It may be an artist combining totally unrelated elements in a painting to challenge the thinking of viewers. Even humor depends on the unexpected for the punch line.

Depicting the Rat Race

The message of this piece concerns the rapid pace of contemporary life. However, what began as a simple statement about the tyranny of time became cynical when I added the clipping of a lab rat. The title completes the statement.

The Rats Are Winning • Nita Leland •
Paper collage on illustration board • 15" x 20" (38cm x 51cm)

joy

depression

anger

sneaky

attack

☞ *Activity* ☜
Speak the Language of Line

Make single continuous-line marks in your sketchbook-journal that express each of these words: angry, joyful, confused, sad, bored, excited, silly and serious. Are your marks similar to mine? Pictorial word symbols like these depict a universal language. Use this line language in your artwork to speak to people who view it.

Now list words that have strong visual or emotional connotations for you:

* *descriptive words*
* *action words*
* *things you like*
* *things you fear*
* *feelings or moods*

Write one of these words in your journal. Now rewrite the word in a new way: Close your eyes and move your pencil around the paper, making marks that feel like the word. Swing your arm, stab at the paper, or caress the page using your gesture to express the word. When you consider a subject to draw, think of words like these and use energetic lines or movements expressing them in your artwork.

Play Mind Games to Collect Ideas

Brainstorming and mind-mapping generate ideas and visual images. When you're stuck, list what comes to mind spontaneously, no matter how unrelated the thoughts may seem to the matter at hand—the crazier, the better. Psychologist A. H. Maslow once said, "If you are afraid of making (a) crazy mistake, then you'll never get any of the bright ideas, either."

The most impractical idea may turn out to be the most useful one. In the early stages, reject nothing. The sorting process comes later. The more ideas you bring to light, the more choices you have. One idea leads to another.

☞ Activity ☜
Brainstorming

Brainstorming is generally a group activity, but you can do it alone by using free association. Fill a page in your sketchbook-journal with a word list, jotting the words down quickly and allowing each to suggest the next. Start with a word that could be the subject of a project.
Write words that have similar meanings and words that mean the opposite—every word that comes to you. If a word slips in that has no apparent connection, write it down anyway. Accept every word that comes. Sift through your list for unusual words to use with your subject. Sketch out ways you might relate these words to your subject.

HAT

beret	mantilla
bonnet	closet
cap	hat rack
dunce cap	drawer
baseball cap	head
sun visor	stack
clown hat	hatbox
helmet	bald
top hat	toupee

Hat Trick

After free association of the word "hat," I discovered this subject in my hall closet—a found still life, ready and waiting to be turned into a picture.

☞ Activity ☜
Mind-Mapping

Some people prefer mind-mapping to making lists, as this technique is more visual. Mind-mapping helps you to see relationships between ideas, to organize tasks, and to visualize creative solutions. Write your keyword or phrase, usually a task or problem you need to solve, on a page in your sketchbook-journal and circle it. Write associated words, enclosing them in circles and connecting them to the keyword with a line. When a new word suggests a satellite of words that doesn't connect to the keyword, attach them to the new word instead.

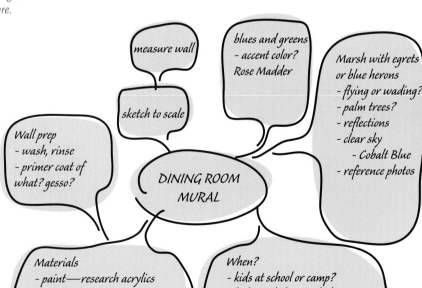

measure wall

blues and greens
- accent color?
Rose Madder

Marsh with egrets or blue herons
- flying or wading?
- palm trees?
- reflections
- clear sky
 - Cobalt Blue
- reference photos

sketch to scale

Wall prep
- wash, rinse
- primer coat of what? gesso?

DINING ROOM MURAL

Materials
- paint—research acrylics
- brushes
- rollers?
- water buckets
- rags, paper towels
- palette—big mixing tray
- masking tape
- ladder

When?
- kids at school or camp?
- kids can help... good idea!
June, before science camp

Stop and Draw the Flowers

People tend to look at things without really seeing them. They block out the unfamiliar and allow access only to what they feel comfortable with. Focus your awareness to discover things you've overlooked and things that others don't see. This opens up a whole world of sensations, a rich resource bank for creativity.

Changing the focus of your sensual awareness is a major key to creativity. Like a zoom lens, your senses are focusing mechanisms. Train them to move around and refocus. Examine a flower, a car, a stone, a building. Notice the smallest detail. Look at it, touch it, smell it. Switch your attention to what you hear: birds singing, children laughing, a lawn mower buzzing. Did you hear them when you were using your eyes, or did you tune them in only when you stopped to listen?

Exaggerate What You See

Her lively imagination and no-holds-barred use of color animate Vierow's surroundings. How do you see your environment? Jazz it up in your artwork.

Red Purse • Judith Vierow • Acrylic on paper • 9" x 12" (23cm x 30cm)

☞ *Activity* ☜
Explore Objects as You Draw Them

Draw a shoe, flower, teakettle or other object from several points of view. Pick up the item and examine it closely. Feel its contours, note its hard and soft edges, look inside it, turn it upside down. You will do a more accurate drawing when you explore the object rather than just looking at it. Draw the object many times from different angles on the same sheet. Approach every subject this way, becoming familiar with it as you draw it.

Heighten Your Familiarity With Everyday Objects

Explore, draw and discover (or rediscover) everything around you. Until I drew this purse, I never noticed the medallion on the zipper-pull.

Check Out the Details

Look closely at sliced fruits and vegetables, noticing differences between the vertical and horizontal cuts in the same object. Notice the variations in rock formations along a mountain road and canyon walls shaped by moving water. Study the patterns of city buildings. Pay attention to your surroundings. Practice memory drawing (see the activity on page 23) to sharpen your awareness of detail in the things you observe.

☞ *Activity* ☜
Borrow Designs From Existing Objects

Look for images or designs in unexpected places. Slice a green pepper, an apple or a head of cabbage and draw the cross-section. Transform this into drawings of landscapes, faces, figures or abstract designs, dropping out some lines and adding others to strengthen the image. Use the natural pattern as a point of departure, then move in any direction the pattern suggests.

Seek Out Designs

These cross-sections of a green pepper show you how to find raw designs in unexpected places. Can you discover a design in a shoe, a flower or a leaf?

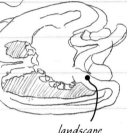

landscape

Translate Found Designs Into Artwork

These landscape and flower forms are derived from cross-sections of the green pepper. Each could be the beginning of a painting or a design for weaving or quilting.

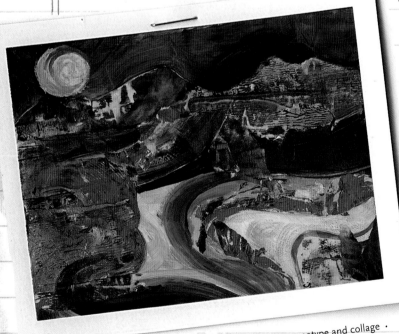

From Vegetable to Landscape

Using brushstrokes based on the organic, rhythmic shapes of a green pepper, I applied a gesso ground. When it dried, I painted the background with acrylic colors in a high-intensity palette. I made abstract monotypes using the same colors, then cut and tore pieces from them to apply to the painted background. I worked intuitively at first and was surprised to notice a landscape emerging, so I pushed the image in that direction.

Notice that my themes of wave and disk, as described on page 25, recur in this painting.

Cross-Section Green · Nita Leland · Acrylic monotype and collage · 15" x 20" (38cm x 51cm) · Private collection

Take the High Road

Nothing is totally new. Your experiences and observations influence everything you create. You modify, add and subtract to make something new. However ordinary a subject may be, what you bring to it that is new is *yourself*. Your insights make it new, because your point of view is different from everyone else's.

Your work should be your own. When you copy, you deny your uniqueness. Copying isn't creativity; it's just the business of making a picture. When a student named Peggie first came to my class she had good watercolor skills, but she had never painted an original picture. She was terrified to work from a real still life, but her first effort was more sensitive and personal than anything she had done before. Her work continues to reflect this sensitivity.

This is the real test of your emerging creative spirit—doing work that is neither repetitive of your previous work nor a copy of the work of others. Even the best crafters, working from patterns, develop a personal style, original color schemes and embellishments on the original.

MAKE IT YOUR OWN

Tap your inner resources to mine your responses to life's experiences. What makes you happy, sad, angry, calm?

Your autobiographical collages draw upon these resources, and your other creative work must do this, too. You're more than an eye; you're a heart and a mind. Reflect this in your art.

When you find an intriguing subject or project, develop it into an original concept. This involves a blend of thinking skills and intuitive awareness. Start with a good understanding of the subject and knowledge of your materials. Upon that foundation combine creative choices of materials, your style of handling them, and most of all, your feelings about the subject. Putting all these factors together results in expressive communication. The more you do it, the easier it gets. Soon this process becomes second nature to you.

Originality Comes in All Forms

Art doesn't have to be shocking and outrageous to be original. Ben Shahn wrote in The Shape of Content:

A work of art may rest its merits in traditional qualities; it may constitute a remarkable feat in craftsmanship; it may be a searching study into psychological states, it may be a hymn to nature, it may be a nostalgic glance backward; it may be any one of an infinite number of concepts, none of which may have any possible bearing upon its degree of newness.

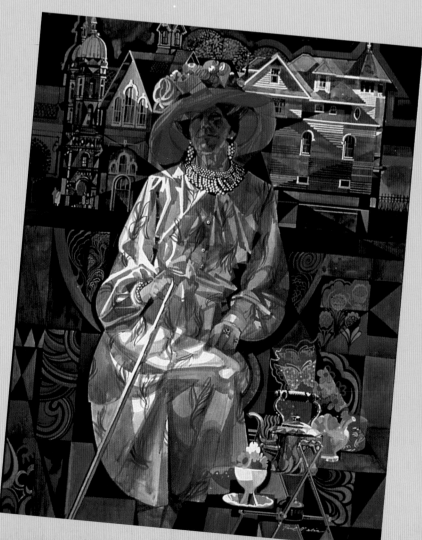

A Highly Original Portrait of a Lady

An elegantly dressed woman flanked by a beautiful home and surrounded by lovely objects is not an unusual subject for a painting. However, Melia's portrait of a lady is a highly original treatment, rich in color and texture.

Sunday Lady · Paul G. Melia · Ink and gouache · 43" x 32" (109cm x 81cm)

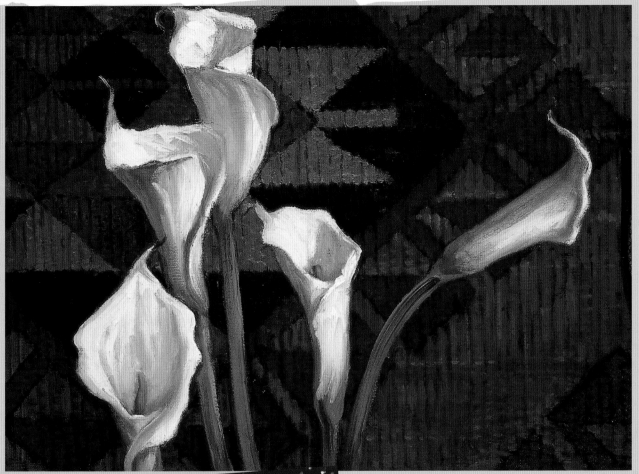

Treating a Formal Subject to an Informal Background

The elegant shapes of calla lilies lend themselves to a formal arrangement, but Oliver has set them on a background of geometric southwestern patterns. The contrasting juxtaposition makes a fascinating creative composition.

Southwest Callas • Julie Ford Oliver • Oil • 11" x 14" (28cm x 36cm)

A Master Has His Own Way

A master folk painter, Bryant creates primitive-style pictures with dazzling color. Within a small format he paints an eye-catching piece here that beautifully evokes a clear desert night with sparkling stars.

Chama Starlight • Bill Bryant • Watercolor • 10½" x 8½" (27cm x 22cm)

Navigating Bumps in the Road

Sometimes you get stuck in the creative process and keep recycling the same ideas or abandoning work at the same unfinished state every time. The higher the stack of incomplete work, the more you avoid your studio.

Nearly everyone, from beginner to creative genius, experiences creative blocks. Many of these blocks are self-imposed. It takes time to make art, to develop skills, to nurture your creative spirit. The best way to deal with blocks is to do something art-related every day, no matter how small, to keep in touch with your creative self.

If you're squeezing your art in between watching a soap opera and reading a romance novel, your priorities are skewed.

BREAKING BLOCKS
Here are a few blockbusting tips to help keep your creativity flowing.

Go to your workspace and putter. File resource material, sort through artwork, sharpen pencils, stretch paper or test paints. You might find a drawing, photo or pattern that suggests a possible project. Even if you don't, you've still accomplished something related to your art.

Carry a sketchbook everywhere you go. Fifteen minutes of sketching while you're waiting in your car or in the doctor's office improves skills and weakens barriers to creativity.

When your projects pile up, don't think about the whole pile. Finish one. It feels good getting that piece out of your system.

Remember that no picture or project is hopeless. You can always toss it in your collage or treasure box. But first, have some fun. Don't try to save it. Experiment with techniques and tools you've been afraid to use on something "good." Try some new tricks. Always be ready to move in a different direction. Occasionally you'll come up with a winner, but even if you don't, you've at least tried some new things. Or—and this is a good thing—you've learned what *not* to do.

 Activity
Start Fresh With an Old Piece

Resurrect an unfinished painting or an old print and see what you can learn by laminating it with translucent papers. Brush matte acrylic medium or white glue over the front and back of an old watercolor or a print on heavyweight paper. Let it dry. Lay a sheet of wrapping tissue or thin rice paper on the picture and gently brush fluid medium or glue on the surface to adhere it. Don't worry about wrinkles; let the piece dry. With more tissue or paper, layer background areas to suggest atmosphere; layer the foreground to enhance texture or recover white areas. Paint the laminated surface with watercolors or acrylics. Make marks with colored pencils or pastels. Brush areas with glue or medium and sprinkle sand or crumpled dry leaves to add texture. Learn something new from every experience with materials.

A Painting Reborn
I transformed my original watercolor sketch (above) with a textured rice paper overlay that creates a whole new mood and texture. First I laminated the piece with one layer of rice paper and let it dry. Then I added a second layer to the sky area and smaller patches along the shoreline. Neutral watercolor washes between layers helped to tone down the color. The piece could be finished as a foggy morning or snow scene with more paint and rice paper.

Art in the Fast Lane

There will always be differences in creative capabilities. People come from many different backgrounds. Some have been encouraged to cultivate art skills since they were children, so they pursue artistic interests freely. Others have been warned not to waste time in such frivolous pursuits, so they feel their artistic efforts are awkward and hopeless. You may have developed the habit of comparing yourself unfavorably with others. Don't do this to yourself. No two people progress at the same speed.

SET YOUR OWN PACE

Some artists benefit from instruction in classes and exchange of ideas in art groups. Others are better off working on their own, using books of self-instruction like this one to help them develop skills and explore new ideas. You may be more likely to develop unique art when you work independently, uninfluenced by fads and frills in techniques.

As you consider your progress as an artist, keep these points in mind:

Have reasonable expectations about what it will take—and how long—to reach your goals. Compare your work only with what you have done before and not with the work of other artists.

You improve each time you do your creative work. Give yourself many opportunities. Start with materials at hand—pencil and paper. One day you will be astonished that you ever thought you were not creative.

Have fun with your art. Having fun is more important than making something. Maybe you're trying too hard to please others. Now is the time to please yourself. Approach your art playfully and not for the approval of other people. Tune out criticism. Persevere in what you're doing regardless of comments from others.

Maybe you're overly concerned with selling your work or getting into shows. In *Fire in the Crucible*, John

Art Imitating Life

The artist allowed her fluid colors to mix freely on the surface, creating bold, colorful washes. Bertolone enjoys making her art, and her delight, in turn, brings pleasure to her viewers. This is largely what creativity is about.

Tall Vase With Flowers • Kathleen M. Bertolone • Ink and pastel • 29" x 21" (74cm x 53cm)

Briggs relates that people involved in creative tasks work harder and are more absorbed in their work when they're doing it for their own satisfaction. When offered a reward, they become less creative and do only what they have to do to get the reward.

Creativity is its own reward.

Ten Ways to Lessen Stress

You have three commissions to finish, two submissions due for exhibitions and a demo to do for the local art group; your studio is a mess, you have to carpool Little League today, your driver's license has expired, and it's past time for the cat's shots. Who ya gonna call, Stress-Busters? We all have to deal with stress at some level on a daily basis. Even good stress takes its toll. Since stress is inevitable, prepare yourself to deal with it more effectively:

1. *Set doable goals.*
2. *List your priorities.*
3. *Organize your time.*
4. *Take care of yourself.*
5. *Say "no" once in awhile.*
6. *Ask for help.*
7. *Don't waste time on things you can't control.*
8. *Do what must be done and move on.*
9. *Write in your sketchbook-journal.*
10. *Play with crayons and finger paints.*

Moving in Different Directions

The desire to change and grow is a manifestation of creativity. People who are dissatisfied with current achievements or are restless to move into new territory are ripe for creative change. This is what prompts a non-artist to venture into the realm of art or causes an accomplished artist to switch to a different medium or style.

CHANGE BREEDS CREATIVITY

How can you improve your creative skills at your present level or break through to the next level? Change. How can you get more in touch with your creative self? Change.

Change and risk-taking are normal aspects of the creative process. They are the lubricants that keep the wheels in motion. A creative act is not necessarily something that has never been done; it is something *you* have never done. Every day, try something you haven't done before. As anthropologist Margaret Mead said, "To the extent a person makes, invents or thinks something that is new to him, he may be said to have performed a creative act."

Build the courage to try new things. Would you like to learn to sew a quilt or decorate a chair? Do you want to take an oil-painting class at a local arts center or attend art school in New York? Take a watercolor workshop in Alaska? Exhibit in a national show? Go for it! A change in direction—even a small one—frees your creative spirit. You never know what you can do until you try.

Look for creative alternatives to everything you think and do. Search for possibilities, not just the habitual or the obvious. Mix media, find an unusual viewpoint, use ordinary tools in extraordinary ways, or juxtapose bits and pieces of unrelated objects and ideas to create new forms or ideas. There are many answers to a question; there are many solutions to a problem. You find them by looking for them.

Combining Imagination and Reality
Melia's boats suggest different levels of reality, including what is seen and what is imagined in the same picture.

Déjà Vu · Paul G. Melia · Pen and ink, gouache and acrylic · 30" x 40" (76cm x 102cm)

☞ *Activity* ☜
Explore Boats as a Subject

On these two pages, three artists approach the subject of boats using different media and techniques. How many ways can you think of to paint boats? List them in your sketchbook-journal. On the water, at dock, beached? In a storm, in the sky, upside down in the grass? Carrying cargo or passengers? Sailing, cruising, racing, towing, tugging? What if you changed your medium? The center of interest? The shape of the support? What if you made a cubist or an abstract boat? Or turned the boat into a watermelon sailing on a sea of cranberry punch?

A Plein Air Picture

Here is another way of looking at boats. Good design and solid technique are the strong points in Sovek's plein air painting.

Marina · Charles Sovek · Oil on canvas · 20" x 24" (51cm x 61cm) · Private collection

Recording for Reference

This sketchbook notation records information for future reference. What Barrish sees in the harbor is different from what you might see.

Harbor Scene, Boothbay, Maine · A. Joseph Barrish, S.M. · Markers · 12" x 9" (30cm x 23cm)

Ideas Are Everywhere

Where do you find ideas? In familiar places such as super-markets, libraries, malls, flea markets and parks, at the beach, at work, in the newspaper—try the classified section for a change!—at museums, galleries and art fairs. In short, everywhere you go you'll find something to inspire your creativity. It won't jump out at you; you have to be looking for it.

Find Inspiration at Home

This artist didn't go to an exotic location for inspira-tion: she used images of cake ingredients found in her kitchen, accented with bits of collage—her recipe for a lively composition.

Black Forest Cake · Shirley Eley Nachtrieb · Mixed media · 10" x 8" (25cm x 20cm)

You're On Your Way

Rollo May, in *The Courage to Create*, wrote: "Creativity... requires limits, for the creative act arises out of the struggle of human beings with and against that which limits them."

When you decide on your medium, choose a subject or select a color scheme, you're setting boundaries for your creative energy. You have great freedom within this framework. Without such limits, however, everything is chaos. Limitations focus your creativity. These limits define the challenge that makes creative art an exciting and satisfying pursuit.

WHAT ABOUT TALENT?

Pablo Picasso, a great artist of the twentieth century, drew and painted well at a young age. His artist father took an avid interest in his artistic training. If you've been similarly motivated by praise and moral support, you probably take it for granted you're talented. But it isn't enough just to believe you're talented. You have to work hard to develop your talent to its full potential.

Many definitions of creativity exclude talent as a prerequisite to art, placing emphasis on desire, perseverance and determination. In short, it takes self-discipline. Sydney Harris, a newspaper columnist, once wrote: "Self-discipline without talent can often achieve astounding results, whereas talent without self-discipline inevitably dooms itself to failure."

Creativity is not a magical ingredient of personality granted to a chosen few. Creativity is an attitude you hold toward the choices you make in life, as well as in art. There is always a better way of doing things, and creative people are out there looking for it.

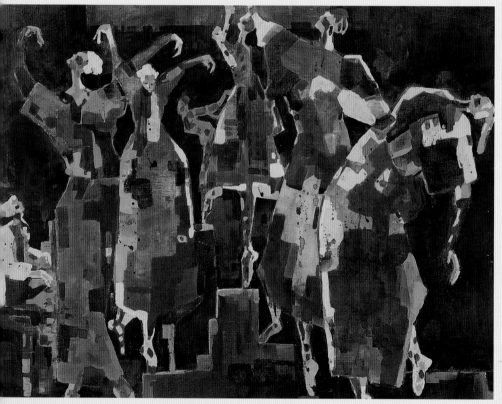

A Creative Combination

Creativity is fun and life enhancing. When you combine playfulness and a spirit of adventure with discipline and self-control, you experience the true joy of creativity. Baspaly shares her joy with us in her colorful paintings.

The Tuesday Group's Interpretive Dance Class · Donna Baspaly · Mixed Media · 22" x 30" (56cm x 76cm)

Self-Discipline Reinforces Creativity

Self-discipline is the road to creative freedom. Get control of yourself and your environment, and your creative spirit will flourish. Be a self-starter. No one will do it for you. Value your time and use it wisely. Set limits to focus your creativity. Pace yourself and make yourself take breaks. Think positively. You can do it, if you think you can.

Share the Ride

As you access your creative potential, acknowledge the potential of others, as well. What you give to others in the way of encouragement will be returned to you, stoking your creative fire.

Share your knowledge and skills with others. Community outreach is a great boost to your creative spirit. I've worked with all age groups, some professionally and some as a volunteer. They have taught me so much. From children I've learned the wonder of natural creativity. From teenagers in a probationary program, I've learned the transformative power of art. From active seniors in a retirement community, I've learned the joy of creating for pure fun. And from early Alzheimer's patients, I've learned that art reaches the depths of the mind. Your creativity expands the more you share it with others.

MENTORING OTHER ARTISTS

Competition in the art world is so prevalent we forget how much we gain through cooperation. Start a small art group or better yet, teach, so you may learn. Working out a lesson plan reinforces your comprehension of a technique or design principle. Include critiques in your groups and classes so everyone can benefit from feedback. Critiques should be helpful, not hurtful. Here are some tips on class critiques:

Ask the artist what he or she wishes to communicate in the piece.

Offer a positive comment before pointing out problems in the work.

Be honest and don't gloss over errors.

Suggest a solution to every problem.

Point out that most artists have similar problems.

Allow group members to contribute comments in the proper spirit.

Conclude with words of encouragement.

Artistic Fellowship

Kolman was a beginning student in my class in the 1970s. We became friends as I mentored her through her early watercolor years. We are colleagues now and share ideas and thoughts about art and creativity daily by email. She often explores mixed media, as in this creative portrait of her grandmother.

Grandmere ·

Stephanie H. Kolman · Collage and mixed media · 31" x 25" (79cm x 64cm)

☞ Activity ☜
Participate in Artistic Outreach

Visit a local school or senior center and volunteer to work with a craft group or art club. You needn't make a time-consuming commitment; just offer to drop in now and then to help out, do a demo or show slides. Put together a collage kit with a few magazines, glue sticks, scissors and sheets of paper for backgrounds, and you'll be prepared to entertain children of all ages with a fun art experience. Your attention can make a difference in someone's life and will undoubtedly enrich yours.

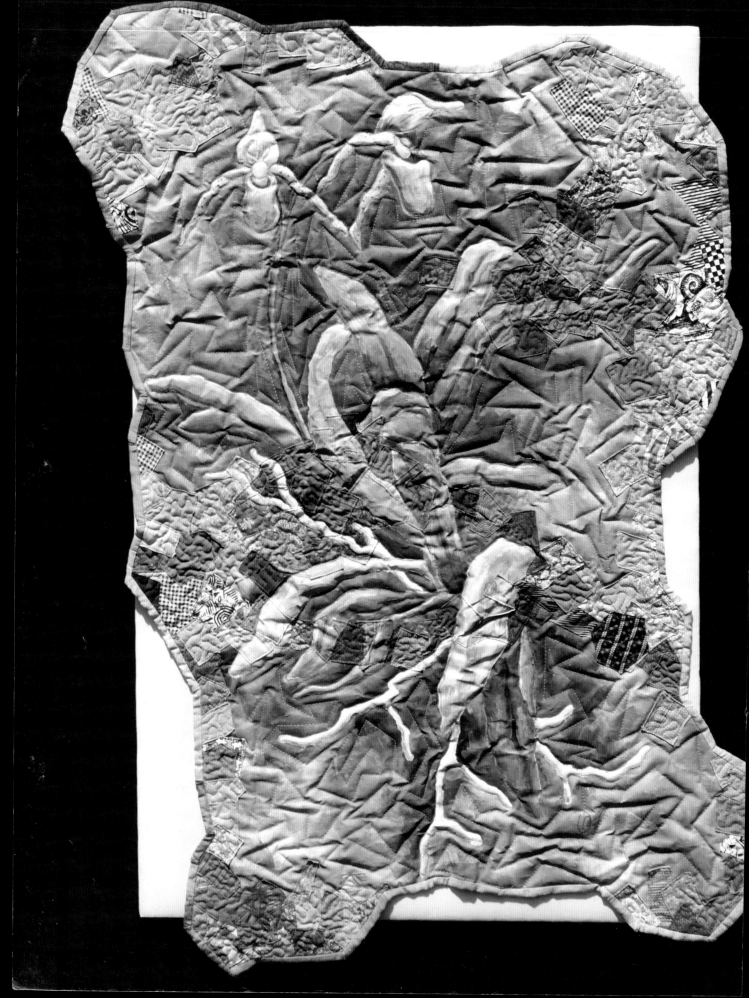

2 ART AND CRAFT:
Highways and Byways

Night Visions · Ardis Macaulay · Handmade artist's book · colored pencil, copper and gold acrylic on black paper · 11" x 12" (28cm x 30cm)

People often separate crafts from Art-with-a-capital-"A." Some label certain creative activities as hobbies, not to be taken seriously as art, even though these might well be the launching pad for original creative production. Fortunately, current art trends include fiber works, paper arts, printmaking, photography and much more. And why not? The same creative design processes are used in these activities as in painting, drawing and sculpting. The results produce similar responses in viewers and benefit the creators in innumerable ways.

Definitions of art should include all arts that allow us to express that basic impulse to create, which is the essence of being human. You need thinking and technical skills to make the best crafts. If you work hard at any skill, whether drawing or painting, weaving or lettering, call yourself an artist. The lines have blurred between fine art and craft in recent years, allowing myriad opportunities for a creative spirit to blossom. Some of the crossovers between art and craft are described in this chapter. Working with a variety of arts and crafts could enhance your artistic abilities. There are many side trips worth exploring on your creative journey.

" During all your life as an artist, learn through painstaking experimentation, exercise, and practice how to acquire a masterly knowledge of your craft."

Paul Jacques Grillo

Metaphor for the Soul · Alan R. Kelchner · Mixed-media quilt · 42" x 28" (107cm x 71cm) · Private collection

Art vs. Craft

The word "art" originally meant a craft or specialized skill and included poetry as well as carpentry. Renaissance painters considered themselves craftsmen, not *artists* as we think of the term today. Toward the end of the eighteenth century a distinction was made between fine art—that which was considered beautiful, but not necessarily practical—and craft, which was primarily functional. Arguments over what comprises art and what is craft have been raging ever since.

BUT IS IT 'ART'?

Some definitions say that a craftsperson makes an object for a stated purpose using a pattern and specific materials, while an artist creates an object that has no practical use other than decoration or artistic expression. Many craftspeople go well beyond this limited definition, designing their own creative patterns and using innovative materials to create objects that are beautiful as well as practical. Clearly, you can find expression in crafts, as well.

Does this semantic debate matter? Not really. What counts is your passion for what you do and your desire to become more knowledgeable and skilled with the techniques you use. For example, in my definition of art, scrapbooking is closely related to the art of collage; until Picasso and Braque used it in their paintings, collage wasn't considered an art.

CHOOSING YOUR PATH

Most people believe they can do crafts but not art. Ignore that belief. If you're a creative crafter, you already have the creative spirit. Now develop the skills to do whatever you want to do in art or craft.

You don't have to limit yourself to art *or* craft. Have it both ways. An oil or watercolor painter can indulge in crafts or a creative crafter can aspire to be a painter. Many craft skills also apply to painting and other fine arts. Venture into new skills you perceive as more difficult. It isn't as hard as you think. Picking up a new craft skill is a perfect way for visual artists to work their way out of creative blocks.

Most people become involved in creative activities long before they have any notion that what they're doing has artistic value. For years I color-coordinated my gardens, designed my own clothing and organized parties and outings for my children, but I never considered taking an art class because I didn't think I was creative. Now I realize that all those activities were stepping-stones leading me to the creative life I enjoy today. If I had it to do over, I would follow the same path, focusing on my family before I became involved in my life as an artist. But I would have a greater appreciation of the creativity involved in my daily life. And I would no longer apologize for wasting time with crafts when I should be painting.

Blending Craft and Art

Betts is well known for her striking realistic watercolors. In a creative departure from her usual techniques, she cuts and folds her demonstration paintings, arranging them in colorful constructions on a background.

Lucky Bounce · Judi Betts · Watercolor collage construction · 22" x 15" (56cm x 38cm)

☞ Activity ☜
Discover the Depth of Crafts

Visiting museums and galleries fills your mental storehouse of art images and techniques. This is just as important when your primary interest is a craft. This week, find at least one craft museum, website, exhibition or gallery where you can immerse yourself in the creative possibilities of crafts. In your sketchbook or journal list themes, subjects or techniques that might be useful ideas for projects. If photography is allowed, take pictures to file with your notes for future reference. Study the exhibits for aspects of design. Note what resonates with you in the work.

Fine Art vs. Commercial Art

The artists' forums I've belonged to on the Internet periodically engage in spirited debates over where to draw the line between fine art and commercial art. Some place commercial art in the category of craft, considering it less creative than fine-art painting. This argument is specious in my opinion. The commercial artists I've known are fantastically creative. Several of the most successful visual artists I'm acquainted with were experienced commercial artists before they became painters.

The benefits of beginning as a commercial artist (often called a graphic designer) are many. Aside from the knowledge of tools and materials gained in school and on the job, graphic artists learn self-discipline and are motivated to produce in a professional manner, unlike many fine artists who dilly-dally waiting for their muse to awaken. The harder you work, the more skilled you become. Quantity evolves into quality.

Some critics draw a hard line between fine art and commercial design, but the test of either should be how much of the artist is found in the art. Some graphic artists put themselves heart and soul into their work and others are just doing the job, but the same may be said about many fine artists, too. Beginning your career as a creative artist by studying graphic design is a great way to establish a foundation of knowledge and skills. Such specialties as cartooning and airbrush art are full of originality and humor, two important aspects of creativity.

Computer software in commercial design has resulted in an explosion of digital fine-art applications. Artists use computers to plan value schemes, rearrange compositions or resolve creative blocks simply by breaking up their art routines and allowing them to play. They apply dazzling special effects to original artwork to make it even more exciting. They can even change their photos to sketches, eliminating confusing detail in their resource material.

Spring Orchard · Barbara Livingston · Pastel on sanded paper · 8½" x 11" (22cm x 28cm)

Cincinnati, Inc. · Barbara Livingston · Watercolor on Crescent board · 13" x 10" (33cm x 25cm) · Courtesy of *Cincinnati Business Courier*

One Artist, Two Means of Expression

Livingston is a multi-talented graphic artist who can create an expressive, original representation of nature as well as put together a commercial commission without missing a beat.

☞ Activity ☜
Learn From a Graphic Artist's Work

Find an eye-catching advertisement in a quality magazine. Look for strong values, interesting shapes and appealing colors. Cut out the ad and paste it in your sketchbook-journal. Examine its creative qualities and write answers to the following questions:

* Why does this ad appeal to you?
* How did the graphic artist use imagination to capture attention?
* What skills did the artist need to create the ad?
* Does the artist know how to draw?
* Does the artist appear to understand color theory and other design principles?
* Is humor a part of the content?
* What did you learn from this graphic artist that might help you improve your art or craft?

Repeat this activity with a new ad every day for a week. Change magazines for different types of graphic design. Become aware of good design everywhere you look.

Papermaking

*L*et's explore some creative arts that cross over into fine art, beginning with the ancient craft of papermaking. Paper is more than just a surface for painting. Paper is also an art medium. Paper was invented in China between the years 140 and 87 B.C. Handmade and decorated papers have been employed for centuries as backgrounds for calligraphy. Artists mold paper into masks and papier mâché objects, fold paper into origami sculptures, and use papers of all types in collage and scrapbooking. Can you even begin to imagine a creative world without paper?

HANDMADE AND MOLDED PAPER

Nothing in art or craft seems quite so elemental as making your own paper. The sensation of working with pulp and the excitement of pulling your first sheet of handmade paper from a mold and deckle or a low-relief cast paper form from a three-dimensional mold defy description. The creative joy of making something from a slurry mix of water and cotton linters or shredded papers is nothing short of amazing.

There are many ways of being creative with handmade paper by using color and adding leaves, ribbons, lace and more to wet pulp. This simple activity is described in many books, including a two-page basic papermaking demo on pages 116–117 of my book, *Creative Collage Techniques*. In your local arts and crafts stores you may find user-friendly papermaking kits that contain all the essentials for a quick start in this fun, creative process. You can also sculpt paper in low relief with materials right at hand.

Handpainted Cast Paper

Cast paper has a noteworthy sculptural appearance, even when in low relief. Grimm adds handpainted touches of color for a rich, elegant effect.

Tchaikovsky's Waltz of the Flowers · Esther R. Grimm · Handpainted cast cotton relief · 34" x 31" x ½" (86cm x 79cm x 1cm) · Collection of Michael and Jennifer Funk

Handmade Paper as a Backdrop

A selection of sentimental artifacts becomes a work of art combined with elegant handmade paper. Papermaking is an art in the Far Eastern tradition, but here it is westernized with the combination of non-paper elements.

Paper, Lace and Pearls · Rosemarie Huart · Handmade paper and mixed media · 21" x 12" (53cm x 30cm)

 Activity 🖘

Paper Sculpting

Use a medium-weight piece of cardboard or illustration board as your base. Lay a piece of bond paper or medium-weight rice paper on the board. Coat the paper completely with white glue or acrylic matte medium. When the paper becomes limp, mold it into various shapes. Then let the piece dry thoroughly. Decorate the sculpture with glued-on bits of colored paper, or size the surface with a coat of gesso and paint it with acrylics. Try a bright color scheme or design on your hand-sculpted form.

My Low-Relief Sculpture

I followed the procedure described, using illustration board, acrylic matte medium and medium-weight rice paper, which molded beautifully. I might tint this piece, which measures 9" x 12" x 1" (23cm x 30cm x 3cm), with watercolors and frame it in a shadowbox. I wouldn't coat it with gesso, which would cover the beautiful natural fibers in the paper.

Scrapbooking and Rubber Stamping

Who knew that the lowly scrapbook would evolve into an art form? Not I. I have stacks of scrapbooks I made in high school and college, and they're falling apart. In the dark ages of my youth we didn't recognize the importance of archival materials, so the wood-pulp paper and acid-content rubber cement have taken their toll on the pages. Today an entire industry has grown up to provide scrapbook artists with acid-free paper, adhesives, pens, stickers and nearly everything else used in a scrapbook to preserve your photos and mementos.

Shop scrapbook stores for decorative papers and other archival materials to enhance your watercolors and mixed-media arts and crafts. Rubber stamping, frequently found in scrapbooks, is also used to make greeting cards and invitations, as well as interesting additions to collage and mixed-media paintings.

APPLY ARTISTIC PRINCIPLES ACROSS MEDIUMS

Creativity flows freely when the scrapbooker or stamper combines imagination with art principles to compose a beautiful or entertaining page or card. Use creative design skills to make good scrapbook pages and cards, as an artist uses the elements of design to organize a painting or drawing.

Layout is key to presenting your featured photos or rubber stamping to the best advantage. Color schemes create unified pages. Add your own drawings, decorations, rubber stamps and calligraphy to your scrapbook pages for an original touch. Water-color paints, acrylics and acid-free, lightfast markers are useful tools for the creative scrapbooker.

Preserve and Protect

Make your scrapbooks to last. Test materials with a pen-like pH tool to assure they are acid-free. Krylon sprays protect your photos from UV damage or de-acidify non-acid-free papers. Use proper ventilation with all sprays.

☞ Activity ☜
Make a Family Scrapbook Page

Make a scrapbook page using family photos. Peruse books and magazines dedicated to scrapbooking to get an idea of the type of page you would like to design. Sort through your photos and select three or more that have a common theme, such as sisters, birthdays, soccer or wildflowers. Many scrapbookers advise scanning photos rather than using the originals, but that's up to you. Arrange your photos on a piece of heavyweight acid-free paper. Adhere them with acrylic gel medium, acid-free white glue or dry-mounting tape. Add cutouts from decorative papers or stickers. Write a brief description or story about the photos on the page. Journaling is an important creative aspect of scrapbooking. Your scrapbook pages connect with people in the same way that a painting speaks from the walls of a museum.

Stamping for a Painting
Here I stamped the Kokopelli figure on my hand-marbled handmade paper and mounted it on machine-made collage papers. The "gold" around the edges of the cave consists of mica flakes in acrylic medium.

Guardians of the Gold · Nita Leland ·
Mixed-media collage on illustration board ·
10" x 15" (25cm x 38cm)

My Page
I selected several old family photos with a common theme: a boy's enthusiasm for cars. I scanned, cropped and arranged the photos on a 12" x 12" (30cm x 30cm) page related to the theme of wheels. I'm afraid I got carried away with the photos and ran out of space, so I used stickers instead of handwritten notes to tell the story.

Far Eastern Influences

Most Far Eastern arts are relatively simple to begin with but include a wide range of complex techniques and elegant forms. Many paper arts have come to us from China and Japan. Some originated nearly as long ago as the invention of paper in ancient China. Creative paper arts range from manipulation techniques, such as *origami* (paper folding) to *suminagashi* (marbling) and *sumi-e*, the Japanese art of brush painting with black ink on paper.

ORIGAMI

Paper folding calls for manual dexterity, but beginning projects are relatively easy. You've probably already made paper airplanes. Purchase inexpensive origami papers in art and craft stores and follow the enclosed instructions for creating three-dimensional paper sculptures of birds and other subjects. Accomplished artisans create more complicated figures. Learning to make origami objects develops the understanding of three-dimensional form necessary for many other arts.

SUMINAGASHI

Suminagashi is Japanese marbling with inks, a process that results in elegant papers with subtle organic patterns and delicate shading. Gently stroking and blowing a drop of ink on water in a tray forms subtle, naturalistic patterns, unlike the decorative designs on traditional marbled papers. The artist places paper carefully on the surface and lifts it off to take a print from the delicate pattern. It takes just

Tabletop Sculpture

Sullivan folds complicated figures and assembles them in three-dimensional scenes. The result is a creative, entertaining tabletop sculpture.

The Roundup • June Ann M. Sullivan • Origami • Figures approximately 9½" x 9" (24cm x 23cm) • Courtesy of Watermark Gallery

☞ *Activity* ☜
Japanese Marbling

Put two inches (5cm) of water in a flat plastic tray. Place a teaspoon of Bombay India Ink into a small palette well. (You can experiment with other watermedia, but I've had my best results with Bombay inks, which come in several lovely colors.) Place a teaspoon of water in another well and stir in a drop of Kodak Photo-Flo dispersant.

Using slightly damp, one-inch (25mm) pointed Oriental brushes, load one with ink and another with dispersant solution. Touch the tip of the ink-filled brush to the water in the tray. A pale circle of ink film spreads on the surface. Touch this circle with the tip of the dispersant brush. Alternate paint and dispersant as many times as you like, tapping different areas of the surface or gently blowing across it to generate patterns.

Make your print on the rough side of sumi-e paper cut smaller than your tray. Lay the paper on the surface of the water, holding it at diagonal corners. Lift the paper quickly but gently, rinse off the excess ink, and lay it on newspapers to dry. Try different types of paper to see what gives you the best results.

the right touch so the inks don't sink in the water.

Many books on paper art describe this technique in detail, so check the library and online for more information. Use your suminagashi papers for collage, notepaper, wrapping paper and even as backgrounds for paintings.

BRUSH PAINTING

Children in the Far East learn at an early age to use a brush to make characters that comprise their written language. Many use their brush-handling skills in *sumi-e* (black-ink painting) and other traditional styles of brush painting. I recommend that watercolor students seek a class in Japanese or Chinese brush painting where they can practice brush-handling techniques, even if they don't wish to paint bamboo and Japanese iris.

The meditative grinding of ink in sumi-e fosters awareness. As the painting develops, the artist accepts what happens without trying to fix it and learns to appreciate the beauty of imperfection. This concept, sometimes called *wabi-sabi*, must be experienced to be understood. Westerners tend to get wrapped up in trying to make our creations perfect. No wonder artists get blocked! Perfectionism is another word for procrastination. The Far Eastern approach helps you to overcome this mindset and develop your creative spirit.

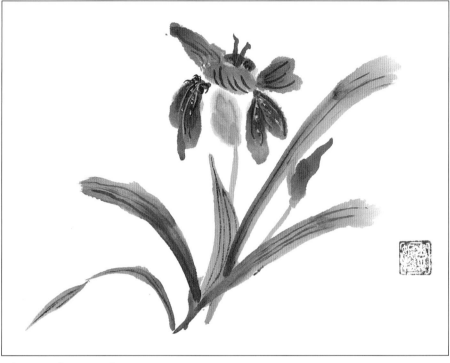

The Simplicity and Serenity of Brush Painting

I took a short course on brush painting from a Chinese woman, and my appreciation of the art grew immensely. I'm not an accomplished brush painter, but I enjoy the serenity of the process.

Iris · Nita Leland · Mineral colors on mulberry paper · 6½" x 9" (17cm x 23cm)

☞ Activity ☜
Sumi-e

Practice brushstrokes with both flat and round brushes. You can work on traditional mulberry or rice papers, but any paper will do for practice. Make each stroke with watercolor, ink or thinned acrylics by varying the pressure and direction of the brush. Visit your library or bookstore to find books on sumi-e for more examples and instruction on brushstrokes. These techniques give you greater brush control for any type of painting or decorative art.

Start Simply With Single Strokes

Japanese and Chinese brush techniques begin with traditional subjects, such as bamboo. Use a single stroke to represent a leaf or section of the stalk instead of filling in an outline.

Bamboo · Nita Leland · Sumi-e on mulberry paper · 9" x 12" (23cm x 30cm)

Decorative Painting

The list of traditional folk arts and crafts is long. Many artists cross over freely from one to another. Each requires its own techniques and materials, and many call for specific skills not common to other crafts. Some are closely related to fine art, using media such as acrylics and oils, but applying them to functional as well as nonfunctional surfaces.

From the sixteenth through the eighteenth centuries, detailed Dutch still-life paintings were considered high art, and they are still shown in museums throughout the world. Decorative painters use the same techniques and styles today to decorate furniture, walls, boxes, plates and such. The hallmark of decorative painting is a controlled style.

Because decorative painters usually start out by copying their paintings from patterns, they're sometimes derided for lack of originality and creativity. What goes unnoticed is the exceptionally high degree of skill practiced by master decorative painters, who often design their carefully crafted paintings. The skills of many decorative painters surpass those of realistic painters by a country mile.

Is decorative painting creative? Remember that anything you've never done before is creative for you. So if you feel more comfortable starting out with patterns, give it a try. The creativity comes in when you begin to deviate from the patterns, stylize your brushstrokes and design your own pieces.

Functional Art

Master Decorative Artist Louise Jackson creates her own beautiful designs and color schemes to paint functional objects such as these wood pieces, which were decorated with alkyd oils. She also creates original watercolor portraits and florals. Practicing both disciplines keeps her skills sharply honed.

☞ *Activity* ☜
Explore a Craft

What art or craft would you like to begin? Brainstorm as many as possible and list ther in your sketchbook-journal. Select one to investigate. List at least five steps you must tak to become competent in this craft. Check them off as you complete each one. Steps could b "find a class," "buy an instruction book," or "locate a source of supplies." Set up an area your home to play with materials and explore your new creative activity.

Here are some possibilities to explore:

Ceramics: porcelain, pottery

Collage, assemblage

Computer art, digital imaging

Decorative painting: on canvas, ceramic, glass, fabric, metal, paper, slate

Drawing: caricature, cartooning, charcoal, colored pencil, pastel, pen and ink, pencil

Fiber arts: batik, embroidery, knitting, needlepoint, quilting, rug-hooking, sewing, silk painting, tapestry, tie-dye, weaving

Jewelry: beadwork, construction, lapidary

Mosaic: ceramic, glass, pebbles

Painting: acrylic, casein, egg tempera, gouache, monotype, oil, pastel, watercolor

Paper arts: altered-books, artist's tradir cards, calligraphy, greeting cards, ma bling, origami, papermaking, rubber- stamping, scrapbooking, suminagash

Photography: film or digital, photo trans,

Printmaking: serigraphy, blockprinting, etching, engraving, lithography

Sculpture: bronze, clay, found materials, Sculpey, stone, wood

Stained glass

Woodcarving, woodworking

Paper Quilt (from Nature Series) · Shirley Eley Nachtrieb · Collage with leaves, stamping and handpainted papers · 10" x 8" (25cm x 20cm)

Fiber Arts

Many people think of fiber works, such as sewing, weaving, knitting, quilting and embroidery, as domestic products that have practical uses but no artistic value. Not so! There has been an explosion of artistic output in these and other fiber arts in recent years. The work keeps getting more and more amazing. Fiber pieces traditionally have been found in history museums as a reflection of different cultures, but they are swiftly making their way into fine-arts exhibits, and deservedly so.

QUILTING

My mother and my grandmother made many quilts together. I remember watching them sort colors for traditional patterns. Grandmother pieced the quilts by hand and Mother did the quilting, creating different stitchery patterns for each quilt. I treasure these quilts and regret only that my mother believed that she hadn't an ounce of talent or creativity. It would be fun to see what she might think of quilting now, as artistically creative as it is today.

Look through a quilting magazine or book at the library or bookstore and you will be amazed. New approaches to quilting involving fancy machine work, as well as hand sewing, are fabulous. The artistry in color schemes and quilting-fabric combinations is awesome. Painted quilts like Alan Kelchner's stunning piece on page 38 have launched a whole new means of expression for quilt artists. Quite a few men are wrapped up in quilting, so to speak, so don't think of this as an exclusively domestic-female art. Quilting creatively requires a good design and knowledge of color relationships.

WEAVING

Weaving, like other fiber arts, has a meditative quality to it. There is no way to rush when setting up the warp on a loom to create a blanket, wall hanging or garment. The rhythm of the shuttle moving back and forth is almost hypnotic. But before a weaver begins to weave, a lot of planning occurs. Weavers dye many fibers and diagram their designs to fit the warp. Weavers become skilled in applying the proper tension to the shuttle, so the edges of the piece will be even. And most weavers apply themselves with all the passion and creativity they can muster, just like painters do. Creative weavers incorporate found materials into their work and combine different textures of fibers. Knowledge of color theory is essential, since the warp and weft affect each other much like the colors in a painting.

Technicolor Quilt

Johnson doodles designs until she sees one she likes. Then she creates variations on the design and invents a dynamite color scheme for her quilted piece.

Lollipops #1 · Melody Johnson · Hand-dyed fabric, hand- and machine-quilting and fusing · 15" x 13" (38cm x 33cm)

A Collaborative Effort

What could be more creative than a quilt collaboration between adults and children? This delightful piece was crafted at The Day Academy daycare, each square made by a different age group and their teachers. Painting, sewing, lettering and gluing on fabric are all incorporated.

Tenth Anniversary Quilt · Designed by Jill Brown and Shayna Schroeder; decorated by students and teachers of The Day Academy · Fabric and mixed media · 42" x 42" (107cm x 107cm)

Paper artists also do weaving. Some collage artists and painters cut up paintings and weave them into new configurations of color and pattern. You might enjoy paper weaving, because it doesn't require a loom.

NEEDLE ARTS

The list of creative needle arts is lengthy, so I'll just mention three here: tapestry, hooking and sewing. Each of these arts has guilds and groups that specialize in specific techniques resulting in beautiful artwork. They all lend themselves well to creating images for wall hangings and interior accent pieces.

The skills of tapestry and needlepoint are similar, only tapestry uses finer canvas and smaller needles, allowing a greater degree of shading within images. It's said that legendary football player Rosie Greer did needlepoint—and no one laughed—so there's no reason why men can't do needle arts if they want to. Needle arts require color and design skills like any other art to make a beautiful, creative piece. Before I learned to paint, I sewed, embroidered, knitted, hooked and did needlepoint.

With three daughters to clothe during the Depression, my mother had to be creative with her sewing. We sketched out designs we had seen in stores (or on our friends) and Mother transformed inexpensive fabrics into designer outfits for us. We all wore "Martha Originals" to proms and fraternity dances and, eventually, the same wedding dress, designed and sewn by our mother.

Embellished Woven Collage

Goldman incorporates printed papers and mixed media in her woven collages. Once you have done your paper-weaving, embellish your piece with paint and found objects if you like.

Passages · Sandra Goldman · Mixed-media collage · 46" x 46" (117cm x 117cm)

☞ Activity ☜
Painted-Paper Weaving

Flow thinned watercolor or acrylic colors onto a twelve-inch (30cm) square sheet of wet 140-lb. (300gsm) watercolor paper, using rich, harmonious blends of color. Repeat on another twelve-inch (30cm) square sheet of paper, using the same colors, but allowing one color to dominate. Let both sheets dry flat.

Cut each into strips of uneven width. The edges of the strips may be straight or slightly curved. Keep the sheets separate from each other and in the same order in which you cut them. Lay one set of strips in the original order on a flat surface, such as a drawing board or Plexiglas sheet. The edges needn't be even. Tape the top edge with masking or drafting tape to hold this warp securely while weaving the remaining strips over and under alternating strips, just as you would weave fibers on a loom.

Mount the finished piece on mat board, painted illustration board or heavy watercolor paper. Invent your own variations of this activity, weaving yarn fibers or ribbon with the paper strips and creating vibrant color schemes.

◄ Woven Fabrics

Kathleen Zien's weavings—incorporating cotton, silk, chenille, metallic inlay, ribbon and sequins—are luscious. Her colors are spectacular and so are the textures she works throughout each piece. She usually weaves more than one piece on the same warp, yet they come out remarkably different. The woven fabrics become beautiful fringed jackets and stoles.

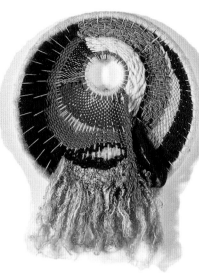

An Off-Loom Weaving

A teenager in art class wove this captivating off-loom piece. Christine did a beautiful job of selecting harmonious colors and interesting textures, not to mention the challenge of weaving in a circular format. The open spaces and asymmetrical balance of the piece show an intuitive sense of design.

Roots • Christine Dugan • Wool and cotton fibers on wood frame • 19" x 13" (48cm x 33cm) • Collection of Lawrence and Sylvia Dugan

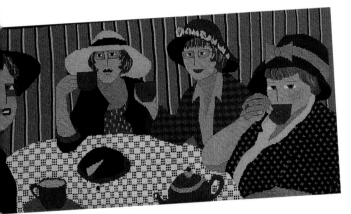

A Sisterly Tapestry

Betsy and her sisters enjoy their dates for high tea in New York City. She used her photograph of the four of them to design a delightful original tapestry, painting her picture with yarns.

Sisters • Betsy Snope • Tapestry: Cotton warp, wool and cotton weft • 17½" x 36½" (45cm x 93cm)

A One-of-a-Kind Rug

Todd Wimer designed this original piece from his mother's description of what she wanted to include in the image. She created a beautifully textured and patterned rug that deserves to be hung as art.

Clothesline Dining • Carolyn R. Wimer; designed by Todd Wimer • All wool fibers • 34" x 39" (86cm x 99cm)

☞ Activity ☜
Creative Quilting

❋ Modify a clever commercial quilt pattern to create a delightful piece of clothing. Adjust the layout of the squares or change their dimensions so you can lay a pattern on the quilted pieces. Cut and sew the garment, binding the edges with bias tape or lining with fabric.

❋ Exercise your creativity with old quilts that are worn around the edges. Cut them down to a smaller size and rebind or sew a jacket or vest using a simple commercial pattern, adding your own colorful trims around the edges.

A Quilted Creation

Instead of making the rectangular quilt shown in a commercial pattern, Ellen Kay shaped the patches so she could sew them into a clever, appliqued vest. The herringbone stitch around the patches is a nice design touch. (*Too Many Cats* design by Debora Konchinsky, Critter Pattern Works; used with permission)

Photography

Controversy has raged over the inclusion of photography in fine arts ever since the process became popular in the nineteenth century. Artists who painted from photos refused to recognize them as art, stating that the mechanical and chemical nature of the photographic processes relegated photography to the classification of craft.

Fortunately, today photography is widely accepted as art. Museum collections include the work of fine photographers, such as Edward Weston and Alfred Stieglitz. What are some of the creative aspects of photography and how can photography help you grow as a creative artist?

THE CREATIVE NATURE OF PHOTOGRAPHY

The finest equipment can't make a good picture by itself. Regardless of the mechanical nature of photographic equipment, a human being takes the picture. The photographer responds to a subject just as a painter does, composes the picture in the viewfinder or LCD and shoots the photo, taking advantage of the light to get the best exposure. In some ways photography is more difficult than painting. A painter is free to move elements around in a painting and create a new color scheme, but the photographer must accept what is given, positioning himself to gain a good viewpoint and waiting for the best light to appear. Photography helps you sharpen your creative awareness of the world around you. Take the time to learn to use it to advantage.

Learn to see with a camera. Sharpen your eye for composition by cropping with the viewfinder. Play with your camera to find a creative view of your world. Express your passion for

☞ *Activity* ☜
Experiment With Your Camera

Take an experimental photo field trip, deliberately distorting some of the pictures you shoot. Use your imagination to get photos that are a little different. For example:

* Tilt your camera at a 45-degree angle in any direction and shoot.

* Shoot a close-up—too close for the range of the camera—to get a deliberately out-of-focus view.

* Slowly move your camera sideways while shooting to create motion-blur.

* Stand next to a building or under a tree and shoot straight up.

* Stand in one place and turn in a circle. Stop and shoot several photos as you turn.

* Shoot a couple of pictures inside without a flash toward a window to capture rimlight or backlight.

* Use macro, wide-angle, telephoto or zoom lenses, if you have them, for special effects.

* Move in close to your subject for tight cropping.

Photographer as Designer

A good photographer is a designer who understands the elements and principles of design and uses skill and experience to bring them together to make an expressive picture. Becoming a better photographer will improve your sense of creative design. If you hesitate to invest in camera equipment, try shooting a few rolls of film with disposable cameras or use an inexpensive digital camera, taking care to frame your shots just as carefully as you would plan the composition of a painting. Have enlargements made of your best shots and study their good and bad points.

Get Close

Try to see subjects from different angles and in unexpected places. I took a series of photos in a fiber arts workplace. This photo of a piece of equipment works as a realistic image and an abstract design shape.

Canyon
Emergence #4 · Richard Newman ·
Digital photomontage · 12" x 16" (30cm x 41cm)

A Photo-Manipulation Master

Newman's photography and digital montages bring the photographic arts into the twenty-first century. He achieves his dazzling kaleidoscopic effects in Photoshop working from his own photos. Part of his success is beginning with the right kind of photo; not every picture will replicate patterns effectively. His canyon series photos are well suited to this digital technique.

Canyon of the Gods · Richard Newman · Digital photomontage ·
12" x 16" (30cm x 41cm)

the subject you photograph, or show your sense of humor.

THE DAWN OF THE DIGITAL DARKROOM

Photography has exploded with creativity since the advent of digital cameras and scanners and the computer manipulation of images. Techniques once used only by specialists in graphic design with expensive equipment are now accessible and affordable.

If you haven't tried digital photography and editing, don't wait a moment longer. A simple high-resolution digital camera with many features on it can be found for under $150, and many photo-editing programs are free. Prices for color printers have plummeted, as well. You may need more memory and a bigger hard drive on your computer to hold all your images. As with all art tools, buy the best you can afford.

You can be an excellent photographer without using a digital camera, but for a creative high, play around with editing your film or digital images on your computer. Software programs offer a multitude of options for creative imaging. There is a learning curve; however, it's worth it. If you're not into computers, you can shoot your images with a digital camera and take them to a mini-lab for processing.

FREEDOM FROM FILM

One of my favorite features on digital cameras is the LCD screen that allows you to replay your images and delete those you don't want. This feature eliminates the expense of printing poor images. Photography is far less intimidating when you don't have to pay for processing of bad shots. Just delete them and print the good ones on your home printer or take selected shots to a photo processor. Store your better images on your computer or on CDs and print them as needed.

Another nice feature is a macro setting that allows extreme close-ups of a subject. Viewing with an LCD screen, whether macro, wide-angle or telephoto view, makes it easier to compose a good picture than looking through a viewfinder. Most people have fun taking creative liberties with pocket-sized digital cameras, playing with them like toys—shooting over their heads, around corners and in tight places.

Creativity by Way of Computer

Here are some creative things to do with your digital photos, scanner, computer, software and printer:

❋ *Crop and enlarge your photos.*

❋ *Keep a file of photo resources for your paintings.*

❋ *Photograph and print your artwork.*

❋ *Create collages with photos or paintings.*

❋ *Lay out scrapbook pages on your computer monitor.*

❋ *Make digital photo transfers for quilts and collages.*

❋ *Make greeting cards, posters and signs.*

❋ *Create a black-and-white value study for a painting.*

❋ *Manipulate elements in a composition. Edit people or objects into or out of a picture, or move them around.*

❋ *Create painterly effects, unusual color schemes and light effects in your photos.*

❋ *Sharpen or blur elements in a picture.*

❋ *Distort elements for expressive effect.*

3 DRAWING: *Don't Leave Home Without It*

Urban Cow ·
Bill Bryant · Watercolor ·
17" x 22" (43cm x 56cm)

What vehicle is the most reliable means to carry you on your venture into creativity?

Drawing!

Drawing is the foundation of art and craft. This chapter is not just about how to draw, but how to enjoy the creative experience of drawing, so you'll draw more and build a stronger base for your art. With less emphasis on perfect results, drawing is more enjoyable. Drawing requires no exceptional ability—only normal vision and a degree of coordination. You instinctively know how to draw.

If you feel drawing isn't your strong suit, this chapter will help you gain confidence. If you already draw with assurance, you'll develop more individuality and creativity in your drawing.

As you draw, you gather information about what makes things work, how the pieces fit together. You gain insight into nature's laws: the way a stream creates its meandering path, how the wind twists trees, how a leaf mimics a tree. You find and record relationships. Drawing furnishes a subconscious warehouse of creative imagery. Your job is to fill the warehouse.

In a drawing you define something you can't describe in words. You reveal your visual experience in a unique way by your touch with tools and materials. You learn about yourself when you draw: the power of your motivation, concentration and endurance. You develop self-confidence.

> *"You are not copying nature, but responding to nature in full awareness, to the way nature expresses itself in that object."*
>
> *Frederick Franck,*
> **The Zen of Seeing/Drawing**

St. Paul de Vence · Kathleen M. Bertolone · Pastel, inks and charcoal pencil · 29" x 21" (74cm x 53cm)

Your Drawing Tool Kit

*I*n the simplest terms, drawing is making marks on a surface. Everyone has a unique touch with a tool: a different speed or pressure, a distinctive gesture or stroke. Creative drawing capitalizes on your unique way of making marks—your personal touch.

You make two marks when you draw: a dot and a line. What could be easier? There is no right way to make the marks. They may be sharp and decisive or soft and fuzzy, nervous and agitated, or placid and even-handed. Do whatever feels natural to you and you'll put your personal imprint indelibly in your drawing. Your drawing is always a reflection of yourself.

I'll bet there are a lot of art materials you haven't investigated. Now's the time. Explore anything that makes a mark and every surface that accepts a mark. Change materials frequently. Use different combinations of tools and surfaces. Play, play, *play!*

Consider the Source

Barrish makes his on-site sketches with a distinctive mark that is the result of the medium used and the artist's individual style. Consider the subject when deciding on an approach. Landscape permits a careful drawing, while a living animal is a moving target, best captured in a quick sketch.

Boothbay Harbor, Maine
• A. Joseph Barrish, S.M. •
Markers • 12" x 9" (30cm x 23cm)

felt pen

ballpoint pen

lip liner

eye shadow

wax crayon

food coloring

wood stain

🖝 *Activity* 🖝
Test Drawing Tools and Surfaces

Try these tools: pencils, graphite sticks, charcoal, markers, wax crayons, Conté crayons, watercolor crayons, colored pencils, watercolor pencils, pastels, oil pastels or ordinary chalk. Test a ballpoint pen, a steel nib pen, a sliver of bamboo or a stick dipped in ink, or a brush dipped in watercolor. Find ten more tools that make marks and experiment with them. Don't limit yourself to "art" materials; try using everyday items you find around the house.

Make marks on drawing paper, newspapers, bond paper, crumpled paper bags, freezer paper, wrapping tissue, paper towels, charcoal or pastel paper, rice paper, watercolor paper, corrugated cardboard, illustration board or pebble mat board. Draw on wet and dry paper. Find ten new surfaces to make marks on and try them.

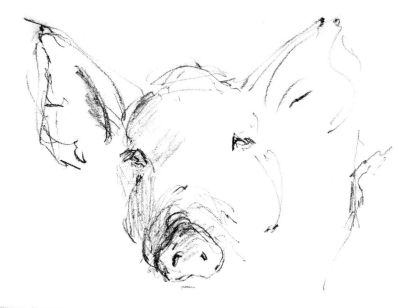

Capturing the Subject's Essence

Drawing animals from life requires a quick assessment of proportions, rapid recording of marks, and a suggestion of significant detail. Stolzenberger accomplishes all of this with an unlabored line that quickly suggests the personality of the animal.

Pig · Sharon Stolzenberger · Charcoal · 12" x 17½" (30cm x 44cm)

Developing Your Drawing Style

As you examine the marks you make, ask yourself which you like better: sensuous, flowing marks or spontaneous, rough marks? A free, gestural stroke or a tightly controlled mark? Delicate pencil marks or bold marker lines? Describe your marks in your sketchbook. They have a character of their own, determined by the tools you use and your manner of handling them. Your style develops as your preferences for certain tools and your unique way of working come to the surface.

☞ Activity ☜
Make a Variety of Marks

✳ *In your sketchbook-journal draw two or three six-inch (15cm) squares. Begin with a standard pencil and make dots, lines and areas in the squares. Vary the pressure on the pencil, turn it this way and that, move it across the paper at different speeds and jab it into the page. See how many different kinds of lines one implement will make. Close your eyes as you move the pencil over the paper. Sense the resistance of the surface. Try a smooth sheet of bond paper, then a textured sheet of charcoal or pastel paper. Try the same exercise with various tools. Switch to a ballpoint pen, a marker or a piece of colored chalk, and fill a square with marks. Compare these marks with your other marks.*

✳ *A broad drawing tool covers an area more quickly than an ordinary pencil. Experiment with different tools that make broader marks. Use the side of a stick of charcoal or graphite or a soft, broad carpenter's pencil. Softer pencils (2B-9B, for example) make darker marks than hard ones (2H-9H). Try these tools on textured papers, too.*

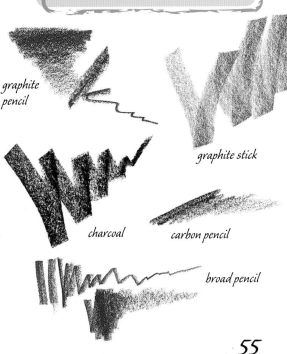

graphite pencil

graphite stick

charcoal

carbon pencil

broad pencil

The Many Marks Graphite Can Make

Start with a pencil, making different kinds of lines and textures.

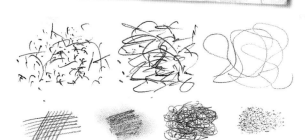

Recognizing Classic Lines

Random marks don't make a picture. Organize dots and lines to be most effective. Combine dots and lines according to basic patterns found in nature. Manmade and natural objects all have structural integrity and dynamic energy that strengthen and animate your artwork, making it more creative. Look for a pattern; then make marks that emphasize this underlying design.

SPOTTING PATTERNS OF LINE

In spite of the infinite variety surrounding us, design in nature is based upon just a few basic patterns. Look for these classic natural patterns in your subjects.

spiral

The *spiral* pattern appears in many seashells, vining plants, whirlpools and tornadoes. The spiral line coils around itself without reconnecting.

branching

Trees and leaves both have a *branching* pattern with lines radiating from a central trunk. The tributaries of a river and the human circulatory system are other examples.

radial

In a *radial* pattern, lines move outward from or inward to a center. Examine a spider web, a daisy or a starfish.

meandering

A *meandering* line twists and doubles back toward itself in a direction dictated by natural forces, as seen in the carving of a stream-bed by water. A curving road following the contours of hills and valleys is a similar line.

Manmade lines create patterns in brick or stone walls, fences and other constructions. The façade of a building has patterns in its windows and doors.

INTERPRETING LINE IN YOUR OWN WAY

There is no correct line in art. The patterns and lines of nature may be simplified, expanded or combined in any way that pleases you. Your representation of this may be bold and direct or delicate and sensitive. Do it your way.

☞ *Activity* ☜
Go Line-Spotting

Take your creativity kit on a field trip outdoors. Look for lines and patterns in nature and the manmade environment. Record them in your sketchbook-journal: the bark on a tree, the veins of a leaf, the whorls of a shell, the framework of a house under construction. Sketch the objects with a variety of tools to make a different expressive statement in each sketch. Draw close-ups to make the most of a found design.

From a Crack in the Road to a Painting on the Wall
You don't have to go far to find a plethora of patterns in nature and the manmade environment. Benedetti found the sensuous line in her painting in drizzled tar that repaired a crack in the road. How creative can you get!

Harmony in Spirit · Karen Becker Benedetti · Image transfer and fluid acrylics · 5" x 21" (13cm x 53cm)

Have fun discovering visual delights you never noticed before.

Drawing from nature sharpens your eye and your motor skills at the same time. It helps you understand nature's laws. Correct observation of nature carries over into greater accuracy in your realistic work, as well as awareness of abstract patterns that exist beneath the surface. While you're drawing, use different techniques and tools to depict what you see. Reveal your creative response to nature in the quality of your line and in your selection of which elements to include or leave out.

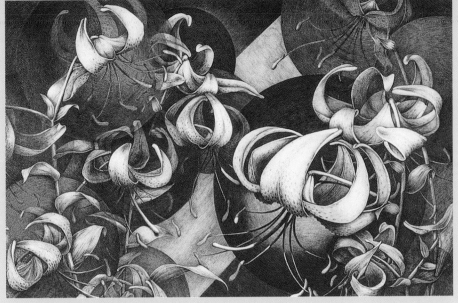

The Rhythm and Repetition in Flowers

Parry imparts life and energy to her nature subjects far above what is typically seen in pencil drawings. The rhythms and repetitions of shapes keep the viewer's eye on the move throughout the picture.

Tiger Lily #5 · Tomoko Parry · Graphite pencil · 14" x 21" (36cm x 53cm)

☞ Activity ☜
Doodle

Keep a pencil or pen and some scrap paper handy to draw when you're on the phone or watching TV. Doodle lines and shapes without making pictures. Begin anywhere on the page and draw a curved line. Make another curved line next to it, attaching the two lines at both ends. After you've made three or four such lines, make a new line that starts at some point in your drawing and proceeds in a different direction. Repeat the process, winding your way around the paper with curling lines, circles and spirals. Let your hand enjoy the sense of motion, rhythm and direction. Express the natural flow of lines without making a composition or image.

☞ Activity ☜
Mark Like the Masters and Others

Pick an Old Master drawing, a drawing from this book, an editorial cartoon or a magazine illustration. Make a viewfinder from a piece of heavy paper with a one-inch (3cm) square opening. Place it over a small area of the drawing. Copy the marks inside the viewfinder into a larger square in your sketchbook-journal. Notice the quality of line, estimate the pressure and speed of the mark, and emulate these in your drawing. Change tools and make another drawing of a different area. Observe how the lines made by each tool alter the character of the drawing. Control the expression in a drawing by using a variety of tools and adjusting your touch to them.

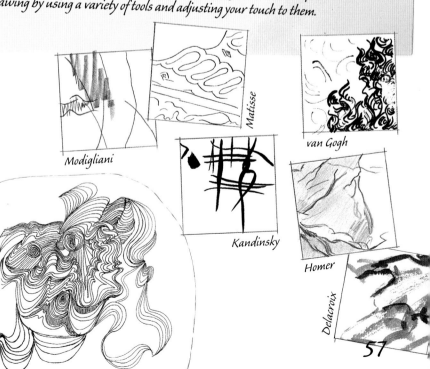

Modigliani

Matisse

van Gogh

Kandinsky

Homer

Delacroix

57

Routine Maintenance

You can draw, even if you think you can't. You can improve, even if you think you're hopeless. And you can benefit from drawing, even if you don't make realistic art. Drawing carries you to your artistic destination in nearly every art and craft. Establish and maintain a drawing habit.

Drawing is a mechanical skill that improves with practice. If you really want to draw well, you can do it—by *doing* it. Don't worry about who is watching or even whether the drawing will turn out. Your main concern should be simply to draw.

A working artist knows that drawing strengthens observation skills and manual dexterity. What some think is a talent for drawing is a skill that has been highly developed through exercise. Every drawing experience is an opportunity for you to improve this skill. Develop the conviction that you can draw, and you *can* do it. Then you don't have to prove or apologize for your drawing skill.

Confidence in your drawing skill enables you to be more daring in all your creative work.

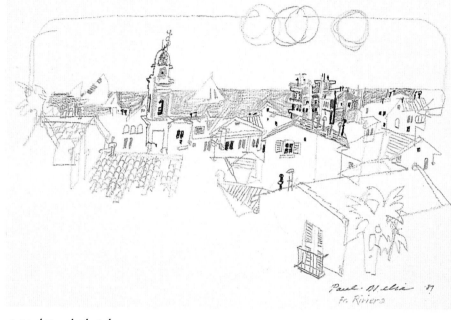

A Habitual Sketcher

Melia feels compelled to draw just about everything he sees, so he makes a telling statement every time he puts a drawing tool to paper. His files are packed with drawings of every imaginable subject.

French Riviera · Paul G. Melia · Colored pencil · 10" x 14" (25cm x 36cm)

☞ *Activity* ☜
Do a Drawing a Day

Reinforce your drawing habit. Draw something—anything—every day. Keep a pencil and paper in the family room, in the kitchen and in the car. Draw odds and ends: a phone, soda can, bone, pencil sharpener, teakettle or geranium plant. Draw from memory and imagination: an apple orchard, the neighbor's dog, a man-eating flower, a frog who is a prince, a Martian.

Draw with your right hand, then your left; with your eyes open or closed. Whenever you see a pencil, pick it up and draw. You learn to draw by drawing.

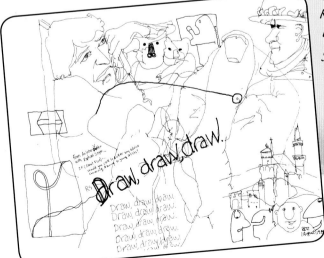

Draw Every Chance You Get

This sketch says it all. The way to become adept at drawing is to draw at every opportunity.

Draw, Draw, Draw · A. Brian Zampier, S.M. · Pen and ink · 9" x 12" (23cm x 30cm)

☞ *Activity* ☜
Sketch From TV

Turn on the TV and sketch a newsperson, an announcer or a weather forecaster—someone who doesn't move around a lot. Scribble lines for the head and shoulders and just a suggestion of features in a few seconds. Don't be concerned with a likeness (although it's nice if your sketch looks human!). Eventually you'll be able to capture a likeness in a few swift strokes. While you're at it, you can sketch others in the room who are watching television with you. They're less likely to move around as quickly as the TV personalities.

Switch to a sports event and scribble drawings to capture the action. Note that certain poses and movements are repeated frequently; for example, the setup of a football lineman or a tennis player's serve. Start your drawing; then wait until the same pose is taken to carry it further. When you sketch, don't be concerned about making a finished drawing. Draw for the fun of it. Draw often and your skills will rapidly improve.

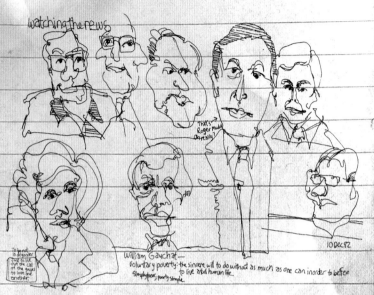

Talking Heads

Each quick portrait sketch has a personality.

Watching the News • A. Brian Zampier, S.M.
• Pen and ink • 7½" x 10½" (19cm x 27cm)

Watch Someone Watching

Zampier's busy pen notes the bored pose of someone watching TV, an ideal stationary model. Work back and forth between the TV picture and the still model.

Man Watching TV • A. Brian Zampier, S.M. • Pen and ink
• 13½" x 10½" (34cm x 27cm)

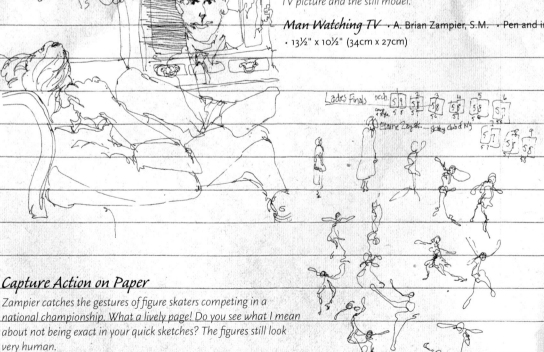

Capture Action on Paper

Zampier catches the gestures of figure skaters competing in a national championship. What a lively page! Do you see what I mean about not being exact in your quick sketches? The figures still look very human.

Figure Skating • A. Brian Zampier, S.M. • Pen and ink • 13½" x 10½" (34cm x 27cm)

Get Your Wheels Turning

Drawing helps you see and seeing helps you draw. You think that when your eyes are open you're seeing, but your brain deceives you, reporting stereotypes instead of the image your eyes actually see. Your logical brain gives you a quick-and-easy symbol—the tree looks like a lollipop, the eye looks like an almond—so it won't have to work so hard searching for individual differences. You must trick your brain to see what is really there.

TAKE TIME TO SEE

Studies in right-brain drawing by Dr. Betty Edwards suggest that most people see and draw more accurately when they shut down the time-oriented, verbal left side of the brain and allow the space-oriented, intuitive right side to function more freely at its own pace.

Do this by confusing the left brain. One way is to change the labels. Don't call what you're drawing by name. Think of it as a curved line about so long, or a space this high and that wide. Another way is to slow down your pace so the efficient brain gets frustrated and quits pressuring you.

Some use drawing as a mystical experience, entering into a silent, internal dialogue with an object, searching for its special qualities, seeing it as if nothing else exists at that moment.

Improve your ability to see by touching, smelling, tasting and

☞ *Activity* ☜
See It, Draw It

Place an object on a table: a shell, a leaf, a weed or flower, an acorn or a twig. What do you see? Is it worn or broken? Smooth or rough? What forces of nature have affected it? Does it have imperfections? How is it unique from others of its kind?

Slowly draw what you see, including all the imperfections, sensing the meaning and life history of what you're looking at. Make your dots and lines express the fragility or enduring quality of the object. Draw it as you see it!

Really Observe Your Subject

Use all your senses to discover the essence of every object you draw—especially objects you see every day, like a flower. Notice the lyrical curve of the petals and the intricate tracing of the veins in the leaves. Take your time and enjoy the full experience of drawing and the joy of really seeing a flower.

☞ *Activity* ☜
Shadow Drawing

Tape a piece of bond paper to a table in direct sunlight. Hold an object (a pair of scissors, a figurine, a monkey wrench or a garden implement, for example) over the paper, rotating it until you see an interesting shadow shape. Trace the outlines of the shadow. You can fill in some of the shapes with black marker to make an abstract pattern. Work on larger papers, too, using bigger objects with interesting projections and shapes: a lawn chair, a wagon wheel or a garden cart.

Draw the Shadows of a Shape

Change shapes in a shadow drawing by turning the object slightly. Make several drawings of the object on the same sheet of paper, creating abstract shapes that don't show clearly what the object is. See if your friends and family can guess what you drew. I drew an antelope figurine three times. Turn it sideways and you can see a landscape.

listening as well as looking. Use all of your senses to experience the object in different ways. Your perception is sharper with unfamiliar objects or things that have changed in some way that attracts your attention. Frederick Franck, artist and philosopher, wrote in *The Zen of Seeing/Drawing*: "I have learned that what I have not drawn I have never really seen, and that when I start drawing an ordinary thing I realize how extraordinary it is, sheer miracle…."

🖝 Activity 🖝
Draw on the Flip Side

In class, Suzy was ready to give up on her drawing of a swan floating on a quiet pond. She had the reflection just right, but couldn't get the swan. So she flipped her reference photo and her picture and drew a perfect swan upside down.

Try this activity for yourself, using the drawing shown here, a cartoon or a line drawing from an art book. Place the drawing upside down beside your drawing paper. Outline a frame on your paper. Starting at the top of your page, draw each line, moving slowly from one line or shape to the next. Work slowly, connecting shapes as you would attach pieces to a jigsaw puzzle. Frequently check the size of the spaces between lines, the angles and directions of each line, and their distance from the edges of the paper. Frustrate your efficient left brain by concentrating and working deliberately and intently.

See Your Subject Differently
Drawing upside down turns off the logical, analytical part of your brain, allowing the spatially oriented side to take over.

Bill · Chisel marker · 11" x 8½" (28xcm x 22cm)

🖝 Activity 🖝
Feel It, Draw It

Challenge your senses with a group of creative friends. Mark numbers on several small paper lunch bags. Place a single object in each bag without showing it to anyone. Give each person a bag, a sheet of paper and a pencil.

Mark the paper with the number of the bag. Ask participants to reach into their bags without looking, feel the object and then draw it without looking at it. Switch bags and make another drawing on a new sheet of paper. Finally, lay the objects on top of the bags and compare your drawings.

🖝 Activity 🖝
Differentiate Shapes From Decoration

Find an object around your house, office or garage: a power drill, an ice skate, a leaf blower or a pencil sharpener, for instance. Place it on a table and study it. Does it have a cord or a handle? How many eyelets are there for the laces? What kind of blade does it have? Is it sharp? Heavy? Pick the object up and examine it. Feel it, smell it, shake it. Does it rattle? Ask yourself: How is it constructed? How do the pieces fit together? What makes it work? Look for basic shapes and notice how they are connected. Details are simply decoration on the surface of these major shapes: circles, triangles and rectangles. Start with an analysis of the simple shapes. Find the larger shapes first, then fit the smaller shapes into them.

Tackle a Complex Subject One Section at a Time
Concentrate on one section of a complicated object rather than the entire thing, and you'll find interesting compositions like this one. Work out the relationships of parts before you tackle the whole.

My Bike · A. Brian Zampier, S.M. · Pen and ink · 9" x 12" (23cm x 30cm)

A Guided Tour of Drawing Methods

A drawing method is just a way of making marks. Artists use controlled lines, free lines or a combination of both in many different applications. Sketching is a quick notation technique used by artists to record ideas on the fly and to practice drawing skills. Contour, gesture and tonal drawing are the essential skills targeted to teach observation and drawing. Let's explore various ways to spark your creativity through drawing.

SKETCHING

Sketching is the note-taking of drawing. You don't need details, just a reminder. Mistakes don't count. Study your subject carefully first; feel its presence. Then, with a few quick strokes, note the essential information from your observation, a partial statement. Use the power of suggestion and a minimum of lines. Be selective. Simplify. Put in the big things first and add only the most important details. Let your memory finish the picture when you look at it.

Sketching allows you to explore and enjoy the things that interest and amuse you. The word "sketch" implies something quickly done, but sketch at your own pace, quickly or slowly.

"The sketch hunter moves through life as he finds it, not passing negligently the things he loves, but stopping to know them, and to note them down in the shorthand of his sketchbook...."

Robert Henri,
The Art Spirit

Have fun with it. Keep a sketchbook in the car; take it to the beach. I prefer a small spiral-bound sketchbook and a mechanical pencil or fine-line Pigma pen. Sketch a little every day, and in no time you'll notice substantial improvement in your skills and greater confidence in your drawing.

Hurried Lines Still Communicate
I had to sketch the woman's gesture quickly with the broad side of my pencil. Quick! She's about to leave!

Try Big, Bold Strokes
Sketching with a brush and watercolor or ink forces you to make a few bold strokes to record shapes without noodling unnecessary detail. Use a big round brush to suggest form. Don't worry about distortion—describe the gesture.

Time for the Details
Melia records gesture, pattern and volume. His rendition imparts personality to his subject with just a few swift lines.

Woman in a Chair · Paul G. Melia · Pen and ink · 11" x 8½" (28cm x 22cm)

BIG PINE KEY 3/13

If you only have time for a quick, on-the-spot notation, get it down and check the perspective later. To record a detail for future reference, make a more careful drawing of the specific area. Don't get hung up on making an entire picture when you sketch.

Although pen and pencil are the easiest and most portable tools to work with, use anything that suits you. Watercolor pencils or crayons are popular with sketchers, who make their drawings on location in color, later wetting areas on the page to blend the colors. Colored markers are also fun, making bold marks in an exciting range of vivid colors.

Capturing Just Enough Information On Location

A few pencil lines to describe the pelicans and transparent watercolor notes on location give the artist enough information to develop a sketch into a larger painting in the studio.

Pine Island Key · Sharon Stolzenberger · Watercolor · 12" x 18" (30cm x 46cm)

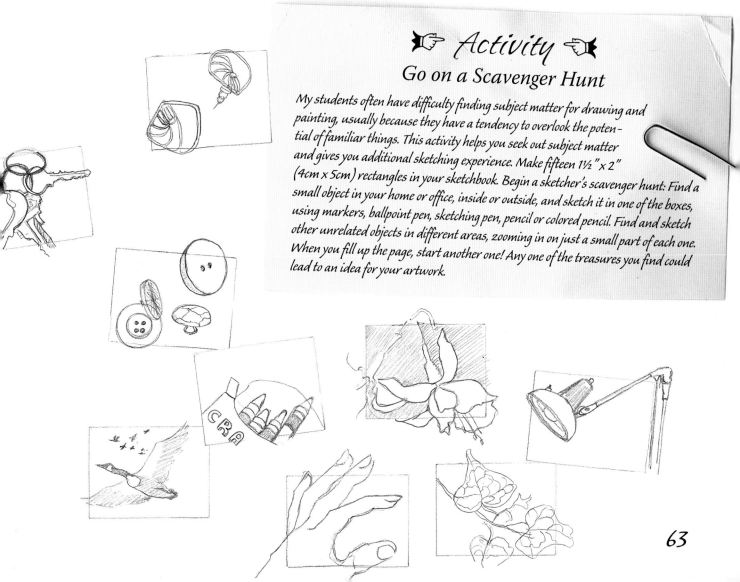

☞ Activity ☜
Go on a Scavenger Hunt

My students often have difficulty finding subject matter for drawing and painting, usually because they have a tendency to overlook the potential of familiar things. This activity helps you seek out subject matter and gives you additional sketching experience. Make fifteen 1½" x 2" (4cm x 5cm) rectangles in your sketchbook. Begin a sketcher's scavenger hunt: Find a small object in your home or office, inside or outside, and sketch it in one of the boxes, using markers, ballpoint pen, sketching pen, pencil or colored pencil. Find and sketch other unrelated objects in different areas, zooming in on just a small part of each one. When you fill up the page, start another one! Any one of the treasures you find could lead to an idea for your artwork.

63

CONTOUR DRAWING

A contour drawing differs from an outline. A contour line describes three-dimensional form, moving into and across an object to indicate volume. An outline follows only the outer boundaries. Use contour lines in your sketches and drawings to record important shapes and forms accurately. Concentration, careful observation and slow, coordinated movement of your eye and hand are essential to contour drawing. Your right brain enjoys this slow tempo, noting all the ins and outs of the line as you draw; your left brain gives up and lets you play.

When you make a *pure contour drawing*, you look only at the object and not your paper while you're drawing. The drawing is usually skewed and somewhat awkward-looking, but it is still more vital and true-to-life than those in which you work for total control over your lines.

With *controlled contour drawing* you may look at the paper occasionally to check on the location or direction of your pencil. Continue to work slowly with most of your focus on the object you're drawing and not on the paper. When you do look at the paper, check for space relationships and measurements of parts to the whole.

Quick contour drawing comprises a rapid line that captures only the essential contour lines. Take a hard look at the object, then look at your paper and draw quickly.

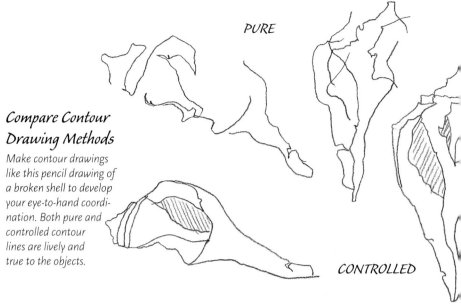

PURE

CONTROLLED

Compare Contour Drawing Methods

Make contour drawings like this pencil drawing of a broken shell to develop your eye-to-hand coordination. Both pure and controlled contour lines are lively and true to the objects.

☞ Activity ☜
Try Your Hand at Drawing Contours

Practice contour drawing your hand in your sketchbook or on drawing paper taped to a tabletop. To make a pure contour drawing, follow the subject's contours with your pencil without looking at the paper. Begin anywhere, moving your pencil as though it is attached to your eye as it moves slowly around your hand. Concentrate. Distortion in contour drawings is caused by moving your eye and hand at different rates of speed or by losing your concentration. Imagine that your pencil is following an ant as it creeps along the contour. If you go too fast, you'll crush the ant.

Now make a quick contour drawing of your hand with felt-tip pen on absorbent paper, such as rice or mulberry. Keep your pen in contact with the paper at all times. Your pen will track the starts and stops in your line as you pause to look and then continue drawing. The character of the line looks very different from a pencil line.

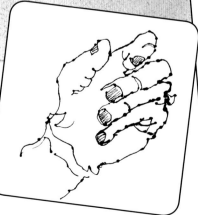

Quick Contour Drawing ·
Nita Leland · Felt-tip pen on rice paper · 8" x 7" (20cm x 18cm)

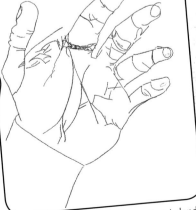

Pure Contour Drawing · Kurt Leland
Graphite pencil · 11" x 8½" (28cm x 22cm)

64

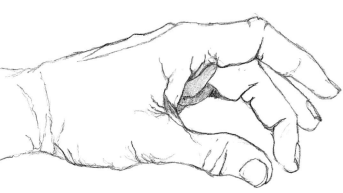

Same Exercise, Two Styles

Every artist makes distinctive contour lines. Kurt's controlled contour drawing has a strong, uncomplicated line. My controlled contour drawing reveals a different style, even though the process used was the same.

Nita Leland · Graphite pencil · 6" x 8" (15cm x 20cm)

Kurt Leland · Graphite pencil · 11" x 8½" (28cm x 22cm)

 Activity ☞

Make a Controlled Contour Drawing

Tape your paper to a tabletop and lay the leaf next to the paper. Allow your eye to move back and forth between the leaf and the paper, but move both your eye and your pencil slowly and carefully along the contour and around the veins and imperfections on the leaf. Drawing this way is like a calming meditation on the wonders of nature.

Work Slowly and Deliberately

Controlled contour drawing requires patience and concentration. Work slowly and your leaf drawing will be more accurate.

> "It is my firm belief that contour, gesture, and modeled drawing are absolutely fundamental modes of working for all artists.... No artist that I know ever stops using these modes of drawing."
>
> Robert Kaupelis,
> **Experimental Drawing**

GESTURE DRAWING

Gesture drawing captures the action of your subject: not what it looks like, but what it's doing. Brian Zampier's figure skaters on page 59 are perfect examples of gesture drawing. Capture the action by feeling the pose, letting it flow outward through your pencil onto the paper. A gesture drawing may not be a finished drawing. Catch a gesture quickly, doing many sketches from quick poses. Change your position often for different views of the pose.

Gesture lines lend energy to your drawing—the fluid grace of a ballerina or the frantic pedaling of a bicycle racer. Everything has gesture: a cowboy boot, an alley cat, a Volkswagen, a tulip and a Shaker chair. Look for the gesture before you begin to draw.

Gesture drawing isn't just about the gesture of an object. You project your impression or feelings about the object through your own movement as you manipulate your drawing tools. The subject may be inert, but you bring it to life with your physical movements as you cause your pencil or pen to dance or crawl across the paper. Position your subjects in a variety of ways and draw their gestures or use a live model to capture gestures in different poses.

Minimize detail in gesture drawing. Reveal the life force beneath the surface of the object. Interpret your subject's gesture through your own gestures, making firm, hard strokes or using light, delicate marks, whichever are appropriate. Make your drawing more expressive by exaggerating or distorting the gesture.

Body Language Speaks Volumes

In a series of several drawings, Marcus noted her daughter's changing gestures as she sat immersed in the book she was reading. Each drawing immediately communicates to the viewer something about the girl's attitude at that moment. In the first, she is in a state of relaxed concentration. In the second, her body language is more attentive.

Girl Reading (two drawings) · Joan Marcus · Pencil · 14" x 11" (36cm x 28cm)

☞ *Activity* ☜
Gesture Drawing

Take your sketchbook and pencil or markers to the shopping mall. Sit on a bench and draw the gestures of passers-by. Draw children on a playground. Draw the people on your TV screen. Draw a plate of spaghetti or a shell. Everything has a gesture. Make some gesture drawings with your eyes closed. Study an object for two or three minutes, then close your eyes and draw its gesture. Feel the dynamic presence of your subject and let it flow to the paper.

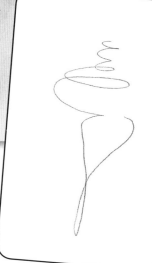

A Seashell

This gesture drawing expresses more than just its shape: The whorls of its growth pattern are also evident, revealed by a single quick gesture with a pencil.

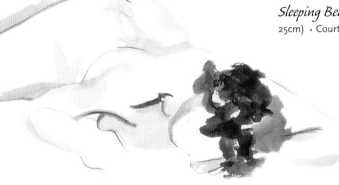

A Gesture Painting

Grace records the relaxed gesture of a model with a brush line. The fluid line is well suited to the curved gesture of the nude.

Sleeping Beauty · Donna M. Grace · Watercolor · 10" x 10" (25cm x 25cm) · Courtesy of Watermark Gallery

☞ *Activity* ☜
Loosen Up With Oversized Drawings

Using a large pad of newsprint paper and a crayon or marker, swing your arm from your shoulder in several wide arcs over the paper. After a few trial sweeps, use this free-swinging gesture to draw a flower, teacup or shell on the large paper. Make many oversized drawings of small objects this way to overcome tendencies to tighten up in your drawings. Begin your painting or craft sessions with gestural warm-ups like these and your work will have a more spontaneous feeling to it.

Big Lines for a Little Teapot

This gesture drawing is three times larger than the original subject, which is less than four inches (10cm) in diameter. I used a graphite stick for a broader line, kneeling on the floor over a pad of 18" x 24" (46cm x 61cm) drawing paper. Swinging my arm, I moved the stick back and forth across the paper, drawing and restating the curves and ovals. I wasn't trying to make a drawing. My objective was to get acquainted with the teapot and feel its gesture as I put down the lines.

TONAL DRAWING

Tonal drawing suggests weight and mass. Accomplish modeling of form with light and dark values ranging from white through midtones to black. Differences in values and gradation help to suggest space. Lighter values fade into the distance, while darker values move forward. Value contrast and gradation create an illusion of three-dimensional form. Shadows lie upon the contours of objects and surfaces, revealing the shapes of the underlying masses. Highlights and shadows indicate the direction of light.

To make a convincing drawing, the light source should be consistent, unless ambiguity is your creative purpose. Light, shade and shadow are fairly easy to represent on flat planes with corners and sharp edges. On curved objects, the lightest light is the *highlight*. This area will be brightest on highly reflective surfaces. The surface facing the source

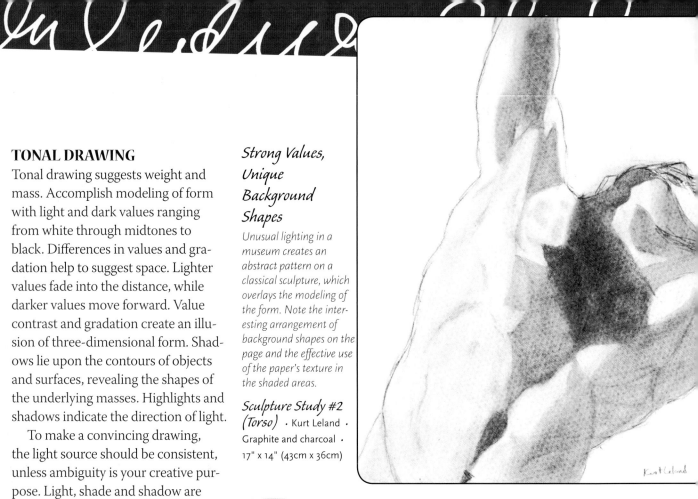

Strong Values, Unique Background Shapes

Unusual lighting in a museum creates an abstract pattern on a classical sculpture, which overlays the modeling of the form. Note the interesting arrangement of background shapes on the page and the effective use of the paper's texture in the shaded areas.

Sculpture Study #2 (Torso) · Kurt Leland · Graphite and charcoal · 17" x 14" (43cm x 36cm)

☞ Activity ☜
Make a Tonal Drawing

Use the broad side of a piece of graphite, charcoal or pastel to create a tonal drawing of a crumpled paper bag, a dented soda can, a piece of driftwood or a wrinkled shirt. Press lightly to represent light areas and heavily to represent shadows. Leave the paper white or use white chalk to suggest highlights. Blend areas of different tones to represent form. Tonal drawing gives a strong illusion of reality.

Make another tonal drawing of a tree, an overstuffed chair or your raincoat. Accent the drawing with contour lines or textures. Add a decorative, fanciful pattern if you feel like it. Or draw something whimsical for a change. As you learn to draw, don't forget to have fun and play with new ideas.

Graphite Pencil
A tonal drawing of driftwood gives a sense of its form and texture.

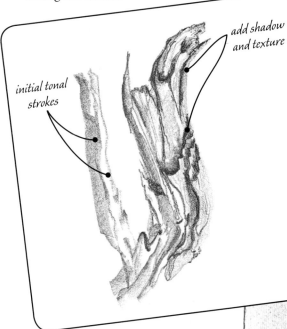

add shadow and texture

initial tonal strokes

of illumination is the *light plane*. The *half light*, or *halftone*, is just at the curve of a surface, but not in shadow. The area turned away from the light is called *shade*. *Shadow* is the dark area created on a surface by a form blocking the light. Areas where light bounces from one surface to another are called *reflected light*. Abstract patterns of light and dark with no apparent source, called *ambiguous light*, are sometimes used to create surface energy in non-objective paintings.

Add lines selectively to a tonal drawing to describe contour, detail and texture. Use such surface enhancement with tonal drawing to strengthen a realistic interpretation of a subject or to suggest a fantastic, surrealistic world. Drawing doesn't always have to be realistic—use your imagination.

Like black-and-white photography, tonal drawing has an austere, elegant appearance unlike color work. Color provides an immediate emotional impact. The content of a tonal drawing is subtler, but equally moving.

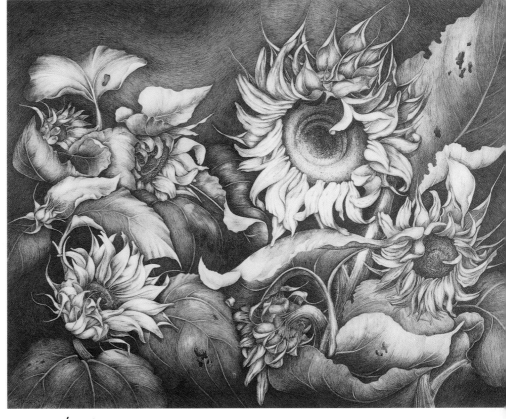

Tones and Texture

Parry's mastery of tonal drawing is impressive. Light and dark values move the viewer's eye around the surface to enjoy detail and texture throughout the picture.

Sundance #3 · Tomoko Parry · Graphite pencil · 20" x 26" (51cm x 66cm)

highlight

light

half light (or halftone)

Consider the Source

Be aware of your light source and light your subject consistently from that direction. It's difficult to represent form properly with more than one source of light. Look for the different qualities of light on an object so you can better describe its form in light and shadow.

reflected light

shade

shadow

AUTOMATIC DRAWING

Making random marks without the intent to draw an image is called automatic drawing. Automatic drawing is said to bring unconscious ideas and symbols to visible form. This intuitive approach to drawing may put you in a creative mode or help to break through creative blocks. Use automatic drawing as a warm-up before a painting or drawing session, or as a way of keeping in touch with your art when you don't have the time or energy to concentrate on a finished piece of work. Let your inner artist play with lines and colors free from the restraints of picture-making.

MANDALAS

A mandala is an art form based upon the idea of automatic drawing. *Mandala* is a Sanskrit word referring to any representation of the cosmos in relation to man. Ancient cultures used mandalas as focus points for their meditations. Drawing a mandala is an act of meditation that brings unconscious thought into being on the paper. The mandala appears in the art of many cultures, quite often as a balanced pattern of symbolic forms.

A circular mandala appeals to artists because they can rotate the drawing in any direction to discover an interesting composition. Complex networks of intersecting, calligraphic lines and shapes form a design that pulsates with spiritual energy. Beginning with Carl Jung, psychologists have interpreted symbols drawn within the mandala circle as revelations of the personality.

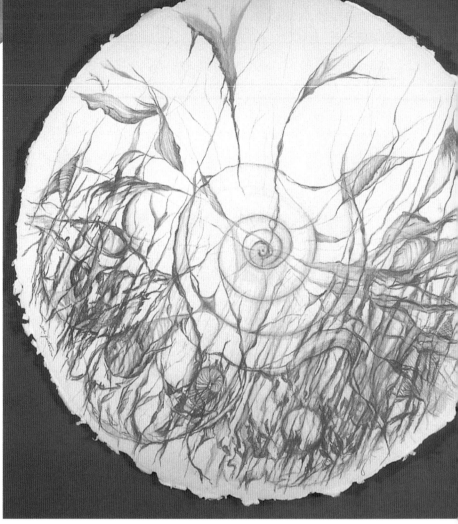

A Doodle With a Destination

When we make drawings with our eyes closed or doodle absentmindedly, natural patterns, such as the spiral found in this piece, sometimes appear spontaneously. Brezine has developed symbols into a mandala that is deeply meaningful to her and visually pleasing to the viewer.

Deep Down Things · Sue Brezine · Colored pencil on handmade paper · 30" (76cm) diameter

My Result

When we try too hard to think about what we're drawing, we tend to tighten up. Automatic drawing helps break creative blocks by freeing you to make more expressive lines.

☞ *Activity* ☜
Don't Think, Just Draw

I like to use plate-finish Bristol board for this; the example shown is 11" x 15" (28cm x 38cm). Work with your eyes closed, then open; standing, then sitting; facing the paper, then at an angle to it. Turn the paper upside down, then rotate it ninety degrees. Start with pencil, charcoal, pastel or colored pencil. Don't think about what the drawing is or what it means. As the drawing progresses, begin to intercept random thoughts about making a change here or there. Go with your impulses. Lift out lights with your eraser. Soften hard edges and adjust values. Scribble, draw, texturize and smudge. Work quickly and don't give your brain a chance to engage. Don't think about drawing; just draw.

Making a Mandala

Artist Ardis Macaulay shows us several stages of the process of mandala drawing. Surrealists, such as Joan Miró, Jean Arp and Salvador Dali, used this technique and transformed their automatic drawings into paintings.

Random Marks

Macaulay establishes a circular format and quickly scribbles random lines into it with graphite pencil. She includes rubbings, templates, patterns and erasures, all rapidly set down without a thought to organization. Later she will employ her artistic skills to complete this mandala.

Developing a Mandala #1
· Ardis Macaulay · Graphite ·
12" (30cm) diameter

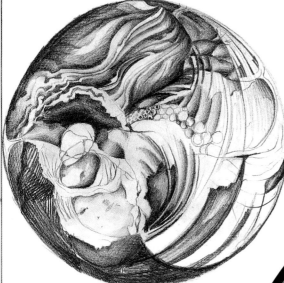

Tonal Development

In a second mandala Macaulay carries the drawing further, thinking consciously about using tones and highlights to unify the design. She still allows some automatic drawing to occur at this stage.

Developing a Mandala #2 · Ardis Macaulay ·
Graphite · 12" (30cm) diameter

Full Realization

Macaulay used colored pencil to complete this mandala after the automatic drawing stage in graphite. A finished mandala is a highly complex example of lines and tonal drawing combining unconscious automatic drawing with conscious artistic choices in the final stages. Its meaning may be apparent only to the artist, but viewers are moved by its mysterious intensity.

Eye Come from the Sea · Ardis
Macaulay · Graphite and colored pencil ·
32" (81cm) diameter

Drawing People

You can draw people. If you can draw an egg, you can draw a leg. It's all the same task. Like all drawing, recording a likeness requires careful observation of contour, gesture and tone—and a lot of practice. Don't be afraid to try. You'll improve every single time you draw. Do the exercises and study the gallery of portraits and figures on the following pages to see how other artists approach these subjects.

FACING UP TO FACES

As a kid I learned to draw faces from Andrew Loomis's book *Fun With a Pencil*, a volume of cartoon characters that showed the structure of the head, features and figures in perspective. The emphasis was on fun, but the basics were there.

Good drawing books teach fundamentals and help you practice drawing people, but there is no substitute for drawing from life. Have a good time while you gain experience. Gather four to six friends and take turns drawing each other's portraits. Bring interesting accessories—floppy brim hats, baseball caps, scarves, clunky jewelry, pipes, neckties and eyeglasses—to make it more interesting.

Make creative portraits by design. Placement and pose of your model, imaginative costuming, and manipulation of the background create a more interesting portrait.

Include caricatures in your studies. Exaggerate features and proportions to create a lofty expression; make the eyebrows arch higher or the innocent eyes wider. Use a grid, as shown on the next page, to distort the portrait. Be a good sport about caricatures. As legendary actress Ethel Barrymore said, "You grow up the day you have your first real laugh at yourself."

Ouch!
Practice capturing outrageous expressions with a quick gesture technique.

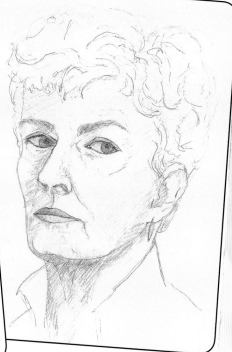

Self-Portrait • Nita Leland • Graphite pencil • 18" x 14" (46cm x 36cm)

☞ *Activity* ☜
Be Your Own Model

The lack of a model shouldn't prevent you from drawing faces. You always have one model handy—yourself. If you've never done a self-portrait, now's the time to do it. Arrange for some uninterrupted time. Work in an area with as little distraction as possible. Set up a medium-sized cosmetic mirror near your eye level. Make a line or tonal drawing of your reflection. Place the mirror higher or lower for a distorted angle.

First, make faces at yourself in the mirror and do a few gesture drawings of your facial expressions in pencil or marker.

A Fitting Portrait

Walton was otherwise occupied when her five-year-old son embellished her finished portrait of him, printing his name both backwards and forwards in the background. Some artists might have erased the graffiti from their artwork, but Walton made a creative choice to include his marks as part of the art. What a wonderful collaboration!

Zachary • Lesley Walton • Graphite on Clayboard • 12" x 16" (30cm x 41cm)

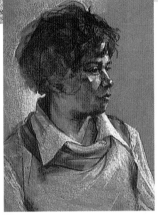

Setting the Tone With Your Paper

Szelestey uses the tone of the paper along with color and value changes to describe the model's facial features and clothing, bringing out highlights with white. Notice the gestural strokes in the hair. Most portrait drawings are a combination of contour, gesture and tone.

Pastel Portrait • Elaine Szelestey • Pastel and charcoal • 25" x 19½" (64cm x 50cm)

☞ Activity ☜
Use a Grid to Distort

Once you understand the structure of the face and features, play with distortion for expression when an exact likeness isn't a priority. Using a grid keeps the features in proper relationships, while exaggerating facial expression and contours.

Use a grid to stretch, compress or distort a face. First draw a marker grid of squares or rectangles on prepared acetate film and tape it on top of a photo or drawing. On a sheet of paper draw a corresponding grid with the same number of lines, skewing the lines to alter the sizes and shapes of the grid sections. Distort the entire grid or parts of it. Transfer your picture to the distorted grid, copying the marks in one section of the original grid into the corresponding section of the distorted grid. The face becomes transformed by the distorted grid.

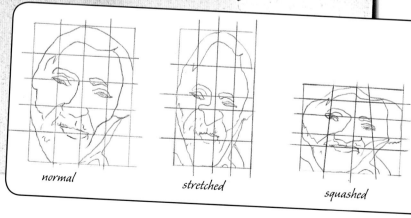

normal stretched squashed

Distort Images for Different Statements

Two of these three grids distort the subject. Distortion makes an expressive statement about the person you're drawing. Use grids with any subject matter, not just portraits.

73

FIGURING OUT FIGURES

Practice making your drawings of people convincing and expressive. Your drawing may be a quick gestural sketch or a finely crafted rendering in any medium. Study books on figure drawing to learn about the proportions and anatomy of the figure.

Don't be embarrassed to draw from live models, whether they are nude or clothed. Draw from life at every opportunity. Join a life-drawing group or form your own group. Set a time limit for each model, no more than thirty minutes. Begin with five minutes of contour drawing of any part of the face or figure. Finish with fifteen minutes of tonal drawing.

Be aware of the relationships between parts of the body when drawing figures. The midpoint of a standing figure is usually at the crotch. To keep a figure in any other position in proportion, estimate the midpoint of the figure and relate elements above and below to that point. Compare directions of lines and relative sizes of parts to each other. Where are the elbows relative to the waist? What's the angle of the tilted head?

☞ *Activity* ☜
Study Proportions

Study the proportions of the body. Trace the left side of the figure diagram on a sheet of tracing paper. Complete the drawing freehand, then repeat with the right side. Enlarge these drawings and use them as references to help you become more comfortable with figure drawing.

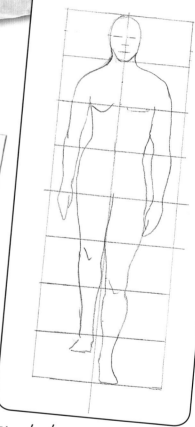

Standard Adult Proportions

Individuals differ greatly, but this is a good starting point.

☞ *Activity* ☜
Draw From an Artist's Mannequin

One helpful tool for learning to draw figures is a wooden mannequin with articulated joints. Most arts and crafts stores have them in different sizes. Arrange the figure in action poses and draw as accurately as you can. Study the proportions and note relationships of parts of the body to each other. Drape your mannequin in a scarf or handkerchief to practice representing folds and drapery on the figure.

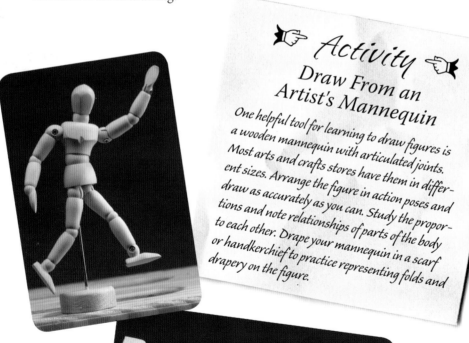

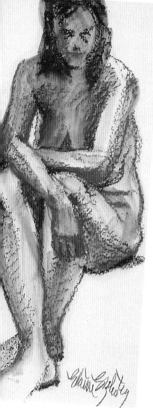

Turn the Tables

When you're working with a group, it's fun to turn about and draw or paint one of the artists at work. It's a little harder than working with a posed model, but you can use the techniques you learned in contour and gesture drawing to capture the subject. Watercolor is a good medium for live figure painting. Gesture and form are quickly noted with brush lines and washes.

Theresa Painting • Arne Westerman •
Watercolor • 21" x 14" (53cm x 36cm)

Practice Makes Perfect

Elaine Szelestey attended life-drawing groups for many years, drawing gestures and contours of figures, as well as portraits, in every conceivable medium. Her dedication paid off in her ability to make an expressive drawing of the most ordinary pose.

Seated Figure • Elaine
Szelestey • Oil pastel • 22½" x 15"
(57cm x 38cm)

Capture Attitude

O'Connor isn't intimidated by a difficult pose. She uses it to express a bit of attitude from the model.

Begin Again • Carla O'Connor •
Watercolor gouache • 30" x 22"
(76cm x 56cm)

Activity
Quick Draw

Practice quick-draw techniques on people everywhere. Use your sketchbook and a pencil or pen. Make the drawing quickly and don't erase anything. Work with contour and gesture lines, observing carefully to capture the action of the figure. Draw the kids as they watch TV, shoppers at the mall, your neighbor working in the yard. You'll become accustomed to drawing in public and drawing real people—if you do it often.

A Decisive Moment

I quick-sketched two of my artist friends as they considered where to set up painting outdoors. This only took a moment, afforded me a little more sketching practice and gave them a laugh when I showed the sketch to them.

Getting a Handle on Perspective

Don't be intimidated by perspective. Your drawing doesn't have to be exact, it just has to look convincing. It's easy if you understand the different types of perspective and follow a few general pointers for creating the illusion of distance from viewer to subject.

AERIAL AND LINEAR PERSPECTIVE

Aerial perspective, sometimes called *atmospheric* perspective, creates an illusion of depth with soft edges, light values and cool color. Nearer objects usually have darker values, warmer color, more texture and crisp edges, with the greatest detail in the foreground. Other means of suggesting distance involve overlapping objects, diminishing size in the distance and gradually reducing values and colors to indicate recession into space.

The most challenging type of perspective is *mechanical* or *linear* perspective. See the diagram on this page for some basics. For more in-depth study (which I recommend, particularly if you draw landscapes or architecture), search "artist's perspective" in the library or online.

PERSPECTIVE TERMS TO KNOW

The most important reference point in a perspective drawing is the artist's *eye level*, which is also called the *horizon line*. This line moves up or down as the artist stands, sits or lies down. A *vanishing point* is the point at which parallel lines appear to converge. From an artist's point of view, all vanishing points must be on the same horizon line.

In *single-point* perspective, there is one vanishing point. *Two-point* perspective has vanishing points on each side of the vertical line closest to the viewer. All parallel horizontal lines converge at these two vanishing points. Above the horizon line, these lines go down to the vanishing point. Below the line, they go up.

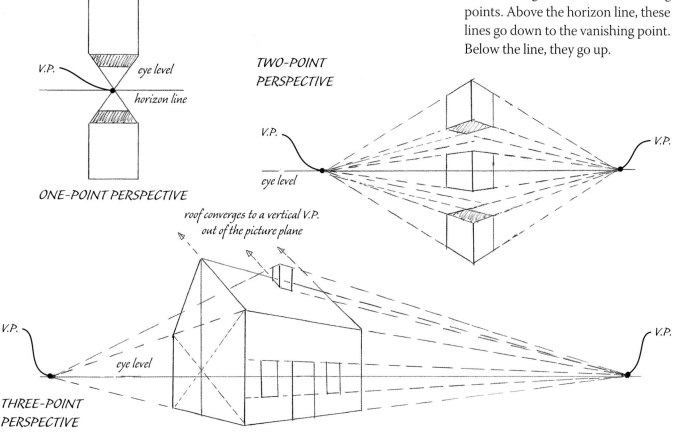

Perspective Basics

These three diagrams show the key elements of one-, two- and three-point perspective. Note that there is a three-point perspective vanishing point (not shown, as it exists off the picture plane) that isn't critical in simple drawings.

What Makes a Drawing Creative?

*I*f good drawing is only a matter of careful observation and skillful recording, how can drawing be creative? Your drawing has your touch in it, your way of handling materials, and your personal point of view. Pick a subject special to you. Rearrange it any way you like. Do whatever will make it fun or satisfying for you.

Change media, reverse values or devise an unusual color scheme. Distort and exaggerate. Draw what you feel instead of what you see. Add a bit of whimsy or humor. Embellish with decoration. Knowing you can draw correctly when you want to gives you the confidence to experiment. So learn the basics. Then throw away the rules when it suits your creative purpose.

LOOK FOR A NEW ANGLE

Always be on the lookout for distinctive ways to present your subject. Study a subject from different viewpoints. Try a side or a rear view. Up close and personal. From directly above—the *bird's-eye* view—you see shapes and relationships differently from the normal view. The *worm's-eye* view—looking up from floor level—distorts the image in another way. You make your drawing creative by not accepting the subject as it is, but by changing it to suit your fancy.

An Intimate View

This angle gives the viewer a feeling of floating over the subject. It takes a good grasp of perspective and sharp observation to do this as effectively as O'Connor.

The Dancer • Carla O'Connor • Watercolor gouache • 30" x 22" (76cm x 56cm)

A Bigger-Than-Life Banker

Looking up, Vanderbeek takes advantage of an unusual viewpoint to exaggerate and distort for dramatic effect.

Banker • Don Vanderbeek • Watercolor and pastel • 15" x 20" (38cm x 51cm)

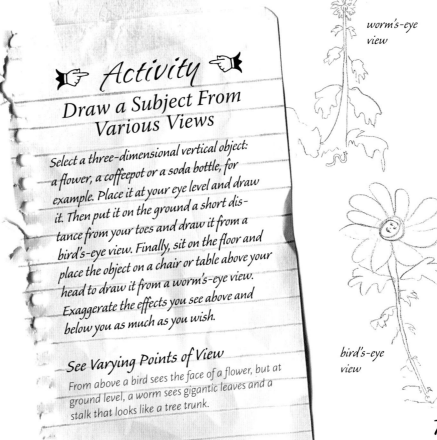

☞ *Activity* ☜

Draw a Subject From Various Views

Select a three-dimensional vertical object: a flower, a coffeepot or a soda bottle, for example. Place it at your eye level and draw it. Then put it on the ground a short distance from your toes and draw it from a bird's-eye view. Finally, sit on the floor and place the object on a chair or table above your head to draw it from a worm's-eye view. Exaggerate the effects you see above and below you as much as you wish.

See Varying Points of View

From above a bird sees the face of a flower, but at ground level, a worm sees gigantic leaves and a stalk that looks like a tree trunk.

worm's-eye view

bird's-eye view

4 DESIGN:
Mapping Your Route

You've decided on your destination, packed your bags, and put your vehicle in good shape for your creative journey. Now you need to map your route, become familiar with the major highways, and learn the rules of the road. Can you find your way without looking at a map? Of course. You might even make some lucky discoveries as you go. But you could also get hopelessly lost. It's better to plan your trip, so you can choose alternate routes as you go, without losing your general sense of direction.

You won't get where you're going simply by exercising technical skill. Your work of art is a synthesis of what you see (sensation), what you feel (emotion), and what you understand (comprehension). Focus these three on one objective: to turn raw materials and technical skills into a work of art. Creativity is more than making a picture or crafting an object. Art begins with a concept: your idea, your interpretation of the essential qualities of a subject. Use your craftsmanship and creative energy to shape your concept into a unique form.

How do you bring these diverse factors together?

Design!

Design turns nature into art. What you see in the world around you may be interesting, beautiful, challenging or frightening, but it isn't art until you shape it into art. Flowers. Baskets. Sunsets. Snakes. Anger. Joy. As an artist, you mold these raw materials into art using design, simplifying the complex, organizing the cluttered world into a coherent, meaningful image that expresses your concept.

Art is a visual language: Drawing is the vocabulary and design principles are the rules of grammar. Once you have a firm grasp on these fundamentals, using them becomes second nature, just like writing and speaking.

Pomegranates and Rice Basket
• Sherry Loehr • Acrylic
• 30" x 24" (76cm x 61cm)

Line and Plummet · Delda Skinner · Acrylic casein · 30" x 22" (76cm x 56cm)

Why Design?

Design is the road map, the blueprint, the organization of your art or craft. Design may be simple or complex—three miles to the grocery or a trip around the world, a simple drawing or a monumental mural. Design is the human mind at work, selecting, simplifying, embellishing and making choices that reveal the artist's personality, perception and insight.

Design is problem solving: the arrangement of shapes, values and colors; the division of space; the placement of major forms. Good work, whether realistic or abstract, art or craft, contains the elements of design.

Each design decision reinforces the expressive idea you wish to communicate. It isn't the object that you paint, draw, weave or photograph that communicates with the viewer; it's how you present it that counts. To express power and energy, use strong diagonals, hard edges and bold brushstrokes to convey these ideas. For sensitivity, use soft edges, close values and delicate color.

Design directs the viewer's eye through the work. Ed Whitney said, "Invite your viewer into the picture and entertain him everywhere." Set the pace and determine the directional movement. Lead your eye path through restful quiet passages to exciting key areas, moving in and around your center of interest. Accomplish this through relationships of shapes, continuity of line, color concept, interaction with the edges of the support, and manipulation of space, using the elements and principles of design as your tools.

> *"The artist reconstructs the random vocabulary of verticals, horizontals, diagonals, planes, volumes, cubes, spheres, textures, darks, lights, patterns and color into an order of vital relationships inextricably linked to the dynamics of life."*
>
> *R.D. Abbey and G. William Fiero,*
> **Art and Geology: Expressive Aspects of the Desert**

Don't Let Design Intimidate You

You are a designer. You make design decisions every day when you select clothing, buy a car, set the dinner table or arrange your office furniture. Design is necessary and natural. Don't be afraid of it. Paying attention and caring about how you do things enables you to do them more creatively. The more creative you are in your daily life, the more creative you are in your artistic pursuits.

Design Makes Sense of the Complex

The only way to resolve such a complex painting is through design. Melia paints pieces of color and shape throughout his picture almost like a weaver uses a loom. Design ties everything together.

Sohio Man · Paul G. Melia · Inks, gouache, acrylic and collage · 40" x 43" (102cm x 109cm)

Does Structure Stifle Creativity?

What happens to your creative spirit if you place so much emphasis on formal design? Do rules and organization interfere with having fun and letting yourself go? Not at all. As we learned in chapter one, creativity doesn't merely tolerate boundaries—it requires them. As Rollo May, psychologist and author of *The Courage to Create*, said, "Creativity is best when it has limits, which force the 'dream' into useable form."

When you plan before you create, you have more freedom for your creative impulses, less need to interrupt your work to make design decisions. Edgar A. Whitney used to say, "Plan like a turtle and paint like a rabbit." Organize the big things and the little things fall into place. When you design first, you put what is really important—yourself—into your work. And, what is more important, when you know the rules, you can break them more creatively.

Letting Color Take Center Stage

A design doesn't have to be complicated to be eye-catching. The beauty of this simple painting is in its understated color. The element of color is the artist's greatest tool for creative expression.

Alley Morning · Elin Pendleton · Oil · 9" x 12" (23cm x 30cm)

Students often ask, "How do I know when my artwork is finished?" Good question. Without a plan it's hard to tell. Design helps you get off to a good start and signals when you have finished. In the classroom, many students are in such a hurry to start working that they miss the excitement of creative planning. Artistic freedom functions best within a framework. Design enables you to make art spontaneously and intuitively. In his foreword to *Form, Space, and Vision* by Graham Collier, author Herbert Read wrote: "Spontaneity is not enough—or, to be more exact, spontaneity is not possible until there is an unconscious coordination of form, space, and vision."

Planning and structuring your work won't stifle your creativity. It isn't the use of design rules that limits creativity, it's lack of artistic vision. Design helps you focus on your vision. What makes your art creative is using design to express your individuality. Each of us manipulates the elements and principles of design in a different way.

☞ *Activity* ☜
Combine Letters and Numbers by Design

Sharpen your awareness of design with an easy exercise. Cut a 3" x 4" (8cm x 10cm) window mat in a piece of heavy paper. Cut letters and numbers four inches (10cm) high out of black construction paper. Make variations in the styles of the letterforms as you cut. (If you have a computer, search your printer fonts for creative alphabets to use.) Place the window mat over one of the letters or numbers, cropping it at the edges. Notice the negative areas where the letter is cropped by the mat. Combine two or more forms and try them with mats of different dimensions.

Use one of your designs as the basis for an abstract art project. After arranging two or three letters, I tried the mats to search for a design I liked. I traced the design and filled it in with black marker. I see several possibilities for a nonobjective painting.

The Elements and Principles of Design

You wouldn't throw darts at a map to decide where you're going. You shouldn't design by accident, either. With intelligent and imaginative use of design, you can bring order from chaos, shaping nature into art. Manipulate design fundamentals to make your work more creative without losing artistic integrity. Design elements and principles are guidelines, not inflexible rules. They're the tools with which you build your composition. They help you find more creative problems to solve and provide the means of solving them. Successfully combining elements and principles of design results in unity, your primary objective in the design process.

What you choose to incorporate or emphasize in your artwork contributes to your distinctive style. You won't use all of the elements of design in every project. Familiarize yourself with them. When you're stuck, introduce an element that isn't typical of your work to stimulate your creativity. Add a playful line, an unusual shape or pattern. You might just find a whole new direction for your creativity.

Manipulate these elements using the principles of design. Repeating shapes with variation in size or color prevents a design from becoming boring. Value contrast is dramatic and eye-catching. Gradation of different elements in your design creates a lively surface. These and other principles add interest, emphasis and cohesiveness to your design.

Post This!

Myriad books define design. Some design elements and principles appear in all of them, while others have different lists. Here's my list, slightly modified from Maitland Graves's THE ART OF COLOR AND DESIGN. Post these in your art space where you can see them at a glance and refer to them often.

DESIGN GOAL: UNITY

ELEMENTS OF DESIGN	PRINCIPLES OF DESIGN
Line	Harmony
Shape	Contrast
Value	Rhythm
Color	Repetition
Size	Gradation
Pattern	Balance
Movement	Dominance

Simple Shapes Pave the Way for Creativity in Other Elements

In realistic artwork the importance of shape is most obvious when the artist isn't attempting to create a photographic illusion of reality. The viewer recognizes trees in this painting by their shapes, allowing Meyer to be creative with color and other elements of design and still represent the subject.

Untitled · Mel Meyer, S.M. · Acrylic on canvas · 25" x 25" (64cm x 64cm)

DESTINATION: UNITY

Your primary destination in design is unity. You feel unity in an artwork intuitively, even before you analyze how the artist designed it. Unity is the organization of all the bits and pieces into a harmonious whole, your ultimate objective in the design process. When you're finished, you sense that nothing can be added or taken away. A unified design may be calm and contemplative or it may be aggressive and abrasive, but it must be consistent. Integrate the pieces into a coherent design using the elements and principles of design. Unity means everything is working.

Nothing More to Do or Add

There is a sense of completeness about this painting, typical of a unified artwork. The elements and principles of design interact as they should, with the artist calling the plays.

Resolution · Sherry Loehr · Acrylic · 24" x 30" (61cm x 76cm)

☞ Activity ☜
Evaluate Art for Unity

Examine the distinctly different styles in these two paintings. Compare them to see how I used the design elements in abstraction and realism.

* ✳ *Does the work seem unified, complete?*
* ✳ *Is the technique consistent?*
* ✳ *Did the artist use design to reinforce an idea?*
* ✳ *Can anything be added or subtracted to improve the design?*

Keep an open mind. These are subjective judgments. Write your ideas about unity in your sketchbook-journal. As you learn more about design, you'll become increasingly aware of specific ways to use design to achieve unity in art and craft.

New Mexico Cemetery · Nita Leland · Watercolor · 24" x 18" (61cm x 46cm)

Remnants of Autumn · Nita Leland · Watercolor · 22" x 15" (56cm x 38cm)

83

Line

Judging by prehistoric drawings, line was the first element of design in two-dimensional art. Line describes contour or gesture, defines structure, and may be descriptive or decorative. Lines may be thick, thin, fast, slow, serene, agitated, jagged, lyrical or aggressive. Line brings energy to a design. Intersecting lines create a focal point. A line drawn from one edge of a rectangle to another creates two shapes. The line acts as the boundary between the shapes: It divides, but also connects.

As you learned in chapter three, you have a distinctive line quality in your drawing. Use this quality to impose style on your artwork, such as the hard lines of geometric design or the soft, organic lines found in nature. Add calligraphic and decorative lines to create patterns on the surface or symbolic lines to suggest hidden meaning.

Limited Lines, Maximum Impact

Gorman uses a limited number of lines to suggest contour, mass and movement at the same time. His line is both earthy and elegant, describing the shape and mood of Changing Woman, a subject of Navajo mythology, whose image is the most persistent of Gorman's themes.

Barefoot Lady · R.C. Gorman · Lithograph · 12" x 15" (30cm x 38cm)

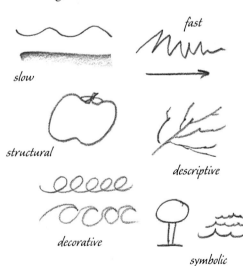

slow

fast

structural

descriptive

decorative

symbolic

Lines With Purpose

It's easy to overlook the creative possibilities of line, so always keep an eye out for ways to use line quality to convey your artistic concept and make your paintings more expressive.

☞ *Activity* ☜
Create Trapped-Shape Designs

Use unruled index cards or trace small rectangles in your sketchbook-journal. Work with pencil, pen, crayon, brush and watercolor, or a stick dipped in ink. Make a continuous line, crossing and recrossing, touching the borders on all four sides. Fill in the shapes created by the intersecting lines. Create a path of shapes similar in value, color or pattern to move the viewer's eye across the design. Continuity of line and color creates a sense of unity in a design. Do several of these trapped-shape designs.

Shape

Arrange shapes, whether realistic or abstract, to design your composition. The actual shape of an object is a positive shape. The background or the spaces between positive shapes are negative shapes. Plan both to assure a strong design. Nothing is more important than a structure of good shapes.

Make shapes visually interesting with varying dimensions and interlocking edges, like the pieces of a jigsaw puzzle. Vary your shapes with lost (soft) and found (hard) edges. Plan the shapes first, then design your subject to fit the shapes.

Consider cropping your design so that its main shapes interact with the edges of the support, creating a more interesting pattern of smaller negative shapes around the edges. When you vignette an image, make contact with three edges, rather than floating it in the center of the design. Ambiguous shapes make weak designs. Combine several small shapes to make a larger, stronger shape.

Shapes as Symbols

Shapes are symbols in many cultures. Use some of these common associations to emphasize a concept in your artwork:

CIRCLE: unity, sun, moon, spirituality

TRIANGLE: trinity, connection, home, desires

SQUARE: stability, solidity, earth, reality

RECTANGLE: foundation, grounding, rationality, solidarity

SPIRAL: growth, cosmic motion, spirit, evolution

☞ *Activity* ☜
Shape-Making With Paper Collage

Practice image and design ideas with paper collage. Cut or tear construction papers into pieces and use them to build layers of small shapes into larger shapes that create realistic images or abstract designs. It's fun to do this freehand, but you can plan your design if you wish. Use white glue, acrylic matte medium or acid-free rubber cement to adhere the pieces to a contrasting background.

Bold, Well-Defined Shapes

Uncomplicated shapes and pure, bright hues suggest grandeur and elegance in this large-scale painting. Look at the picture upside-down and sideways to appreciate the abstract design underlying the realistic image. Geometric shapes dominate the painting.

Untitled · Mel Meyer, S.M. ·
Acrylic on canvas · 72" x 72"
(183cm x 183cm)

My Torn-Paper Collage

I made this freehand collage, measuring 12½" x 10" (32cm x 25cm), from a model in a Polly Hammett workshop, adhering torn papers to contrasting colored papers to develop the figure shape and background. I invented the patterns in the background to create interest, but they were based on the vertical blinds and a plant behind the model.

Value

Value, the range between light and dark in artwork, has powerful expressive potential. Strong value contrast imparts visual strength and makes a forceful statement. Planning your value pattern is the first step in developing your artwork. Correct values define shapes when line isn't a key element.

Use a *high-key* scheme (light values) to suggest an upbeat mood. To project a moody, introspective feeling, use a *low-key* value plan of darks and middle darks. Otherwise, play your values like a musical scale, including all the notes, for the most exciting composition. Your foundation of midtones should vary in range with extremes of light and dark providing emphasis. Don't get stuck in the middle values with little or no contrast in your artwork. To attract your viewer's eye, place your lightest lights and darkest darks near the center of interest.

Value as the Star Element

Several elements of design are found in every picture, but one should dominate. This watercolor has texture, shape and color, among other elements, but value contrast provides the impact.

Focus · Nita Leland · Watercolor · 18" x 24" (46cm x 61cm) · Private collection

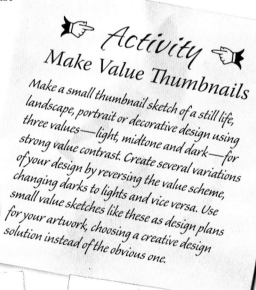

☞ Activity ☜
Make Value Thumbnails

Make a small thumbnail sketch of a still life, landscape, portrait or decorative design using three values—light, midtone and dark—for strong value contrast. Create several variations of your design by reversing the value scheme, changing darks to lights and vice versa. Use small value sketches like these as design plans for your artwork, choosing a creative design solution instead of the obvious one.

☞ Activity ☜
Play With High and Low Key

Make a high-key value sketch in color to create an upbeat mood and a low-key sketch for a somber treatment of the same subject. Which approach do you like best? Your choice of a color-value scheme determines the overall mood and visual impact of your art. Make a preliminary sketch to help you decide which will best suit your subject.

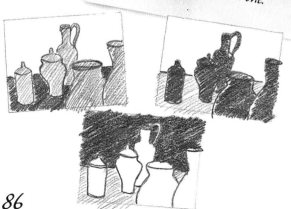

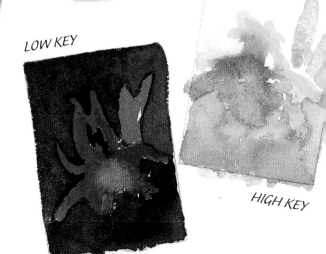

LOW KEY

HIGH KEY

Color

Color is arguably the most expressive element of design. Here's your lesson plan for mastering color:

Learn the properties of color: hue (the name of the color, such as red or blue); value (the lightness or darkness of the hue); intensity (the purity or grayness of the hue); and temperature (the warmth or coolness of the hue).

Learn the characteristics of your painting or drawing pigments inside and out. Understand transparency, opacity, intensity, tinting strength and staining properties to assure you get the best results from your medium. (These characteristics are explained and explored at great length in my book *Exploring Color*.)

Key your colors creatively instead of relying on what you see. Change value key in color to enhance mood.

Experiment with a warm and a cool version of the same composition.

Paint a design in pure, unmixed hues. Do another variation modifying some of the colors to a lower intensity.

Explore your colors to discover distinctive mixtures. Mix complements for exciting contrast and interesting hues.

Study the relationships of colors on the color wheel. Use color schemes to organize and simplify your palette and to locate unusual, expressive combinations of colors.

A Color Wheel of a Different Kind

All the colors of the spectrum are seldom used with such intensity in a common subject, but Horne has done it successfully here. Imagine the creative thinking that turned a dilapidated wagon wheel into a prism.

On the Wagon · Judy Horne · Watercolor · 19½" x 26" (50cm x 66cm)

No one uses or responds to color in the same way you do. Scribble color with abandon, using markers, colored pencils or paint. Become aware of your favorites and find exciting, new combinations. Use the colors you like best to show your color personality. Start with a color idea and find a subject that suits the color. Do you feel "red" today? Paint red!

Communicate With Color

Like shapes, colors are said to have psychological associations. Match color with meaning for a powerful creative statement.

RED: love, passion, excitement, anger

ORANGE: ambition, ego, pride, sociability

YELLOW: intuition, optimism, luminosity, cowardice

GREEN: fertility, growth, sympathy, calm

BLUE: serenity, innocence, truth, sadness

VIOLET: dignity, royalty, spirituality, power

BLACK: sophistication, austerity, emptiness, death

WHITE: innocence, hope, virtue, purity

Size

The size of shapes, colors, objects and the spaces between them contributes energy to a design. Equal sizes are boring, but variations of small and large shapes are interesting to the eye.

Proportion refers to size relationships of all parts of a whole: the hands in relation to the figure, the ears in relation to the head, the wheels in relation to the automobile. Correct proportions make a realistic picture believable. In abstract design, size relationships determine the visual impact of shapes and colors in a painting, quilt or other artwork.

Scale denotes the size of people or objects in relation to their environment. Exaggerate scale by placing tiny people in fantastic settings of huge, threatening size or by having them tower above a Lilliputian landscape like Alice in Wonderland. Or emphasize a sense of the macabre with scary relationships, such as a normal-sized person encountering a giant insect. Your viewers may be amused or puzzled, but the important thing is that you capture their attention.

Size Moves the Eye

The viewer quickly notices the frantic juggling going on in this piece. The activity is generated by the different sizes of balls scattered throughout. If they were all the same size, the painting would be far less interesting.

Keeping All the Balls in the Air · Donna Baspaly · Mixed media · 30" x 22" (76cm x 56cm)

A large mass of color provides impact through weight.

Broken pieces of color express energy and movement.

Small bits of bright color against a large neutral create energy and demand attention.

How Size Affects Color

Size affects color areas in several ways. Manipulate size to create a focal point or spatial tension in your design.

☞ Activity ☜
Show Scale in a Surreal Setting

Create a collage illustrating skewed scale in a surrealistic landscape. Cut out a magazine image of something familiar, like a house, barn or other building, and adhere this to a piece of illustration board or cardboard. Using white glue or acrylic medium, adhere other cutout images representing people, animals and objects, selecting pictures that are too big or too small in relation to the building. Place them so they are obviously the wrong fit for the scene. For example, a tiny woman coming through a doorway, an enormous flower growing out of a chimney, or a very large man with a tiny car in his hand. These no-holds-barred pictures are fun to put together.

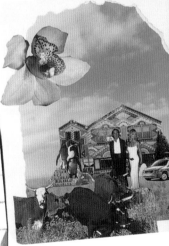

Home on the Range

With a nod to correct perspective I combined disparate elements: a decorated house on the plains with movie stars in formalwear waiting for their taxi. Notice the penguins in the background, also formally dressed. The cattle are family pets. The clincher is the enormous flower floating where the sun should be.

Home on the Range · Nita Leland · Collage · 14" x 10" (36cm x 25cm)

Pattern

Pattern comprises lines, shapes, values, colors and textures that enhance the surface and contribute to movement. A viewer is attracted to a specific feature in the pattern—a color or value, for example—and unconsciously searches for it throughout the artwork.

The patterns in natural and man-made environments are a rich source of ideas: texture, growth patterns, and industrial, mechanical, building and ornamental patterns. Avoid randomness and be aware of how you establish the important patterns. Use similar shapes and forms, for example, a dominant linear pattern or a predominance of dots and circles. Alternate patterned areas with quiet areas to give your viewer's eyes a rest.

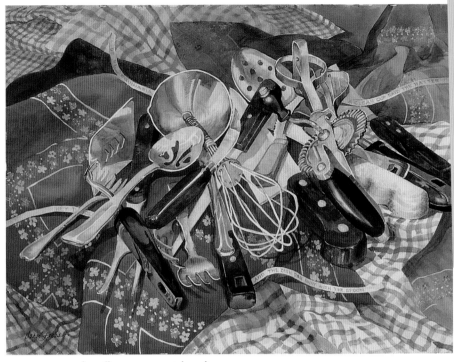

A Pattern of Reflections Guides the Eye

The patterns of kitchen utensils make an exciting composition. Reflections on shiny surfaces flicker throughout the piece, keeping the viewer's eye moving back and forth across the surface.

And the Dish Ran Away · Carol Freas · Watercolor · 20" x 30" (51cm x 76cm)

☞ Activity ☜
Go Pattern-Spotting

Build a design based on patterns from the environment. Make design sketches based on one or more of these patterns:

* ❋ Tree branch
* ❋ Stone wall
* ❋ Honeycomb
* ❋ Cracks in the sidewalk
* ❋ Stripes on a tiger
* ❋ Stack of dishes
* ❋ Slice of lemon

Superimpose decorative patterns on the natural pattern and create an eye path through the design by repeating colors, lines, shapes or values.

▼ Use Contrast of Pattern

First I planned the diagonals of the wings of the Canada geese, with cloud patterns in the background echoing that movement. The strong value pattern of dark heads crosses the softer clouds and dominates the design.

Rushing Wings · Nita Leland · Watercolor · 22" x 30" (56cm x 76cm)

89

Movement

Movement expresses life and energy in a picture. It directs the viewer's eye throughout the composition and controls the speed of the eye's movement.

There are three major movements in artwork. Horizontal, flat movement is static, restful or serene, such as a pastoral landscape, a quiet pond or a reclining figure. Vertical movement suggests dignity, stability or growth; for example, a city skyline, a person standing at attention, or a forest of tall trees. Oblique, diagonal movement implies dynamic action and energy, as in a crashing wave or a running figure. These three movements create surface tension in abstract as well as realistic art.

Make one movement dominant. The dominant movement sets the pace for the dynamics of the entire piece. Use contrast in movement to catch the viewer's eye at key points; for example, add a vertical or diagonal to a predominantly horizontal composition to point toward the focal point of your design.

Contrast of Movement

Barnum's tornado-like movement has everything in an uproar, but the locals seem firmly rooted to the ground and basically unconcerned. This contrast makes the picture lively and entertaining.

J.D.'s · Robert L. Barnum · Watercolor · 16" x 21" (41cm x 53cm)

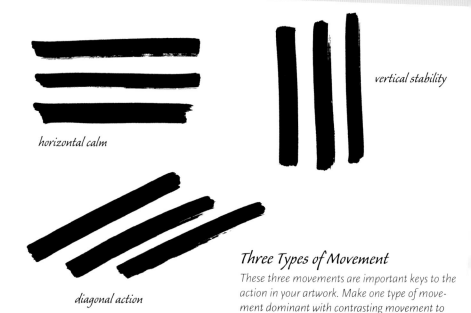

horizontal calm

vertical stability

diagonal action

Three Types of Movement

These three movements are important keys to the action in your artwork. Make one type of movement dominant with contrasting movement to add interest.

Harmony

Harmony emphasizes similarities in relationships. Close values with gentle transitions provide a relaxing visual experience. Colors next to each other on the color wheel work well together. Similarities of lines, shapes and sizes are harmonious. Many artists create tranquil, harmonious works that are pleasing to look at. But beware of too much togetherness leading to boredom. Introduce small differences to enhance visual appeal without discord.

Have Harmony Without Boredom

To liven up a harmonious piece, introduce subtle variations: a slightly brighter color, a different line quality, an unusual format, an altered viewpoint, a tilted horizon line, an unexpected object or a bit of whimsy.

Harmony Through Light Values and Delicate Colors

This high-key watercolor is a good example of harmony in design. The values are close and confined to the upper range of the value scale; the colors are delicate and harmonious. Adding extreme darks to this picture would destroy its ambience.

Iriscape · Glenda Rogers · Watercolor · 22" x 30" (56cm x 76cm)

☞ Activity ☜
Sketch Harmonious Scenes

Use markers, crayons, watercolors, colored pencils or colored papers to create a series of harmonious designs or pictures in your sketchbook, two or more to a page. In the first sketch, select three or four analogous colors and make a pleasing arrangement of simple, similar shapes or an image with slight value contrast and close color relationships. In the next sketch, select a different combination of three or four colors from the opposite side of the color wheel and make another close-harmony design. Create a third design in which you use a complementary (opposite) pair of colors with close values in high-key or low-key relationships.

Complementary Harmony

This watercolor sketch uses high-key analogous colors in the warm sky areas, surrounded by soft gray-violets from the opposite side of the color wheel. Close values maintain harmony in the scene.

Contrast

Contrast is a dynamic element of design, contributing excitement, attracting attention and relieving monotony, like a sudden change of scenery on a trip. Contrast creates tension between opposing elements: curved or straight, light or dark, smooth or jagged, big or small, simple or ornate, bright or grayed, warm or cool. Opposites push and pull, energizing the surface and exciting the viewer's eye.

Introduce and control contrast to make a spirited artwork. Strong value contrast achieves immediate visual impact. Vitalize a low-intensity color scheme with a sudden burst of pure color or energize flat shapes with a bold, aggressive line. When your harmonious design is in danger of becoming boring, add more contrast.

Strength in Values

Hammond's piece reads like an elegant chart of a full range of values in monochrome. Values range from white to black and several steps in between. They are arranged deftly in the design to keep the eye circulating around the focal point.

Beach Nest II · Linda Hammond · Acrylic and watermedia crayon on Yupo · 20" x 26" (51cm x 66cm)

☞ *Activity* ☜
Sketch Contrasts

Using any medium, explore different aspects of contrast in your sketchbook: monochromatic and complementary color contrast. Create a design in one color with a full range of values from white through midtones to black. Make another using complements (opposites) for color contrast and include subtle dark accents. Each approach to contrast has a different expressive effect.

Contrast in Complements

Complementary color contrast makes a vibrant impression even in a small sketch like this 3" x 4" (8cm x 10cm) watercolor. Except for the small patch of yellow at the horizon, the rest of the sketch was done with pure color or mixtures of two complementary colors, red-orange and blue-green, which vibrate when placed side by side and neutralize each other when mixed.

Monochromatic Contrast

A monochromatic value sketch strongly suggests a quality of light. In this 4" x 6" (10cm x 15cm) watercolor, that quality is moonlight on the desert. Use your sketches as thumbnails to map the values for larger paintings.

Rhythm

Everything you design should have an underlying rhythm. Rhythm refers to the intervals at which related elements occur throughout a composition. As artist Greg Albert says, "Never make any two intervals the same." Careful placement of accents directs the viewer's eye across the surface of a painting. The eye travels quickly when elements are closely spaced, more slowly across wider intervals. For example, in a landscape with trees, the eye quickly scans a tight group of verticals, then pauses at a clearing before moving on. This may be the ideal spot for your focal point. An accent point beyond the clearing resumes the rhythm. These accents may be in the form of line, value, shape, color or other elements of design.

Rhythmic Curves and Colors

The curving shapes of violins set up the rhythms in this painting. You can almost hear the vibrations of the strings across the piece as colors and lines resonate with each other.

Dancing Violins · Karen Harrington · Acrylic on watercolor paper · 30" x 22" (76cm x 56cm)

Let Rhythm Lead You There

Your strongest accent creates a focal point. Establish rhythmic accents leading to this center of interest, keeping the viewer's eye dancing throughout the composition.

☞ Activity ☜
Portray the Rhythms of Music

It's natural to think of rhythm in terms of music. Turn on some music you like. On a large sheet of paper, draw the rhythms of the music. Use flowing lines or geometric lines, hard lines or soft lines, depending on the music. Notice when the music changes its rhythms and returns to a basic rhythm. Plan a design based on musical rhythm: waltz, ragtime, jazz or rock. Let the rhythm develop into a concept for a painting.

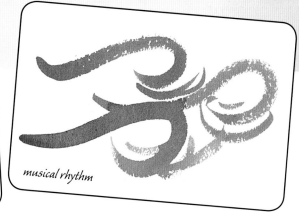

musical rhythm

beginning of an idea

93

Repetition

Repetition provides visual clues that move the viewer's eye. The eye intuitively searches for related elements. Similarities reinforce the viewer's recognition of symbols, strengthen rhythms, encourage movement and produce patterns.

Direct the search so each recurrence of a color, line, shape or value leads the eye toward your focal point. Introduce creative variations of repeated elements to prevent boredom. Pick up the vertical rhythms of a group of trees or a fence. Echo a cool background color in foreground shadows. Repeat a geometric shape in different sizes or colors.

Repetition of a specific element establishes unity through dominance. Some say three repetitions of a color, shape or other element are ideal, but that's a little too formulaic for me. Use as many as you need to advance the movement through the design. Likewise, don't be intimidated by the rule that you must have an uneven number of repetitions. Let your picture dictate the number. You can interpret four repeats as three-and-one if you like. But when you repeat an element, think "repetition with variation."

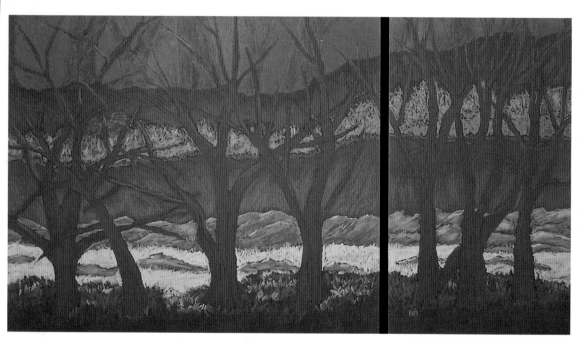

Repetition in Nature's Dance

The trees in Moore's painting are similar in size and shape, but varied so they create a swaying rhythm of trunks and branches across the picture.

Trees Along the River
· Gil Moore · Watercolor crayon · 14" x 24" (36cm x 61cm)

Exercise Repetition With Variety

A human tendency is to design with a regular, symmetrical rhythm. Make an effort to overcome this and use variety in your repetitions of shapes, sizes, colors and spaces—everywhere in your composition. It may take only a slight variation to improve a boring composition.

boring *better* *best*

Gradation

Gradual change implies growth or movement through space. Slowly change a color from warm to cool, a value from light to dark, a line from thick to thin, a shape from small to large. Use gradation of size to suggest deep space, with objects appearing smaller in the distance. A sharp break in gradation interrupts the viewer's eye, creating a rhythmic accent or establishing a focal point.

Unify contrasting elements by making a gradual transition between them. Enhance uninteresting areas by introducing subtle gradations of color or value. California artist Millard Sheets said, "Don't go an inch without changing color." Color and value should both change throughout your artwork. Practice your skills with your medium so you can make subtle gradations of color and value from one area to another. Gradation helps you to control the viewer's eye movement through your artwork.

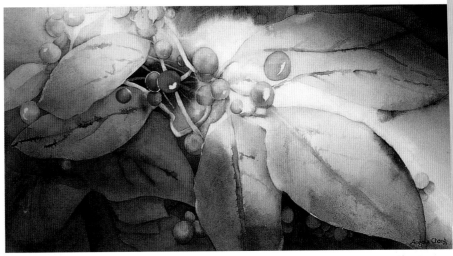

Eye-Catching Gradation of Light

The subject of this picture isn't the branch of berries: it's the light that flows around it, gradually changing as it moves across the surface of the paper. The light catches the viewer's eye and pulls it into the picture, where it reveals the colors and shapes of the branch and berries.

Light · Angela Chang · Transparent watercolor · 11" x 21" (28cm x 53cm)

big to small

thin to thick

vertical to horizontal

light to dark

pure to gray

red to yellow

Kinds of Gradation

Use gradation of color, line, shape, value and more to suggest movement, emotional change or space. Gradual change is subtle and more effective than abrupt change, unless your concept requires a sudden, dramatic jolt.

curved to pointed

Balance

Balance is the distribution of design elements to produce equilibrium. In *symmetrical* balance, equal elements are divided on each side of a vertical axis. In *asymmetrical* balance, dissimilar elements are unevenly divided, but balanced according to visual weight. You can't measure precisely the weight and tension of objects on a two-dimensional surface, so arrange and rearrange them until they look right to you.

You have an innate sense of balance. This is why you straighten your tie or rearrange a picture on the wall. Train your eye to be more conscious of balance in your surroundings and use this awareness in your design. The more elements you include in your design, the trickier the balancing act. Throw your design dramatically off balance if you intentionally want to make your viewer uncomfortable.

Using Knowledge and Instinct to Strike a Balance

Starting out with random lines and flowing paint, Beam superimposes image and design on this creative painting. The artist's intuitive sense of balance is controlled by her knowledge of how to use balance to make the picture work.

Sacred Circuit · Mary Todd Beam · Mixed media on Crescent board · 40" x 60" (102cm x 152cm) · Collection of Michael and Donna High

Keep Viewers on Their Toes

Establish simple visual balance first; then consider ways to make your piece more energetic and interesting by throwing it slightly off balance. Viewers are easily bored by perfect balance.

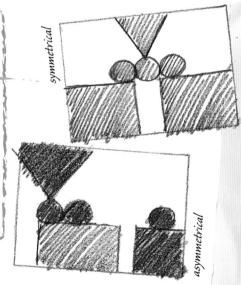

symmetrical

asymmetrical

Symmetry vs. Asymmetry

Balance shapes either symmetrically or asymmetrically. I enhanced the values and rearranged the shapes in the second sketch. The first example is static; the second, more dynamic.

☞ *Activity* ☜
Practice the Balancing Act

Draw two 4" x 5" (10cm x 13cm) rectangles in your sketchbook. In one, make a balanced symmetrical arrangement of a few simple organic or geometric shapes. In the other, make an asymmetrical arrangement of the same or similar elements, balanced, yet not evenly divided. Vary your design, adding more shapes and deliberately forcing imbalance to create a more energetic design.

Dominance

Dominance plays a central role in successful design, resolving conflicts between design elements and principles and restoring unity to your design. Achieve dominance through a variety of means, including rhythm, repetition, size, intensity or movement. As important as variation is, too much variety leads to chaos, which may undermine the content of your artwork.

Your dominant elements are your star players, communicating your idea to the viewer with clarity. Decide which elements will govern. As you organize your composition, consider the potential for each element in supporting your concept. Plan how to implement design principles to further your aim. Some tactics will be more effective for your purpose than others: these should dominate. Always remember that not all elements and principles of design are necessary in every composition, but among those that are included, one must dominate.

Blue Shadows · Charles Sovek · Oil on canvas · 20" x 24" (51cm x 61cm) · Private collection

Blue Dominance on a Sunny Day

Sovek uses color dominance to unify diverse elements in a busy street scene. By contrasting blue shadows with warm, light areas, he strongly suggests a bright, sunny day. Notice, too, how the zigzag of the foreground shadow leads your eye into the picture. Repetition of the dominant blue in the background is softer and suggests deep space. Complementary colors in the center of interest draw the eye and entertain.

The Great Problem-Solver

Resolve conflicts through dominance to make your design work. Too many colors? Make one dominate by its intensity or quantity. Too busy? Combine many small shapes into larger shapes. Values don't work? Establish a dominant value key to create a mood.

☞ Activity ☜
Shift Dominance in Thumbnails

Pick one element of design—line, shape, value, color, size, pattern or movement—to be the dominant factor in a sketch, expressing a definite mood. For example, use line or pattern to express the happy profusion of flowers in a country garden. Make another sketch changing the dominant element to create a dramatic change in the image and mood. You might combine shapes to unify the flower picture or enlarge the size of one or two flowers to fill the paper. Decide on one dominant element before you start each sketch, exploring several ideas.

In a flower garden, the patterns of colors and lines of leaves or stems might dominate.

Looking more closely, you would notice shape or value more prominently.

With an extreme close-up, the sizes of shapes would attract the eye quickly.

Format Options

Design comprises the arrangement of elements within a predetermined format to achieve a specific artistic objective. The most commonly used format for painters is a rectangle, but your art or craft may call for an oval or a square.

Begin your adventure into creative design by changing your format. Use a square, diamond, circle or oval. Stretch your format until it is long and narrow. Turn your horizontal format to vertical. Expand it to a huge surface or reduce it to a miniature. Give your format irregular edges. Each change in size, shape or proportion alters the way you develop the work and stimulates your creativity.

To fit the subject into your format, stretch it, squeeze it, bend it, float it or shrink it. Push it beyond boundaries. Artists sometimes mount their work on top of a mat instead of covering up ragged edges, giving a raw, spontaneous look to the piece. Each approach changes the relationships of positive and negative elements and makes the work more creative.

Intrigue in a Large Square

Here, Loehr designs within a square, breaking away from the rectangle more commonly used by painters. The subject is perfectly balanced, with the lemons at lower left being offset by the leaves at the upper right of the arrangement. The circular symbol piques the viewer's curiosity.

Golden Lemons • Sherry Loehr • Acrylic and gold leaf on board • 24" x 24" (61cm x 61cm)

Seek Fresh Formats

Different formats spark your creative spirit. When you crop your subject, you create interesting negative shapes around the edges of the image.

☞ *Activity* ☜
Fit One Subject Into Different Formats

Draw three different formats on a page in your sketchbook-journal. Select an object such as a teapot, piggy bank, water pitcher, flower, chicken or abstract design and sketch some part of this shape within each format. Stretch it vertically within a tall, narrow format. Then let the subject run off the page of a square format. In the circle, mold the subject to fit the circular format. Each time, change the size or shape of the format and relocate the center of interest within it.

Play around with different sizes and shapes of format in your sketchbook each time you plan, to discover unusual, eye-catching arrangements.

Compositional Choices

Creativity is all about choices, and nowhere is this more apparent than in the arrangement of elements within the picture space. Georgia O'Keeffe remarked that composition was about filling a space in a beautiful way. How, exactly, does an artist do this? Here are some suggestions:

Place the major horizontal and vertical lines in interesting relationships to each other and to the edges of the space.

Find the most effective location for your horizon line and your center of interest.

Develop a pathway throughout the picture to move your viewer's eye.

Select and organize your elements of design carefully, remembering the importance of dominance.

Keep in mind that all parts of the design must work together to establish unity.

FINDING YOUR FOCAL POINT

Within your chosen format you have many options for placing the center of interest. The entire space is at your disposal, not just the middle.

Artists use "sweet spots" to pinpoint the best place for a focal point in their artwork. These spots have the ideal qualities for a focal point: a different distance from each edge of the paper and not too close to the center. Artists use two different systems—the Rule of Thirds and rabatment of the rectangle—which vary slightly in their placement of the spots.

Design Tells the Story

The focal point in Oliver's painting is clearly the garment, located across the vertical space between "sweet spots." The dog's attention is focused on it and the light surrounding the soft shape adds emphasis. The painting has a great design, but I love the story it tells, too.

Time for a Walk · Julie Ford Oliver · Oil · 40" x 30" (102cm x 76cm)

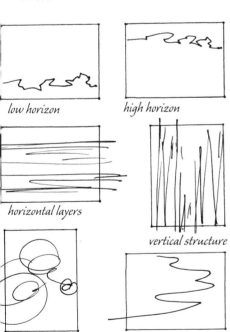

low horizon

high horizon

horizontal layers

vertical structure

spiral or circle

diagonal "S" or "Z"

Compositional Format

In addition to picture format, consider compositional format within the frame as you plan your subject. Here are a few basic ones; come up with some variations of your own. How about a triangle or an L-shape? An explosion radiating from the center?

The Rule of Thirds

The Rule of Thirds dictates that you divide your support into thirds both vertically and horizontally. The intersections indicate the best points for your center of interest.

Rabatment

For this method, draw a diagonal line from one corner to the opposite corner. Now draw a line from either adjacent corner to the diagonal line to form a right angle at the sweet spot.

Design Strategies: Thinking Ahead

The design of your art or craft is every bit as important as your skill with technique. Taking time to plan assures that your design will work. This may take some effort at first, but if you're faithful in your practice, the process will soon become second nature to you.

1 Explore the design in your sketchbook. Does it need a delicate touch or an explosion? Look for a subject's gestures, the descriptive contours. Note important details.

2 Identify your concept, theme or idea. Every composition should have a strong design emphasis based on this. The decisions you make from here on out will depend on it.

3 Determine design dominance to reinforce your concept. Do you want:

Cool colors, restful horizontals?
Curving lines, hot colors?
Dynamic angles and oblique lines?
Large shapes or intricate patterns?
Sensitive colors or strong values?

4 Choose a format that enhances your expressive idea. Use creative variations of design formats. Make distinctive choices in your layout. Have your design interact with the edges, forming interesting negative areas.

5 Develop a design plan. Make big shapes by combining several small shapes. Arrange lights and darks in an effective value pattern. Use your sketchbook to try different plans.

A Design Success

This creative piece has everything going for it. The traditional subject of fruit is set up in a dynamic relationship within the large white space. Gestural marks and shading create rhythmic accents that move the eye around the page. While there is vibrancy and energy in the drawing, it nevertheless radiates stability and serenity.

Still Life With Apples and Pears ·
Kathleen M. Bertolone · Charcoal and pastel ·
18¾" x 29" (48cm x 74cm)

6 Determine the focal point. Place it a different distance from each edge. Plan rhythm, repetition, color and pattern to direct the eye to your focal point. Arrange your greatest contrasts of color and value here.

7 Plan a distinctive color scheme. Use the expressive quality of color and count on dominance to support your concept.

8 Decide on the medium and technique that will pull everything together.

☞ Activity ☜
Surprise Viewers With the Unexpected

Develop a composition that makes your viewer perceive your subject differently. Introduce elements into your design not commonly associated with the subject, or invent unusual juxtapositions as the Surrealists did. Change a peaceful landscape by using hard edges, violent color, jarring contrasts. Interpret a floral bouquet by simplifying the profusion of blossoms and making big geometric shapes.

Be consistent with your original idea throughout your piece. Continuity makes the design work, giving it a sense of rightness from first stroke to last. Startle and amaze your viewers with worlds they've never imagined.

Give the Rules a Rest

Don't be intimidated by rules. Give your plan a twist or an element of surprise, even if it means breaking a rule. Matisse said, "Great art makes its own rules." Every rule is waiting to be broken. Just remember the two rules for breaking a rule: one is to fully understand it; the other is to know why you want to break it.

Your creativity is an expression of your uniqueness. Be yourself. Value your individuality. Creativity is finding different ways of doing things. Look beyond what others see. Reveal the truth of the subject as you—and only you—perceive it. Search for your reality in the rhythms and patterns of nature. Discover the symbolism of shapes, lines and colors. The symbols you select and the way you organize them convey your insights to your viewer.

A Rule Well-Broken

The rule: Never let your subject face out of a picture near the edge of the page. Well, why not? Doesn't this emphasize a sense of isolation or loneliness that fits with the limited palette in this picture?

Fish Sale · Alex Powers · Watercolor, charcoal and white crayon · 30" x 22" (76cm x 56cm) · Collection of Jane and Harry Charles, Myrtle Beach, South Carolina

☞ Activity ☜
Pick a Rule to Break

1. Copy these rules of design in your sketchbook. Once in awhile defy one intentionally to challenge yourself.

 * Keep the center of interest out of the middle.
 * Keep the center of interest away from the edges.
 * Always divide the work into unequal parts.
 * Always use uneven numbers of objects in a composition.
 * Use warm colors in the foreground, cool ones in the background.

 Can you think of other rules that are begging to be broken?

2. Design a piece deliberately breaking one of the rules of design. Decide why you're breaking it: to create a dramatic imbalance, to indicate absolute stability or to destroy the illusion of three dimensions, for example. Let your artistic intent in every piece you do determine whether the rule will prevail or whether you must break it to achieve your purpose.

Defy Another Rule

Yes! Put your center of interest in the middle of the picture if you want to. Break rules, if necessary, to achieve the desired effect. The baby zebra is the center of the picture, within the safe embrace of a whorl of mature adults.

Z's a Crowd · Marcia van Woert · Watercolor · 18" x 24" (46cm x 61cm)

SREALISM:
Taking the Scenic Route

Realistic art is a celebration of life. From the grandeur of the landscape to the humble tools in your kitchen cabinets, everything is subject material for your art or craft. Realism is the representation of objects in the physical world, the external things that are a large part of your inner experience. Their pictorial images are clearly recognized by the viewer, although the objects may be stylized in a number of ways.

Successful, memorable realistic painting involves much more than merely recording what you see in a subject. You must show your heart in the image. You need only the germ of an idea to start your creative process. First, you notice a subject. Your brain tells you what you know about it, shaping your perception. Next, your heart tells you what you feel about it. To get the idea from your brain to your heart you must see yourself within your subject and recognize why this particular subject captures your interest. Then tell this to your viewer.

Rocky Mountain Sunset · Leonard Williams · Acrylic gouache · 25" x 31" (64cm x 79cm)

"The faculty of creating is never given to us all by itself. It always goes hand in hand with the gift of observation. And the true creator may be recognized by his ability to find about him, in the commonest and humblest thing, items worthy of note."

Igor Stravinsky
Poetics of Music

Orange Sunflowers · Michalyn Tarantino · Watercolor · 26" x 20" (66cm x 51cm)

The Realism-Abstraction Connection

Realistic work is every bit as creative as abstraction. Realism is viewed by many as the opposite of abstraction, but in actuality, all good realistic art, including painting, drawing, quilting, photography and other art and craft forms, has abstract structural design. Use design elements to communicate with your viewer, making your realistic image more than just a report of what the subject looks like.

Instead of moving in opposite directions, the paths of realism and abstraction run parallel. Artists move freely between them. Approaches vary because we have different ideas of what is challenging or fun to do. Our ideas might change at any moment.

In *Search for the Real*, abstract expressionist Hans Hofmann wrote: "It makes no difference whether (a) work is naturalistic or abstract; every visual expression follows the same fundamental laws."

Artist Georgia O'Keeffe spoke of the controversy over realism versus abstraction: "It is surprising to me to see how many people separate the objective from the abstract. Objective painting is not good painting unless it is good in the abstract sense. A hill or a tree cannot make a good painting just because it is a hill or a tree. It is lines and colors put together so that they say something."

☞ *Activity* ☜
Seek Good Abstract Design in Realistic Art

Analyze the work of other artists to become more aware of ways to strengthen design in your realistic art. Place tracing paper over magazine images or pictures in this book to screen out details. Trace big shapes, values and movements. These abstract design elements unify the picture. Analyze the value pattern for contrast and value key, the color design for expression. Pick out the dominant design element that establishes unity. Squint at a composition to see the overall design, or view slides out-of-focus. Shapes, values and color relationships become more apparent when detail is blurred.

Bringing a Touch of the Abstract to Reality

By placing realistic figures on the flat planes of an abstract background suggesting a house and yard, Barnes lends a timeless, bigger-than-life quality to an ordinary setting. Although very much alive, the figures seem frozen in suspended motion against the flat background.

Backyard · Curtis Barnes · Oil on cotton canvas · 36" x 48" (93cm x 122cm)

Image vs. Essence

There is a difference between image and essence in realistic art. One artist goes to the mountain carrying painting gear, sets up an easel, and paints a realistic illusion of the mountain—its image. Another artist sits in contemplation of the mountain for a while, turns his back to it and paints MOUNTAIN—its essence. The goal for most realists is to combine image and essence successfully.

Share Your One-of-a-Kind View

ealistic artwork is personal. From the moment you select a subject to the instant you sign your finished piece, whatever you create reflects your subjective interpretation. Your work reveals your personal relationships with family, friends and neighborhood; your cultural heritage and religion; your education and training. Twenty artists painting a subject at the same time and place will come up with twenty different renderings. The subject is transformed as it filters through unconscious thought processes to reflect past experiences and inner convictions.

There's nothing totally new in art. Your choice of subject, craft and medium may be unusual or simply ordinary, but your work is special because of what you do with them. You have something of your own to say about the subject. Instead of reporting unimportant details, reveal how you feel about the subject through your selection and arrangement of colors, lines, shapes and other design elements.

Your art is creative because it reflects your creative spirit, your individuality. Art is not just a recital of facts. Art is about communicating your insights and feelings.

Shake Up Your Biases About What Is Subject-Worthy

You're bombarded by subject matter for realistic art. Use your creativity to find worthwhile subject matter in humble objects. I assigned a class the task of painting a found still life at home. Carla brought in a wonderful picture of her ironing board, iron, shirts on hangers, and a pile of laundry in a basket. Now that's an unlikely subject. But who wouldn't rather paint than iron?

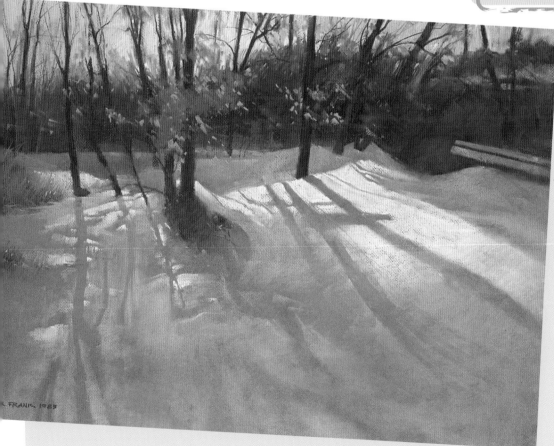

Life Through the Artist's Eyes

Simply stated, this is a snow scene with trees. If these words fully described the scene, we wouldn't need the picture. But words aren't adequate to express the beauty this artist sees in nature. A creative artist expresses things visually so we can see them through his eyes.

January Shadows · Robert Frank · Pastel · 19" x 25" (48cm x 64cm)

What Shall I Paint?

When you ask yourself, "What shall I use for my subject?" the best answer is anything and everything. I've seen good drawings of mop buckets, fine watercolors of table napkins, and delightful paintings of critters on rocks. Open your eyes and consider the creative possibilities of everything you see: cityscape, wildlife, reflections, dolls, backyard, sunlight… keep going.

Start with familiar, picturesque, traditional subjects and look for novel ways to use them. But don't stop there. Widen your search beyond the obvious. Do some brainstorming. In your sketchbook list objects, people, places and experiences, good and bad. (See the "Brainstorming" activity on page 27.) Look for your symbols and themes. (See pages 24–25.) Sketch out possible design treatments. Keep your list growing and refer to it when you're stuck for subject matter.

THE SUBJECT CHOOSES YOU

You don't really choose a subject. Something attracts your attention and insists, "Pick me." Even if the subject isn't new, your interpretation will be unique. Make your experience of the subject real for others. Get excited about it. Get your viewer involved.

Design helps you turn your most sincerely felt emotions into art. Much of the work of my Jewish friend Rebecca includes symbolism from her religion. This isn't sentimental representation. Although religious objects are in her images, the pictures aren't about these things. Rebecca uses design to make subtle references to what these things mean to her and to command the viewer's attention and respect.

When you paint, draw or make a scrapbook, you're "making visible the invisible," as Swiss painter Paul Klee said, something you can't express in words. This includes not only how the subject looks, but also your ideas about it and the intensity of your emotional attachment to it.

Bird Brains
In a captivating series of mixed-media works, Stolzenberger represents crows flying, arguing or chatting. They aren't simply birds; they're birds the way she sees them with almost-human traits. Their contentious nature is reflected in this version.

Crow Confrontation • Sharon Stolzenberger • Acrylic and collage on Yupo • 26" x 30" (66cm x 76cm)

A Slice of Art
Quiel has followed Stravinsky's suggestion (see page 103), finding something worthy of note in a simple, humble subject. You're surrounded by subject matter; open your eyes and discover it.

Edible #17—Pie Slices • Cathy Quiel • Watercolor • 15" x 20" (38cm x 51cm)

> "Everything is a subject; the subject is yourself. It is within yourself that you must look and not around you.... The greatest happiness (is) to reveal it to others, to study oneself, to paint oneself continually in (one's) work."
>
> Eugène Delacroix

Paint
What Catches Your Eye

In the midst of surging crowds in the city, why does Hollerbach record this particular group of people? Even if the scene is a composite of many he has observed, what caused him to put these people in this place at this time—in precisely this way? Hollerbach is telling us the subject grabbed him and he felt compelled to shape it into a painting.

Street Scene in Upper Manhattan · Serge Hollerbach · Acrylic on board · 40" x 40" (102cm x 102cm)

The Story Behind the Scene

How are the apples in this painting related to the antique objects? Could there be maple syrup in the jug? Applesauce cooking on the stove? Help your viewer to become a participant.

Stoneware With Apples ·
Michael J. Weber · Watercolor · 18" x 24" (46cm x 61cm)

Making a Subject Yours

How do you determine what makes a good subject? Ask yourself:

* Why does this subject interest me?
* What do I see in this subject that another person might not see?
* Should I search for something exotic and unique?
* What if I prefer a simple subject?
* How will I communicate what I see in my artwork?

☞ Activity ☜
Draw With All Senses

Start out with a simple subject—for example, an apple. Note the object's shape, color, texture and smell: mostly round but bumpy on the end; crimson red speckled with areas of golden yellow; smooth with a worm hole on one side; spicy scent. Search your mind for past associations: the smell of pies baking; picking apples from twisted trees in an old orchard; feeding an apple to a gentle pony; suffering a tummy ache from eating one apple too many. Take time to think about it and see yourself there.

Make contour drawings of your apple from several angles. Slice the apple and draw the cross section, too. Take a bite and draw the taste: crisp and chewy, a little bit tart—yum!

There Are No Bad Subjects

Paint or draw whatever you like without apology.

I'm convinced there is no such thing as a bad subject. Your attention to a subject makes it important. The subject itself doesn't communicate with the viewer; you do. It doesn't even matter whether or not your viewer agrees with you. What matters is that he or she reacts in some way.

For years I quit painting marshes and waterfowl, my favorite subjects, because I had a watercolor teacher who described wildlife artists as "fin-and-feathers freaks." Eventually I realized I was cheating myself by deferring to another's opinion of what would make suitable subject matter for me. Today I enjoy painting birds occasionally, and others seem to take as much pleasure in looking at my pictures as I do in painting them.

"Picturesque" is in the eye of the beholder. Each viewer comes to your artwork with a different set of perceptions. Someone once couldn't understand why I enjoyed painting watercolors of barns. For me, a barn revived memories of rowdy family reunions with my grandmother's kin. Barns reminded him of rats. You can't please everyone, but you will connect with those who feel as you do.

Explore any subject when you feel you have something to say about it. Another artist may be more successful at selecting unusual subject matter, but those subjects may not be right for you. You paint best what you know best. Feel free to be creative with the familiar.

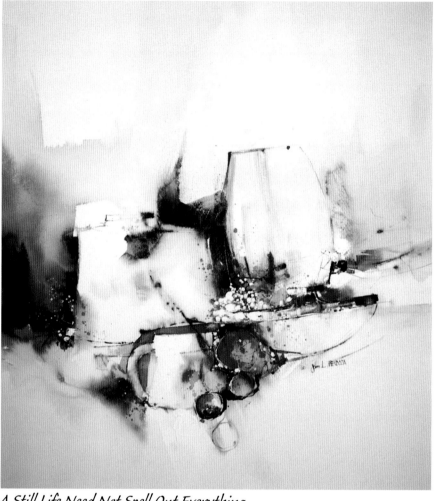

A Still Life Need Not Spell Out Everything

The next time someone tells you still life is a boring subject, show them this painting. Mendoza invents a personal interpretation of ordinary objects in a sensitive still life, using elements of design and his personal touch with his medium. His use of ambiguous space and lost-and-found edges adds mystery to the composition.

A Touch of Porcelain · John L. Mendoza · Watercolor and gouache · 30" x 22" (76cm x 56cm)

☞ *Activity* ☜
List Your Likes and Dislikes

Divide a page in your sketchbook into two columns. Label one column "Things I Like" and the other "Things I Don't Like," or make up your own whimsical titles ("Hooray!" and "Boo!" for instance). List as many things as you can think of in each column. Add to your lists whenever you have a few minutes to play in your sketchbook. Use these lists—both of them—as sources for subject matter in your paintings. Express yourself creatively about the negative things in your life as well as the positive. This may help to relieve the stress they cause.

Do It Your Way

Flowers, fishing shacks, lighthouses and barns—some call these clichés. But if you grew up on the desert, a fishing shack is a novelty. In a rain forest, a lighthouse isn't common. Follow your intuition in selecting a subject. If something intrigues you, it's worthy of exploration. Look for the creative possibilities in every subject.

Once you have found a realistic subject, you have two objectives: to create a good design incorporating the subject and to represent the subject in a distinctive, personal way.

No matter how often a subject has been done, when you integrate your personal concept of it with your special touch with your medium, the result is a new reality, something that never existed before. That's creativity.

Never mind if others have used the subject. Do something unusual with the obvious. You have your own way of doing things. Your approach to a subject may change many times, making it a rich source of imagery over and over again.

Most of us lean toward visually pleasing subject matter. There's certainly nothing wrong with that. Our chaotic world needs the artist's connection to and praise of beauty. Just remember that surface prettiness soon loses its charm. Take command and use the power of design to create a unique expression of how you feel about your subject. Make your viewers sit up and take notice. Don't let them take your art for granted. Create a flamboyant color scheme or use dramatic, attention-getting value contrast. Emphasize rich textures, exotic patterns or sensual lines.

"Paint as you like and die happy."

Henry Miller

☞ *Activity* ☜

Change the Subject You Find

Pick any subject from your list of things you like and don't like. Invoke a sense of mystery. Use soft edges and close values. Eliminate detail. Select unusual colors rather than local colors. Or reveal a powerful feeling about the subject with violent color and agitated gestural lines. There is nearly always a more interesting way to handle a subject than to represent it the way you find it.

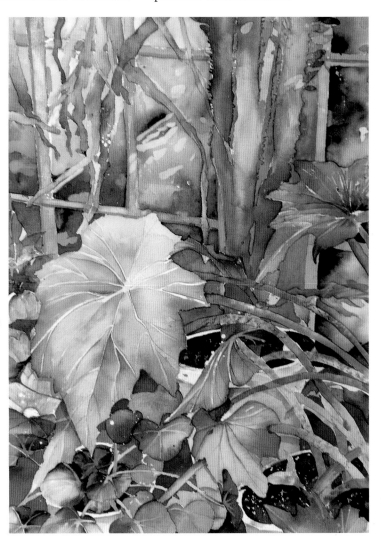

Reality Amplified

Daniels presents his subject on a large format in living color. His foliage is more lush and colors more vivid than the real thing. The viewer is left a little breathless by the spectacle of an ordinary window view seen through his eyes.

Sondra's Window · David R. Daniels · Watercolor · 38" x 28" (97cm x 71cm)

A Strong Subject Made More Powerful by Design

In an original treatment of a traditional Japanese subject, Purdon's richly rendered Kabuki dancer is a striking contrast to the delicate lines of the figures behind him.

Kabuki · Douglas Purdon · Watercolor and gouache · 15" x 22" (38cm x 56cm)

☞ *Activity* ☜
Search Your Subject for Design Qualities

Pick a subject. Ask yourself what design factors are naturally present and emphasize these in a sketch. For a tree, for example, notice how the branches radiate from the trunk as seen from below. Observe how the veins on the leaves branch out just like the branches from the tree. Look for a new design approach. Introduce an imaginary design element: a decorative pattern on the leaves or trunk, or a fantastic color scheme. How many ways can you find to express a single subject?

☞ *Activity* ☜
Do a Multi-Perspective Still Life

Make ordinary subject matter more interesting with an unusual design treatment. Arrange five or more objects for a still life. Change your position two or three times as you draw the objects—stand, sit, move to one side or behind the setup, or view it in a mirror. Draw the objects as you see them from the different angles, and distort or exaggerate if necessary to strengthen the design on the page. Reinforce continuity of line and dynamic movement instead of reporting what you see from a single point of view. Ambiguous perspective creates tension and energy in your design.

Find Your Own Sources of Imagery

Where are you going to find source material for your realistic artwork? Every artist has difficulty with this question now and then. In the classroom, students often copy the work of other artists. Much better sources are your own photos and working from life. Also, use your imagination and your sense of humor creatively when you make realistic images.

COPYING FROM OTHERS

Some students copy the work of other artists to practice skills and techniques. There are many pitfalls to copying:

You can't capture the emotion expressed by an artist in the original work.

A copyist may be copying mistakes and second-rate methods without realizing it. Furthermore, copying prevents you from learning for yourself how to organize a composition and develop your own techniques.

You miss the true creative experience when you copy. Eva was enrolled in a class that copied pictures every week. This was boring, so she quit painting. Later, working in my class with her own source material rekindled her enthusiasm.

Some people become dependent on copying. Rob was a gifted copyist but unable to create original art. The simplest solutions evaded him; he struggled with basic techniques. Only by moving beyond copying could he become a genuinely creative artist.

Copying is not as satisfying as doing your own work, even if the copied piece looks more professional.

Strengthen your creative muscle along with your skills. Take pride in doing your own work.

It's a Dog's Life
O'Brien's creative, colorful interpretation sees life from the dog's point of view. Now, that's originality. People viewing this painting can't help smiling, even if they don't like dogs. The whimsical patterns and symbols are irresistible.

Dog Dreams · Jennifer O'Brien · Mixed media · 30" x 20" (76cm x 51cm)

Showing or Selling Copied Artwork

Students who copy should clearly understand they must not sign the finished work and may not sell or exhibit it except in a student show, and then only if the proper attribution is made to the original artist. Representing another's work as your own is plagiarism, which is illegal.

☞ Activity ☜
Scout Your Home for Subjects

✱ Make a tour of your home looking for subjects to use in your artwork. Carry your sketchbook and a pencil with you, and a camera if you have one. Begin anywhere in the house or apartment and make a note or sketch or take a picture of what you find. You may notice the tomatoes ripening on the windowsill in the kitchen. In the bedroom perhaps there's an antique doll you haven't looked at for years. Any one of these discoveries could be the start of a picture.

✱ Open a closet, search your garage or look in a corner of the yard. Focus on five to seven objects and develop a composition. Unify your design by finding or creating common elements: a similarity of shapes, sizes, colors, lines. Use distortion if necessary. Make a drawing or painting or use your design to embellish a craft.

Use Photographs Creatively

Your photographs are fine source material for your art work. A photo enables you to work with a familiar subject without having it right before your eyes. Your personal involvement with the scene is revealed in your work, even when details are not visible in the photo. You had a reason for taking the photo. Later, you will paint it for the same reason.

Lydia began a watercolor in my class based on her photo of a rounded hill rising out of a lake, taken from a boat. It was a poor photo, but I tried not to dampen her enthusiasm. Imagine my surprise when I looked over her shoulder at her painting in progress and saw several quaint Irish cottages on the hillside. "They were on the other side of the hill," she told me, "but by the time I got my camera ready, they were out of sight." But not out of Lydia's mind.

Some artists work from slides, others prefer prints. With the advent of digital photography, prints are becoming more common than transparencies. The advantage of digital photography to the artist is the capability of shooting numerous different compositions and exposures and deleting inferior pictures without the expense of having them printed. Also, photos can be stored on computers, CDs or online instead of in a dog-eared shoebox.

Be selective and imaginative rather than literal in your use of the camera and the resulting images. Look for unusual effects to make a more creative photo (see sidebar).

A Cropped Composition

I chose one flower among several on the lily plant shown in the viewfinder activity below. Cropping created interesting shapes around the edges of the composition.

Red Tiger · Nita Leland · Watercolor · 24" x 18" (61cm x 46cm)

The camera makes no judgments, so you must. Even a well-composed photo may need tweaking to become a forceful painting or drawing. Flip back to page 51 for ideas on how to use your computer to manipulate your photos for creative artwork.

Take Advantage of Photo Effects and "Mistakes"

* *Some types of camera lenses cause distortion. Exaggerate this for a creative effect.*

* *The eye level may be tilted because the photographer tilted the camera. Take advantage of this in your rendering of the photo.*

* *Ambiguous light sources may affect shadows and forms strangely. Use these peculiarities to make a more expressive picture.*

* *If the photo contrast is weak, make up your own light source.*

☞ *Activity* ☜
Find a Composition Within a Viewfinder

Photos are rarely perfect compositions. Frequently there's more information in your photo than you need to make a good painting or design. Move a small viewfinder or an empty slide mount over a photo and you may discover several good compositions within one picture. Make thumbnail sketches of the compositions you find. Use one of these small sketches for a picture without referring to the photo. This approach gives you lots of leeway in design planning and helps you to become less dependent on the reference photo as you develop your image.

Paint the Real Thing

On-the-spot painting and drawing supplies you with a wealth of realistic subject matter for your art. Working from life includes your direct observation of a subject out-of-doors (sometimes called *plein air* painting) or inside with a still life; a clothed figure in a natural environment or a nude model in the studio.

It's exciting and fun to work from the real thing, more so than copying from a photo or other references. Plein air painting offers many creative choices. First you select just one subject from nature's bountiful display; then you choose how to compose the subject on your support. As with any other artwork, your palette of colors calls for another creative decision.

Through the process of elimination, condense your subject to a manageable number of components. Simplify the shapes; eliminate detail. Organize the separate parts using the elements and principles of design to create a coherent work of art from the raw materials of nature.

Weather and light can be challenging for the outdoor painter. Some artists create traveling studios in their cars or vans for protection from bad weather. But time marches on in all weather and the light changes as you work throughout the day. You can photograph or sketch the shadow patterns you like and add them later or create your own source of light with appropriate shadows, if you like. Although many artists like to complete their plein paintings in one or more sittings at a site, others are happy to get a good start that they can complete in their studios.

Seeing the Light

The best part of painting plein air is seeing glorious light through the eyes of a colorist like Przewodek. In the late nineteenth century, Monet discovered that he could discern the components of natural light on a subject outdoors and paint light instead of local color. Every artist should try outdoor painting to practice observing and recording natural light.

Early Morning Stroll · Camille Przewodek · Oil on canvas · 9" x 12" (23cm x 30cm)

Plein Air Painting Tips

PACK THE RIGHT EQUIPMENT
* sketchbook, viewfinder, camera
* Pochade box, easel or drawing board
* paper or canvas
* paints, brushes, supplies— the minimum necessary
* chair or blanket
* layered clothing, sunshade or hat, comfortable shoes
* bug spray, sunblock, sunglasses
* umbrella
* simple first aid: aspirin, tissues, bandages, ointment, hand wipes
* drinking water, LUNCH! (Don't forget the cookies....)
* litter bag

SELECT A SITE FOR SAFETY AND COMFORT
* Set up away from traffic, in a place that's not too remote.
* Ask for permission to work on private property.
* Paint with a buddy.
* Check on restrooms before you settle in.

FIND YOUR SUBJECT
* Make it simple. Bite off a small piece.
* If you can't decide, turn around twice with your eyes closed, sit down, and paint what you see.
* Use a 35mm slide-mount viewfinder to isolate your main subject.
* Use your camera to gather information for later use.

GET STARTED
* Make thumbnail sketches to establish values and composition.
* Concentrate. Eliminate. Simplify. Combine.
* Don't expect a winner every time.

BEFORE HEADING HOME
* Leave the area cleaner than it was when you arrived.
* Thank your host, when appropriate.

Getting Close to Nature

Nature supplies a multitude of subjects, but nature itself is not art. Pick and choose, simplify and rearrange, until you transform the subject from a literal image into visual expression. Your viewer should sense what you're saying without being distracted by a recitation of irrelevant facts.

Nature is rich in subject matter and generous with detail. An artist can easily become confused with all that nature has to offer. Examine your personal reaction to special qualities of the subject and concentrate on these. What lies beneath the surface?

Design helps you to focus on essentials and turn nature into art without merely depicting what things look like. Choose a design element appropriate to what you want to express and apply it to your composition. In your next nature project pick a different element of design and take off in another direction.

When you work directly from nature, observe carefully. If you're working toward the illusion of reality, be correct, but not picky. Viewers are easily sidetracked by inaccuracies. Suggest deep space by placing lighter values and cooler colors in the distance, by overlapping objects and converging parallel lines, or by making distant objects smaller.

Select aspects of the subject that best express its inner nature or your ideas about it. Take the subject out of context, if necessary, to make your statement: a wildflower blooming on Times Square or an orchid in the desert.

Roadside Beauties

Nature is certainly our greatest resource for realistic artwork, but you don't necessarily find the best flowers in a garden. Hughes noticed these cactus plants growing along the edge of a curb.

Galveston Curbside
- Mary Sorrows Hughes
- Watercolor • 17" x 20" (43cm x 51cm)

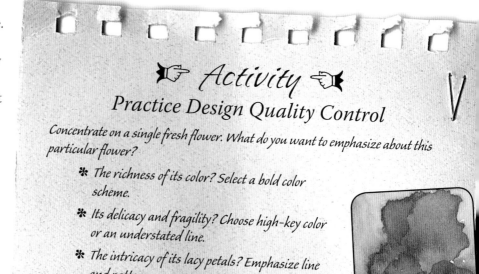

☞ Activity ☜
Practice Design Quality Control

Concentrate on a single fresh flower. What do you want to emphasize about this particular flower?

* The richness of its color? Select a bold color scheme.

* Its delicacy and fragility? Choose high-key color or an understated line.

* The intricacy of its lacy petals? Emphasize line and pattern.

Think of other qualities you might express about the flower. What design elements could you use to express them? Make a painting or drawing from one of your designs. An iris is an iris is an iris, but as you can see from my examples, the design possibilities are endless. Stylize any subject and have some fun with it.

Creative Portraits and Figures

Painting and drawing people is challenging and fun. The possibilities are endless for setting up creative compositions from candid-camera shots or your own imagination. Unless you're painting a commissioned portrait, you have complete freedom with your subjects to make them happy or sad, beautiful or disfigured, lithe or awkward, dressed up or dressed as you'd never see them. So, make lots of sketches or take photos everywhere you go and build a reference file of figures and faces with different expressions and poses. Use your sketches and photos to populate your compositions with interesting, lively people.

Make up a story. Tell us about the happy family that lived in an old historic house a hundred years ago; the tragic fate of the fisherman who sailed out from the rocky coast; the paths by which different people in your painting came together to become your subject. It doesn't matter if the story isn't true, but here's the tricky part: You have to believe it yourself if you want your viewer to believe it.

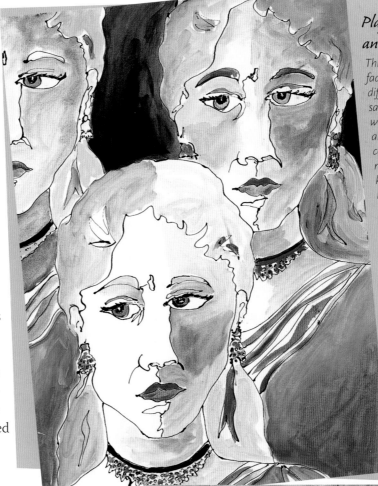

Playful Composition and Color

This contour drawing of faces appears to be slightly different renderings of the same person, suggesting a woman's haughty personality. The artist applied color playfully, but with regard to facial planes, keeping the piece from looking like a cartoon.

The Look · Karen Harrington · Acrylic on watercolor paper · 30" x 22" (76cm x 56cm)

Creative License With Caricature

Caricature gives a novel twist to painting and drawing people. Exaggerate the most easily recognizable features in a person's face and posture and you'll have a creative likeness.

Nita (caricature) · Susan Moreno · Brush-tip markers and pastel · 11" x 8½" (28cm x 22cm)

Reflecting a Subject's Surroundings

Westerman looked beyond his subject and included the reflection, a more creative angle than just a figure study. What can you find in your figure's environment to enhance the subject without distracting from it?

Katie and Friend · Arne Westerman · Watercolor · 21" x 29" (53cm x 74cm) · Private collection

Develop a Realistic Subject With Flair

You've selected your subject. Now what? Even the ideal subject must be shaped and trimmed to fit the idea you want to express. The visual aspect alone isn't enough. A camera can record that. What do you want to say? What's the best way to say it? These are important questions. Your answers set the direction and tone for every creative effort.

You need a strategy to help you get on the road. Every aspect of your art comes into play: choice of medium, type of support, your individual technique, and selection of design principles. The choices seem endless. Flip back to page 100 and review the rules of the road in creative design. Follow these procedures for organizing your realistic artwork.

> *"Painting is just like making an after-dinner speech. If you want to be remembered, say one thing and stop."*
>
> Charles Hawthorne

☞ Activity ☜
Seek a Subject's Main Idea

In your sketchbook list descriptive words that characterize a subject: its physical appearance and the qualities that make it unique or interesting to you. These words might describe intangible qualities like a mood or emotion (happy, contented, sad). They might target physical attributes such as texture (smooth, rough, lacy), shape (crooked, sensuous, jagged), color (exotic, brilliant, delicate), or contrasts (light/dark, smooth/rough, big/small). List as many ideas as possible. Then narrow these down to one clear meaning. This is your CONCEPT. Concentrate on this.

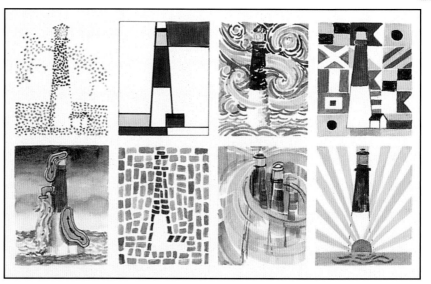

The Lighthouse Through Many Artists' Eyes

This lighthearted approach to a common subject, a lighthouse, captures the viewer immediately, especially if you're familiar with the famous artists whose styles are emulated in each small composition. This painting would make a great test for an art history class.

The Artists Paint Barnegat Light · Carol Freas · Watercolor · 9" x 12" (23cm x 30cm)

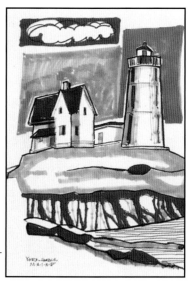

Realism, Stylized

Barrish's stylized approach to a lighthouse is his unique way of creating realistic pictures. Remember, there is no "right" way. Every artist has a different way.

York Harbor, Maine · A. Joseph Barrish, S.M. Markers · 12" x 9" (30cm x 23cm)

Activity
See the Same Subject Three Ways

Select a subject from one of your photos or sketches. Brainstorm a list of thoughts, adjectives and associations that come to mind when you think of the subject. Then work out a series of three design plans. Use the zoom-lens approach:

❋ Start with a middle- or long-range view of the subject in a background.

❋ Zoom in until the subject fills the frame and the background is reduced to negative shapes around the edges of the frame.

❋ Zoom in again for a close-up of some part of the subject.

WINDMILL

Western	bleak	odd
ghost town	old-time	ingenious
abandoned	trough	awkward
hot, dry	wooden	cows
broken	weeds	drought
mountains	tall	forgotten
	obsolete	

Once you have your three views, consider the following from plan to plan:

❋ Change the color, the center of interest, the format, the medium, the value plan.

❋ Add linear design, textural interest, decoration and imaginary elements.

❋ Emphasize a particular quality of light or a seasonal ambience.

❋ Contrast light and dark for dramatic effect; change to misty, soft shapes in high-key colors or values; switch from glowing warm autumn color to icy-cold winter blues in your next image.

Don't always paint your first design. Compare several approaches to push yourself beyond the obvious. Keep changing your viewpoint. Invent what you need to make a better picture.

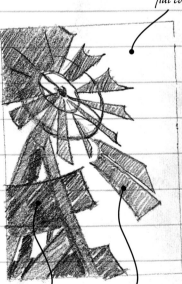

flat color

check detail extend values

abandoned
bleak
broken vanes
dark sky?
value contrast

hot
dry
earth tones
red/yellow sky

Get Real, But Not Too Real

A realist isn't restricted to representing only real objects or scenes. Two valuable creative assets are your memory and imagination, which enable you to visualize something real that isn't actually right before your eyes. Conjuring up an image is part recall and part invention. The recall is memory; the invention is imagination.

No matter how good your memory is, you can't remember everything about a subject. Your mind sweeps away inconsequential details, filing only what is important, eliminating nonessentials, and giving you the opportunity to invent.

Preparatory drawing helps you remember significant details more clearly. Focus on an object to capture its contours, gesture and important details, storing them in your mind for later use. The more you draw, the more source material you have in your mental storage locker for your memory and imagination to work with.

Let your imagination fly. Do the unexpected. As long as you're using recognizable images, the work is realistic, even if it includes a fanciful pattern or an unreal color scheme. Start with the real and enhance it. Don't hesitate to exaggerate or distort your subject deliberately to make it more interesting. Take a humorous approach or invent something unnerving to startle your viewer. Release your creative spirit and have some fun with your art.

Even Serious Artists Play

Zampier frequently draws what he sees quite literally, then his imagination goes wild and funny people and animals begin to populate his pictures. Don't try to make your drawings precious objects. Have fun while you're learning and don't ever stop playing just because you feel you're improving.

Funny Faces · A. Brian Zampier, S.M. · Pen and ink with watercolor · 14" x 10½" (36cm x 27cm)

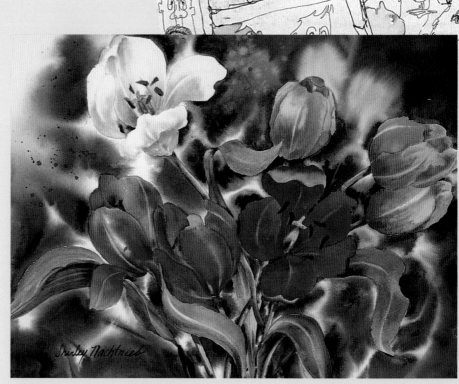

Invent a Bedazzling Background

The tulips are realistic, but the background is far more interesting than a conventional flower garden or the standard still-life-with-vase. The indigo washes strike a beautiful contrast behind the flower forms.

Respect for Blue · Shirley Eley Nachtrieb · Watercolor · 11" x 15" (28cm x 38cm)

Paint a Play on Words

The artist must have had fun collecting the subject matter for this painting, letting the idea expand, and playing around with compositional arrangements. You can tell she was still having a good time when she figured out the title—and that's all part of the creative game.

Table Legs · Judith Vierow · Acrylic on paper · 12" x 9" (30cm x 23cm)

Leave Them Laughing

Shepherd reveals her sense of humor in this painting from her "Bottoms Up" series, a collection of thirty paintings whose subjects range from teddy bear bottoms to bell bottoms. Scenes like this are everywhere. Be watching for them.

Bottom Fishing · Pat Shepherd · Watercolor · 11" x 15" (28cm x 38cm)

☞ *Activity* ☜
Put Away Your Plans Before Painting

Select a realistic subject from a photo or from life. Decide what you want to say and how you're going to say it. Draw it, plan the composition, select dominant design elements, and work out the color scheme. Then put away your source materials, sketches and plans. Everything. Out of sight. Do the artwork from memory. Your memory and imagination will tell you what to do as you work. The reference material only gets in the way during the painting process. Have fun!

Become a More Creative Realist

Here are a number of ways to inject creativity into your realistic artwork:

* Include something that isn't there to make your design more interesting.
* Invent a reality-based fantasy from your imagination.
* Include a visual surprise for your viewers.
* Give a realistic scene a twist: a touch of humor, shock or playfulness. Use your imagination—and the elements of design—to adapt this point of view to your subject.
* Enhance a realistic image with fanciful embellishments.
* Superimpose lines or patterns to create decorative texture or playful movement.
* Apply distortion, either humorous or grotesque.
* Create a mysterious ambience with unusual colors.
* Push colors and value contrasts to the extreme.
* Use your sense of humor to make your viewers smile.

6 ABSTRACTION:
Off the Beaten Path

Little Pieces of Land 23 ·
Cheryl McClure ·
Acrylic on canvas · 30" x 30"
(76cm x 76cm)

*A*n open-minded artist soon discovers that realism and abstraction have a great deal in common. Abstract and realistic art are simply two aspects of the same thing: using the elements and principles of design to shape an artwork. If you can do one, you can do the other. What's more, experimenting with abstraction helps you tap into whole new aspects of your creative spirit.

Realism represents a distinct image of what you see in the physical world, while abstraction refines and reorganizes a realistic image or a mental concept to reveal its essential nature without regard for obvious physical appearances. Pure design without any apparent reference to a subject is called nonobjective, nonfigurative or nonrepresentational art.

Whichever path you follow, learn to understand and appreciate all kinds of art. Look at and analyze art in galleries, museums, books and magazines to expand your potential for growth and change in your own work. If you're a realist, try abstraction. You'll like it. If you're a good abstract artist, master design and you'll be even better.

"Abstract art has come into being as a necessary expression of the feelings and thoughts of our age; it has added new dimensions to creative painting; it is part of the constant change and vital searching that energizes every true art."

Leonard Brooks,
Painting and Understanding Abstract Art

Sundial · Bonnie Lhotka · Lenticular 3-D animation · 40" x 30" (102cm x 76cm) · Printed on the Mutoh Falcon II inkjet printer

Landmarks of Abstraction

Since you're not restricted to a literal image when you make abstract art, the sky's the limit. Abstraction is more than a series of happy accidents, however. Remember: Your creativity flourishes when you set limits to keep things under control. Find out what keeps the wheels of abstraction turning. Abstract design is conducive to creative thinking. Both the real world and your inner world provide good starting points.

Extracting an essence is the primary objective of abstraction. *The American Heritage Dictionary* defines abstraction as "the act or process of separating the inherent qualities or properties of something from the actual physical object or concept to which they belong." This means eliminating the literal and emphasizing the intangible. In short, redesigning nature to reflect your personal response to it.

Formal relationships take a principal role in organizing an abstract design. Some abstracts depend almost entirely on the formal aspects of design. Without relying on the subject itself to suggest meaning, artists use design to express an idea. Later in this chapter we'll look at ways to use basic design factors in abstraction.

Consider the difference between the use of two-dimensional pictorial space in realistic and abstract work. In realism you employ a variety of artistic strategies to suggest three-dimensional form. In abstraction you affirm that nothing in the design is real, freeing yourself of any obligation to create an illusion of reality.

Where an Abstract Painting Begins

Every artwork, whether abstract or realistic, has to start somewhere. Where does one like this originate? From several possible beginnings: the selection of certain materials or a specific size, a particular color combination, or maybe a spontaneous brushstroke with flowing paint. The resolution depends on the artist's concept or idea, which may start the action or come into play as the artist and materials interact.

Rain From the West • Alexander Nepote • Watercolor • 30" x 40" (76cm x 102cm)

☞ *Activity* ☜
Spot Abstract Designs in Pictures

Seeing abstract design becomes easier with practice. Use a viewfinder to train your eye to find them. Move a 35mm slide mount or 1" x 1 ¼" (25mm x 31mm) mat over realistic images in a book or a magazine. Find small abstract designs and copy them in your sketchbook-journal. Note what you like about each one: values, colors, arrangement of shapes, patterns, line quality or directional emphasis.

Use any of your sketches as beginnings for some of the abstraction exercises in this chapter.

Bend Reality by Changing the Rules

Create abstractions by using design to alter a literal image. With every design change, the image moves further from the illusion of reality. The more altered the image, the more abstract the art. Eventually, it may become pure abstraction, revealing no apparent connection with the original subject. Intelligent use of design makes such a transformation work.

Abstract design allows you to:

1 Suppress the illusion of deep space.

Reverse values and color temperature: Place dark values and warm colors in the background, with light values and cool colors in front of them.

Change shapes: Enlarge distant shapes to bring them closer.

Eliminate clues to recession, such as gradation into space.

2 Establish a visually flat picture space.

Discard converging lines, or make them converge in the foreground instead of the background.

Use different eye levels in the same design, along with tilting planes.

3 Suggest ambiguous space.

Depict unnaturally floating objects with detached shadows.

Intermingle advancing and receding shapes.

4 Eliminate background and foreground.

Connect objects to the edges of the paper.

Show the support as a totally flat environment.

Hidden Meanings
Flow Throughout Abstraction

This powerful abstraction includes both realistic images and symbolic references unified by strong color and shape relationships. The design expresses movement, ambiguous space, and a sense of mystery.

Lomita Rosa · Veloy Vigil · Acrylic on canvas · 48" x 48" (122cm x 122cm)

Walking the Line

Most artists begin as realists. Many move back and forth successfully between realism and abstraction. It's all expression in art. Follow a new direction experimenting in abstraction and either one of two things is likely to happen: Your realistic design will begin to carry greater authority or you will become a confirmed abstract artist.

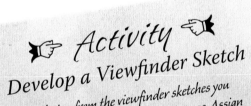

☞ Activity ☜
Develop a Viewfinder Sketch

Pick a design from the viewfinder sketches you found for the activity on the opposite page. Assign one or more descriptive words to it—something you would like to express using this design. Develop a color sketch or painting. Choose colors, lines, values and patterns supporting the idea or feeling you want to convey. Control the expression in the design by the elements you choose. Remember: One element must dominate.

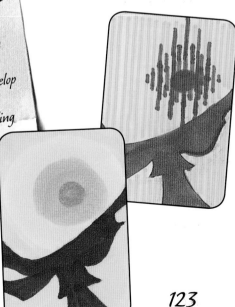

Three Steps to Abstract Art

There are three steps in making abstract art, just as in realistic art: exploration, development and execution. The biggest difference between the two modes of expression is in the exploratory phase. A realistic artist searches for ways to represent the visual appearance of a subject, while the abstract artist is looking for the means to overcome physical appearance and describe a hidden essence.

EXPLORATION

Abstract design begins with the selection of a subject, theme or motif. Anything can be abstracted. Why do you pick a certain subject or idea for your abstraction? For any reason—or no reason. Because it's there. Abstraction and nonobjective artwork run the gamut from deeply personal expression to formal analysis of design with many levels in-between.

Verbalizing helps to capture the essence, especially if you want to abstract a feeling or experience. List words describing the feeling or synonyms for it: For example, serenity is cool, drifting, quiet, peaceful. Invent metaphors: Serenity is the calm sea of life; anger is a festering wound.

Drawing may clarify the essence for you. Decide what particular quality intrigues you in the subject or theme. In your sketchbook make pencil marks with your eyes closed, drawing words and lines that describe the subject: horizontals, verticals, angles, curves, scratches, blobs. Draw lines and shapes symbolizing feelings. Concentrate on what you want to emphasize in your abstraction. Reduce your theme to a manageable expressive *concept*. Say one thing.

DEVELOPMENT

The developmental phase takes the adventure a step further as you discover new ways of saying things, translating the drawn or verbal image into the language of abstraction. Simplify. Stylize. Ask yourself questions:

Can I accent this, enlarge it, reduce it, distort it?

What materials will work best with my interpretation?

What techniques will enhance the concept?

Which should dominate: color or line? Value or shape? Size? Movement? Pattern? Repetition, gradation, conflict or harmony?

EXECUTION

Now you're ready to go. You've played with ideas and words, gaining insight into what you want to say and some ways to say it. Play with your materials, sketch different designs, be flexible and ready for change. Every time something changes, everything changes. Look for these changes and be ready to veer off in new directions.

Stage 1: Putting Something Down and Exploring

Ed Betts begins with a "largely unconscious improvisation...(as) a way of getting things going pictorially." This is like automatic drawing, only with a brush and paint.

Stage 2: Developing Through Suggestion

Working from his abstract design, Betts begins to develop a subject by painting shapes suggesting rocks and surf into the colorful, undefined masses.

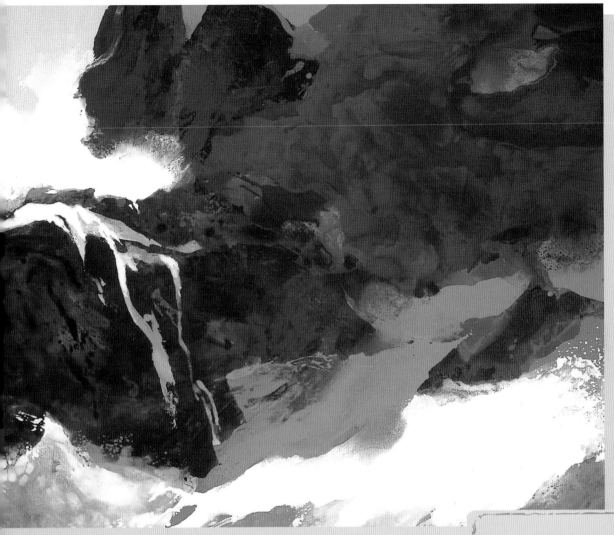

Stage 3: Executing an Original Take on Nature

Betts captures the essence of the sea crashing on rocks. "The end result," says the artist, "is a consciously controlled arrangement of colors, shapes and textures that refer to nature but do not imitate or copy it."

Northcoast · Edward Betts · Acrylic · 40" x 50" (102cm x 127cm) · Private collection · Photograph courtesy of Midtown Galleries, Inc., New York City

☞ *Activity* ☜
Get to the Heart of a Subject by Abstraction

You've made lists of realistic subjects in your sketchbook-journal. Add active, descriptive and emotional words to your lists: absurd, angry, apathetic, bold, beautiful, brittle and so on. Select at random an image word and a descriptive word as a point of departure for an inventive abstraction: absurd/garden, angry/forest or brittle/chair. Abstract the image to reflect this description and create a new essence for the subject. As you develop your composition, select design elements revealing this essence. Your end result will not be a literal image of a garden, for example, but an intriguing abstraction.

Communicate Without Stating the Obvious

Recite this mantra when you're just starting out in abstraction: "Abstraction isn't difficult; it's just different." Do you like birds? Their songs? Their coloration? Their mannerisms? Their freedom to soar above the earth? The power of large birds in flight? Tell about it without making an image of a bird. That's abstraction.

Directions in Abstraction

Abstraction is a two-way street. Start with a realistic image and abstract it. Or create an abstract design and configure nature to fit, making an unusual landscape, floral, portrait or still life.

FROM REALISM TO ABSTRACTION

Working from a realistic image toward abstraction is a reduction process. Reduce the subject to simple shapes and lines. Eliminate superfluous detail, accenting only the essentials. Stylize

the image to emphasize qualities you want to express. Symbolic lines and colors refer to the subject without representing its actual appearance: vertical greens for trees, horizontal blues for the sea.

A realistic subject can also be reduced to symbolic geometric shapes: circles and triangles for trees, squares and rectangles for buildings. Combine many small shapes to make a few large ones. Or, as Ed Whitney suggested, design interesting shapes and make nature fit the shapes. Arrange these shapes in an interesting composition suggesting a landscape or a group of figures.

Often one abstraction leads to another and a series is born. Stay with

a series until you find out where it's going. The process of abstraction is like the metamorphosis of caterpillar to butterfly, when changes lead to a result bearing little resemblance to the original subject.

FROM ABSTRACTION TO REALISM

When you begin your artwork with an abstract design or pattern and develop it into a more representational image, you're invoking an additive process. There is no subject to begin with and the sky's the limit. This gives new meaning to "play" in creative art. Start anywhere and see what happens as you manipulate your materials. Flow paint and make spontaneous marks until a realistic image begins to take

Hints of Calico

This cubist-style print contains the image of a calico cat. Karaffa bypassed realistic interpretation and represented the multi-colored patterns of a cat's fur in a black-and-white abstract design.

Cat Slumber · Emily Karaffa · Intaglio print · 9¾" x 7" (25cm x 18cm)

realistic

stylized

abstract

☞ Activity ☜
Design a Tree Abstraction

In your sketchbook-journal create abstractions of trees, placing emphasis on a different element in each sketch. For example:

* Emphasize the lacy, linear quality of the branches.
* Develop large, cylindrical shapes—the essence of tree trunks.
* Use expressive color or imaginary patterns of leaves.
* Experiment with different directional movements: vertical, horizontal, diagonal.
* Make your abstraction threatening, inviting or playful.

Remember, you're not making a representation of a tree. You're causing an abstract design to evolve, beginning with the natural aspects of a tree. Any subject can be abstracted this way.

The Path to Abstraction

Realistic, stylized or abstract—move from one style to another, exploring creative possibilities. Did you know that Piet Mondrian painted realistic apple trees early in his career? They evolved into stylized trees and finally into his well-known geometric abstractions.

shape. Your unconscious, packed with your experiences and ideas, directs the apparently accidental effects on your artwork until you finally see something there. Practice using your visualization skills and imagination with these spontaneous beginnings.

Set some limits. Since you're not restricted to a realistic subject, select an unusual size or format and work out a creative color scheme. Start with big, abstract shapes or gestural marks, arranging them on the support with an eye on the overall division of space. Pause occasionally to look for any suggestion of a subject: a spattered area that looks like weeds, a red splotch that suggests a flower, a hidden face or figure. As the abstraction develops, focus on what is happening in the composition. The original abstract design is just a starting point. When an image suggests itself, move in that direction. Be subtle; suggest rather than insist. Let your viewer discover the image.

Use this spontaneous method sometimes as a warmup to get your creativity flowing. Rotate your paper or canvas occasionally and study it from different directions to see what's happening. Continue adding marks or shapes to change relationships and keep things moving. Put aside the unfinished abstraction for another day if no images reveal themselves.

Stage 1: Choose an Ambiguous Design

From a page of abstract design sketches done from images isolated with my viewfinder, I selected one shape, then chose a limited palette of Cobalt Blue and Cadmium Scarlet. The design suggested an eagle in flight to me. I dampened illustration board within the general area of the predetermined shape and mingled the two colors there.

Stage 2: Develop It

After the initial wash dried, I drew the eagle on the abstract shape. I painted darker values and lifted out lighter values to develop the image. The lightest values are the white of the paper. There's a touch of Aureolin in the eye. I avoid using staining pigments when I intend to lift colors in watercolor.

Splendid Spirit · Nita Leland · Watercolor on illustration board · 20" x 30" (51cm x 76cm) · Collection of Carl G. Leland

☞ Activity ☜
Fracture an Image for an Abstract Feel

Many artists find grids useful to break a subject into a fractured abstraction. Start with a grid, or sketch the subject first and draw your grid on top. Make three or four intersecting lines both vertically and horizontally. Using very pale washes of thinned watercolors or acrylics, tint each section of the grid a pale transparent wash from a limited palette of three or four colors. As you paint your subject, work into sections with overlapping transparent washes, bringing the subject out of the background grid with an abstract fractured appearance to it.

I started this painting in a Judi Betts workshop and found the effect intriguing. I like the vibrations of the shapes and colors against each other, and the arbitrary lines striking through the subject in unexpected places. It's a challenge to break up an image this way and try to maintain unity.

Georgia on My Mind · Nita Leland · Watercolor · 9" x 6" (23cm x 15cm)

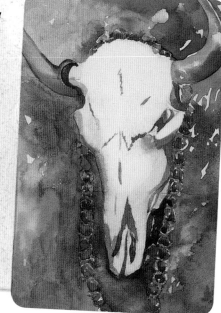

Abstracting Your Feelings

Artists are able to express strong feelings with abstraction. Many abstract works have figurative subject matter or recognizable graphic symbols. Some express intangible emotion through gesture, color and other elements of design. Both positive and negative energy can be released and expressed this way.

Study art in magazines and books—better yet, in museums and galleries—to see how they do it. Artists express joy with warm, bright colors and expansive compositions and praise beauty with expressive color schemes, and elegant lines and shapes. They show the flip side of the coin with bold, angry brushstrokes, violent color or aggressive lines to represent tremendous energy and explosive emotion. This energy filters through the artist's knowledge of art principles to emerge as a powerful statement of feeling.

Not all creative art is beautiful and pleasing to look at. Imagine abstracting your feelings from a headline in the newspaper about a tragic disaster or a monstrous act of terrorism. Expressionist paintings probing the depths of the human psyche are filled with anxiety and pain.

You have the option of choosing the feelings you wish to express in your artwork. Keep in mind that the broad spectrum of emotion is your creative playing field. Make pleasing artwork when you want to, and don't be afraid to express sorrow or even depression if that's how you feel. The activity on this page can help you get started in either direction.

Extremes Communicate Extreme Emotion

The intensity of this painting is gripping, even before you read the title. Extreme contrasts of color and value strike hard at the emotions, unlike gradual changes. The artist expresses raw emotion without a clear image to attach it to.

Rage · Marie Dolmas Lekorenos · Inks on hot-press watercolor paper · 22" x 30" (56cm x 76cm) · Private collection

DESPAIR
hopeless
colorless
shapeless
directionless
empty

DELIGHT
bright
curving
colorful
dancing
warm

☞ *Activity* ☜
Paint Emotion

Try abstract expression. Make a design without any reference to a real object. Think of a strong emotion: love, hate, rage, fear or ecstasy. Write down words describing the feeling you wish to express. Decide what will dominate your composition: agitated line, intense color, jagged shapes. How would you use repetition? Rhythm? Gradation? Design an abstraction based on the emotion. For example, fury: red-orange, blue-purple, zig-zag, helter-skelter, slash-bash, vertical-diagonal, out-of-control. Work out a suitable color scheme in a small sketch, then plan your shapes and format. When you're ready to paint, don't hold back.

Design for Design's Sake

Some abstract art has no apparent reference to objects in the real world or to emotional expression. Such nonfigurative art comes in several forms. *Optical* art uses color and value to create illusions of light and movement. *Color-field* art relies on color relationships for visual effects of floating or vibrating color. Geometric design emphasizes shape. *Nonobjective* art is primarily rational and analytical, but artists rarely make art completely without emotion, so distinctions may not be clear.

The subject of nonobjective art is design. Use color for its own sake, line or pattern as your theme. Create ambiguous space by defying the laws of perspective. Design optical illusions to suggest radiant illumination or the effect of moving shapes. A nonobjective composition may contain a combination of design elements, but its impact is derived from the dominance of one of them. That element is the subject.

Hidden Meaning?

Contrast of complementary colors is visually exciting. Shapes and textures enhance this piece without concern for hidden meanings. This doesn't mean such meanings aren't there—only that a viewer's response to the artwork doesn't necessarily depend on them to appreciate it fully.

Fulani • Virginia Lee Williams • Sand, modeling paste, gel medium, acrylic paint • 18" x 14" (46cm x 36cm)

☞ *Activity* ☜
Play With "Subject-Free" Design

Grab some markers and paper that can handle the color without bleeding. Then:

✳ Design a picture based on a simple ½-inch (12mm) grid drawn on a 6-inch (15cm) square. Use color and value contrast to move the viewer's eye around the square. For my picture, I started at the bottom and gradually changed colors and values from one section to the next. At the apex of dark value, I changed abruptly to the lightest value and began to reverse the gradation.

✳ Make a nonobjective design of overlapping circles, triangles and rectangles in flat, pure hues. Repeat shapes with variations in size and color, using contrast in hue, value and temperature to energize the design. Unify the composition through color or shape dominance. Embellish with line or texture if you like.

Planning Your Abstraction

You can't exhaust the material for creative abstraction. Abstract art uses many combinations of design elements. Planning keeps you from getting confused and allows you to make unique and personal abstract compositions.

Making abstract art involves more than throwing paint or having an artistic tantrum on paper. Expressive art needs some control. The power of a work of art comes from your ability to shape the raw energy of your original concept into a pictorial form accessible to your viewer.

The elements and principles of design are essential to the organization of a good abstract composition, just as they are for realistic work from painting to scrapbooking. Design helps you get started and keeps the process from getting out of hand. Design points you in the right direction, but you may change direction when it suits your purpose. You make, break and modify the rules of the road as you go along.

Start with your plan, then improvise, elaborate, exaggerate. Design your abstract works in a series, changing your emphasis each time. The more you do, the easier it gets.

Begin your adventure in abstraction with simple media you feel comfortable with: pencil, charcoal, pen and ink, colored pencil, marker or crayon. Use bond paper or newsprint, and lots of it. Play, plan and paint—not necessarily in the same order every time.

APPLYING THE ELEMENTS OF DESIGN TO ABSTRACT ART

On the following pages we'll explore some of the basic elements of design as they apply to abstraction, compared with their use in realistic artwork. First, review the discussion of elements and principles of design in chapter four. There isn't really such a big difference between working with design in abstraction and realism, but it sometimes seems more difficult to design without a subject.

The Moment of Creation Expressed in Paint

In the first of her "Creation Series," Skinner's plan was to attempt to portray her idea of "what the act of creation might have looked like the nanosecond before materiality. What the mind of the Creator foresaw." You can start with any such idea, but each decision brings you closer to the moment when your creative muse kicks in as you begin to paint. You never know what will happen next.

In That Instant · Delda Skinner · Liquid acrylic on Sekishu paper · 39" x 28" (99cm x 71cm)

Set Boundaries, Then Create Freely

Define your artistic challenge and set boundaries for your creativity. Then push the boundaries to the limit. Decide your theme, the size of your artwork, the medium. Determine the design emphasis—line, shape, color or value. Give yourself a time limit— one hour for this composition or ten variations in three hours. Now go to it. Within the framework of the boundaries you've set, you're free to paint, draw or quilt your creative abstract design. Without such boundaries to focus your creativity, you may falter in the plethora of media, techniques and subjects available to every artist.

Line

Abstract expressionist Hans Hofmann described line as "the direct flow of the personality into the work." Line is flexible, adaptable, changeable, a "plastic weapon with which to invent new forms." Hofmann felt line to be "one of the twentieth century's greatest formal inventions." Of course, line has had a principal role in defining shapes since the beginning of art, but only recently has line been used as the primary subject. The gestural line is emotional; the controlled line is rational. Pay attention to the quality of your line: lyrical or dancing, aggressive or gentle. In realistic and abstract art these same qualities of line convey the emotional content of your artwork.

Line-by-Line Design

Perry's fluid line follows the organic shapes in her composition. Her line doesn't describe a concrete object, though her title suggests an image. Nor is her line mere decoration. The line is the design.

Mask • Nancy Perry • Watercolor, acrylic and ink on watercolor board • 10½" x 14" (27cm x 36cm)

☞ *Activity* ☜
Develop Abstract Art From Scribbles

Use free, gestural lines to begin an abstraction. Scribble in your sketchbook or on ordinary bond paper. Move your pen, pencil or charcoal slowly around the page, staying in contact with the paper at all times. Increase your pressure and speed. Don't think about a subject. Keep the implement moving. Let your unconscious mind make the drawing.

Do two or three scribble drawings. Then select a section of one to develop into an abstraction. Erase, blend or darken areas to create value gradation and textural changes, enhancing the quality of line peculiar to the drawing.

Shape

Abstract Design Basics

You have more latitude in the arrangement of shapes in an abstraction than in an image representing reality. To maintain the integrity of the image in a realistic picture, you typically make few adjustments to the shapes of the subject, particularly if you're doing a portrait or landscape commission. In an abstract design, you may take liberties with image shapes, distorting, exaggerating, sometimes losing them entirely. Simplify and arrange shapes creatively to make a visually exciting abstract design.

Shapes are major design factors in nonobjective art as well, using either angular geometric configurations or ambiguous curving shapes. Organization within the picture space continues to be key, but you have a lot of options. Rearrange the same elements many different ways to make exciting, varied designs. Similar shapes will work together, as will related lines and colors.

Bottle-Based Abstraction

Using a single bottle as my model, I painted this still-life exercise with a limited palette of three primary colors: Quinacridone Magenta, Winsor Lemon and Winsor Blue (Green Shade). Inventing bottle shapes and letting the colors mix themselves, I created a unified, vibrant abstract composition based on repetition of shapes with variation, a cardinal principle of design.

Lost and Found · Nita Leland · Watercolor · 15" x 20" (38cm x 51cm)

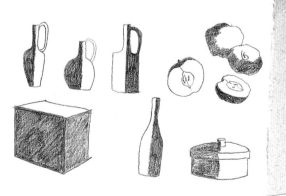

☞ Activity ☜
Transform Traditional Still-Life Objects

Create an abstract design using the objects of a traditional still life. Begin with line drawings of the objects from various viewpoints. You might draw a pitcher, a cup and saucer, a glass, a plate, some fruit and vegetables, for example. Distort the forms if you like. Add dark values to create distinct shapes within the forms, using different light sources.

Cut the drawings into pieces, separating them according to values. Then arrange them in an integrated abstract composition. Assemble the pieces in fractured planes of light and dark, using only pieces that aid the design. Unify the design with line, enhanced values, pattern or texture. Try several arrangements before adhering the pieces to illustration board or cardboard with acrylic medium or white glue.

Angular Inspiration

Bradshaw aligns parallel L-shapes of different colors and widths, securing them within the narrow picture space with solid blue geometric shapes at three corners. Contrasting linear calligraphy contributes texture and movement to his nonobjective composition.

Tracks and Traces · Glenn R. Bradshaw · Casein on rice paper · 37" x 73" (94cm x 185cm) · Corporate collection

BASIC DESIGN

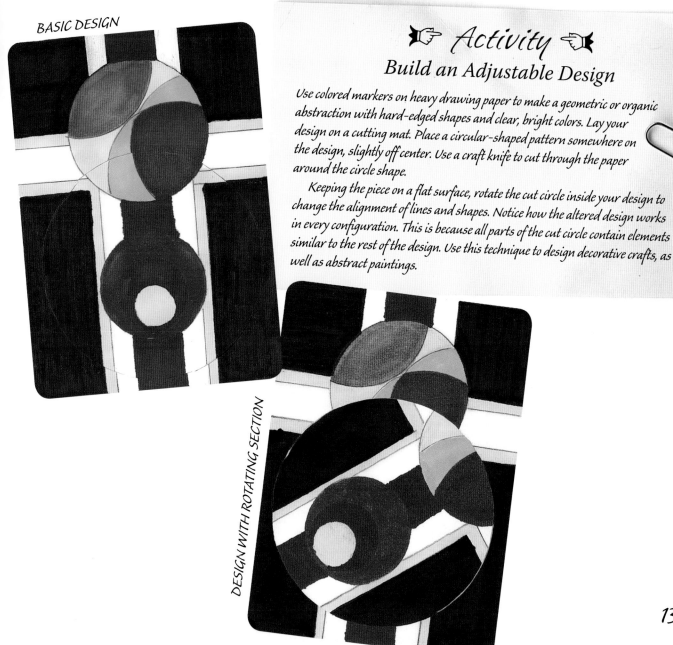

DESIGN WITH ROTATING SECTION

☞ Activity ☜
Build an Adjustable Design

Use colored markers on heavy drawing paper to make a geometric or organic abstraction with hard-edged shapes and clear, bright colors. Lay your design on a cutting mat. Place a circular-shaped pattern somewhere on the design, slightly off center. Use a craft knife to cut through the paper around the circle shape.

Keeping the piece on a flat surface, rotate the cut circle inside your design to change the alignment of lines and shapes. Notice how the altered design works in every configuration. This is because all parts of the cut circle contain elements similar to the rest of the design. Use this technique to design decorative crafts, as well as abstract paintings.

Value

Value defines shapes, making it a key element in abstract design. Patterns of light and dark values help to create movement and direct the viewer's eye throughout a composition. Value contrasts are generally more subtle in realistic art. As contrasts become extreme, the art is considered more abstract. Use high-key and low-key values, too, for expression in your abstract design: high-key values for a light, serene feeling; low-key for a somber mood.

☞ Activity ☜
Make a Gestural Statement

Dramatic value contrast—for example, a high-intensity gestural brushstroke on white paper—creates visual shock. Combine gesture with value and color contrast. Draw on large paper, newsprint or old newspapers. Use old brushes and colored ink or black, red, blue or purple fluid paint. Paint with a two- or three-inch (51mm or 75mm) varnish brush, swinging your arm in a large gesture, sweeping the brush beyond the edges of the paper. Set limits, such as five brushstrokes in three minutes, to add energy to your movements.

Gesture Painting

Gesture along with vibrant color creates stark contrast against a white background. This is pure nonobjective abstraction.

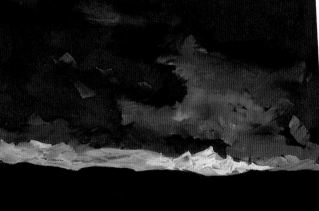

Unwavering Contrast Denotes Drama

Jarring contrast without modulation makes a dramatic statement. There is no other way to express the devastation of a forest fire. The abstract becomes very real in this striking image.

Careless Smoking: Southern California 2003
• Christopher Dodds • Oil on canvas • 30" x 30" (76cm x 76cm)

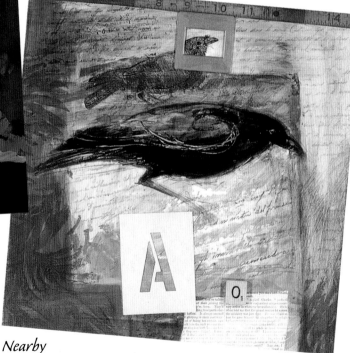

Nearby
Gradation Softens Contrast

Gradation of middle values surrounding the realistic image softens the stark contrast of the bird against its background. The focal point is clear, but the image isn't as sharply set off from the background as in Dodds' painting.

Crow Message • Sharon Stolzenberger • Acrylic, collage and image transfer on cradled Claybord • 12" x 12" (30cm x 30cm)

Color

When you abstract a real-istic subject, use creative color instead of local color (the real color of the objects). You have a color personality that affects the way you use color in your art. Learn which colors are right for you by exploring pigments and experimenting with mixtures. Be as whimsical or dramatic with color as you choose. Set your own boundaries. Limit the number of pigments, pick a distinctive color scheme, or choose an unusual con-trast effect.

When you contrast pure hues in an abstract design—yellow against purple, red next to turquoise—the shock of the color vibration energizes the work. But you have other options. Occasionally, contrast your pure hues with neutral gray or with a color modified toward gray. The pure hues seem more vivid when there are grays to provide visual relief.

Create ambiguous spatial relation-ships by reversing the traditional order of receding cool colors and advancing warm colors.

Use the logic of color schemes to get the most from your color effects. For harmony choose from color schemes having similar col-ors. Incorporate vivid contrasts for dramatic impact. Complementary colors—opposites on the color wheel—provide color excitement in any design, whether realistic or abstract. When you place comple-ments side by side, they set up a vibration that makes the colors sing.

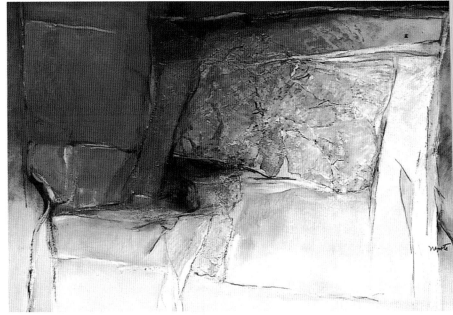

Warm Color Pushes Forward

Red aggressively pushes itself into the foreground. Imagine this abstract com-position with a cool blue or green in that spot. What would happen to the dramatic color effect in the painting?

Rock Mosaic · Alexander Nepote · Layered mixed media · 30" x 40" (76cm x 102cm)

Activity — Reverse the Rules of Realism

Make an abstraction of landscape forms, chang-ing the traditional temperature, intensity and value arrangements to flatten the picture space and create color vibration, which in turn creates visual excitement. Reverse the typical arrange-ment of warm colors in the foreground and cool colors in the background, and exagger-ate temperature and intensity differences.

REALITY

cool colors far warm colors near

REALITY REVERSED

135

Tension and Energy

Just like realistic artwork, an abstraction can express the extremes of serenity or passion. Create tension and energy in your abstract design by manipulating the elements of design. Begin with lines, then shapes and colors. Use contrasts and variations of these elements to produce visual excitement on the surface. Introduce repetition and gradation to suggest movement. Play with different rhythms.

Vary line quality to create movement, suggesting energy, action and speed. Reinforce the sense of movement in colors and shapes through gradation, repetition and rhythm. Dominance of an element or principle of design keeps the design cohesive.

An Explosion of Color

Colors seem to explode from a point low in the picture, beginning with narrow collage pieces and expanding to larger shapes. Other shapes float as though displaced by the shock of growth or change. The large solid areas above keep the design grounded.

African Rain Forest #2 ·
Willis Bing Davis · Collage · 40" x 30" (102cm x 76cm) · Collection of Paul Nelson

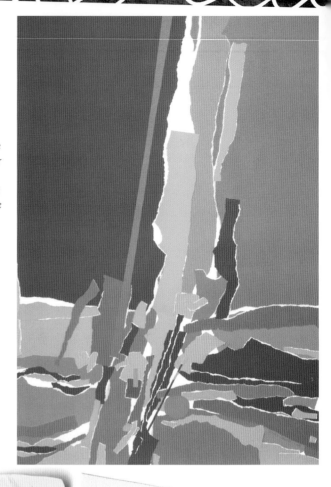

🖝 Activity 🖝
Introduce Tension Into a Rigid Design

In a workshop, artist Mario Cooper used a checkerboard as an example of "push and pull." See for yourself how it works. With a black marker, make an 8" x 8" (20cm x 20cm) checkerboard grid with sixty-four alternating black and white squares. Boring! Make another square with wavy lines. Much better. Now make a rectangle instead of a square. Make the lines straight, wavy or a combination of both. Fill in alternating shapes to see how the checkerboard design changes. Areas with small shapes seem more active, while larger areas are visually quiet.

🖝 Activity 🖝
Express Energy With Line

Make abstract sketches using energy lines. Emphasize a particular type of movement or direction—static, flowing or rhythmic. Create variations on one composition or make many unique designs. Select one to enlarge and render in color. Enhance the energy in the design with gradations of color and value, changing hues from warm to cool, pure to dull, light to dark. Change line direction and color abruptly for tension.

Line Change
Notice how quickly diagonal lines impart energy to a boring design.

STATIC

DYNAMIC

Pattern and Texture

The patterns of nature adapt beautifully to abstract design: Use the patterns in microscopic views of organisms, cross-sections of fruits and vegetables, rocks, shells and sponges. Learn about natural fractal patterns and incorporate these into dazzling abstract designs. (The Internet is a great resource for information on fractals.) The manmade environment and mechanical objects you drew in earlier exercises afford additional opportunities for abstraction: brick or stone walls, stacked objects, machinery, tools and gears. These are excellent starting points for abstract art.

☞ Activity ☜

Create Collage Abstractions

Create a collage abstraction in your sketchbook using papers cut and torn from magazines. Start with large, simple shapes in colors you like. Repeat the shapes in different sizes and colors. Move them around, keeping in mind the elements and principles of design. When you have a design that works, adhere the pieces with a glue stick, white glue or acrylic medium. Enhance with patterns and texture, using more collage papers or paint. Create lots of abstract collage designs and use them as starting points for your artwork.

Countless Compositions

See what Barnes has done with a checkerboard. One of a series based on aspects of the game of chess and the game of life, this painting is structured with a limited palette of patterns: sixty-four squares, each different yet containing similar elements or connecting in some way with adjacent squares. Every square is a composition in itself, as are various groupings of the squares.

64 Squares · Curtis Barnes · Oil on canvas · 32" x 32" (81cm x 81cm)

My Collage

My favorite sources for abstract magazine collages are fashion magazines. They're filled with colors and textures, organic and geometric shapes, and patterns of every kind imaginable.

7 EXPERIMENTATION:
Exploring New Territory

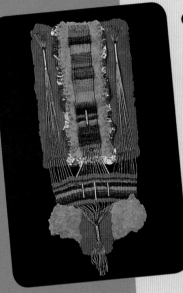

Aztec Autumn · Esther R. Grimm · Handmade, hand-dyed cast cotton with hand weaving and copper · 32" x 18" x ¾" (81cm x 46cm x 19mm) · Collection of Dr. and Mrs. Robert J. Stern

*M*ake your creative journey interesting and exciting—venture into the unknown. Don't wrack your brain trying to think of something no one has ever heard of. Just do something **you** haven't done before. Sometimes the simplest thing is the most creative. Paint with a gigantic brush, draw with your non-dominant hand or use both hands simultaneously. Make a miniature collage, paint a watercolor postcard or quilt a small decorative square. Experimentation is simply getting into the creative mode by an unaccustomed route.

A couple of new colors, a few scribbles or marks with a different tool or medium, an unusual fiber or fabric—start with these. Each touch of the brush or pencil, every added color or texture in your craft changes relationships or brings up another idea. Action calls for response. Ask yourself, "Where does this want to go?" It doesn't matter if the outcome isn't a finished piece. "Art is an experience, not an object," said Robert Motherwell. Experimenting in arts and crafts develops your creative spirit, making you ask questions and search for solutions.

In this chapter are many techniques to try with various media. No medium or method is better than another; they're only different. Each has advantages for the creative artist. You probably have your own favorites. Mixed media offer the challenge of change. Consider all the possibilities. The important thing is to begin. This is an adventure—open your mind and heart to your creative spirit and make things happen.

> *Creation is dominated by three absolutely different factors : first, nature, which works upon us by its laws ; second, the artist, who creates a spiritual contact with nature and his materials ; third, the medium of expression through which the artist translates his inner world."*
>
> Hans Hofmann,
> **Search for the Real**

Egyptian Passage · Richard Newman · Mixed-media collage · 30" x 22" (76cm x 56cm)

Be Ready for Adventure

Experimentation is a vital component of the creative process. No doubt there are many things you haven't attempted yet. You don't need to accomplish something that has never been done in the history of art. There isn't much that's really new.

Play with something different, even though it feels awkward at first. Technical virtuosity alone doesn't make an expressive painting. Slick art impresses people, but it doesn't necessarily move them. Most people prefer sincerity to glibness. When you have something to say and are sincere or having fun saying it, this shows in your work. So get out there and play.

Give each new medium, tool or technique you try a chance. Don't be intimidated by materials. Work quickly, spontaneously and confidently. Your unconscious mind will do some of the work for you. The key words are "relaxed control." Do many small samples of an experiment. Keep them for references.

You'll have an affinity for some media and others may leave you cold. You'll find your preferences as you work—and you may even be surprised. Experience and practice give you the confidence to invent and innovate.

Use materials you enjoy working with, but don't settle on one too soon. Once you begin to experiment, keep moving. Change a technique, a tool, a surface—not all at once, but often enough to hold your interest. Make a trial run with new materials before starting a project. Turn off your judgmental, critical left brain as you work and let your right brain take over. Encourage yourself to work without stopping to think. Set a time limit: ten minutes for a watercolor, three drawings in fifteen minutes. Don't keep telling yourself what to do—simply *do*. Save evaluation for later, so you don't interrupt your creative flow. Enjoy the process. Allow mistakes when you're trying something new, and above all, have fun.

Stick With a Piece to See What You Can Learn From It

After a disastrous start pouring inks on Morilla board, I discovered I could peel the damp paper off in layers, revealing a white, rough texture underneath. Spots and stains had soaked through from the top layer. These revelations prompted me to keep developing the painting with paint and collage.

Tidal Surge · Nita Leland · Inks and collage · 18" x 24" (46cm x 61cm) · Collection of Charles and Victoria Bricker

Take Notes as You Go

As you try new things, take notes in your sketchbook for future use. When you create a fantastic effect with a unique combination of materials, your notes will help you remember how you did it so you can use the technique again in another piece.

Direct Your Impulses

A lot of workshops emphasize flashy techniques without addressing structure and organization. Hoping to become more spontaneous and free, students flow paint with abandon and pray something will happen. After all, the demo looked so easy. Remember, the instructor has done this technique many times. Experience makes a huge difference, even with spontaneous art.

It's fun to spatter or flow paint as an underpainting and develop a concept from the results. Searching for image and composition in the relationships on the page boosts your visualizing skills. In experimental art you need freedom to explore, but you still should have a general idea of what your objective is in any art or craft.

Choose a format, develop a basic design plan, determine a focal point, plan color, decide on medium and technique. These limitations circumscribe your creative quest. Within these parameters your creative spirit will soar. Maintain flexibility; adapt to the unexpected; force change as you experiment. Move back and forth freely between plan and impulse.

Every beginning has possibilities. Some people determine the concept early on; for others it takes shape as the work progresses. Through the process of elimination, correction and realignment, you shape the artwork to fit your concept. Without a concept and your control over the design, the piece is just an accident, happy or otherwise. Don't stop at the happy accident when you're making art. Direct your creativity. Resolve the composition. Take control.

Delayed Reaction

It took me ten hours to get to Louisiana to teach a workshop. I was exhausted, but too wound up for sleep. So I got out my watercolors and gave myself fifteen minutes to play. No thinking, just throwing paint. Three years later I revisited the piece and saw a dream-catcher image. Just a few brushstrokes suggested the feathers, and it was done.

Dream Catcher · Nita Leland · Watercolor · 24" x 18" (61cm x 46cm)

☞ Activity ☜
Paint Spontaneous Starts

Choose a limited number of preferably bright-colored paints that you can thin to a fluid consistency: watercolor, acrylic, craft or poster paint. Use heavyweight sketching paper or watercolor paper, and your biggest flat or round brush. Mix puddles of color, then drip, pour and splash paint on the paper, moving your arm freely from your shoulder. (This works better if you stand, rather than sit.) Work wet on dry, wet in wet, or both. Tilt your paper to move the paint around. Paint for a limited time and stop before the colors begin to mix too much and get muddy.

Let the piece dry, then study it from different angles to see if you notice an image or an abstract design you can develop. If not, put it aside and let it grow on you until you get an idea of how to finish it. Lay mats of different sizes on the picture to find several smaller compositions within the piece. Do lots of these spontaneous beginnings. Sort through them occasionally and pick one to develop into a finished picture.

A Good Start

I had no subject in mind, but I did think about placement on the page, using a cruciform-like shape with different-sized areas of negative space at the corners.

Trailblazing

Sometimes when you think you're a pioneer in the wilderness, you discover someone has already been there. That's all right. What you do will be different.

Learn the limitations and advantages of media. Each has unique qualities. Find out what they are. You use a particular medium or tool because it feels right to you, but have you explored its creative possibilities? Switch to an unfamiliar medium to challenge yourself or satisfy your curiosity.

Combine media to realize greater potential from each one. Do some detective work. Which media are compatible? Are they readily available to you? How do other artists use them? What you learn is a point of departure for your experimentation. There is no substitute for your own experience with a medium. Play with tools. Explore pigments. Learn by doing.

If you suddenly feel like sewing buttons onto canvas or cutting up your watercolors and weaving them, do it. When you're thinking creatively, you come up with unusual ideas. Give new ideas a chance.

Creativity Doesn't Require Complexity

A simple subject in a medium new to me provided a creative challenge. I was forced to reject detail and illusion and concentrate on design.

Moonshadows · Nita Leland · Serigraph · 12" x 9" (30cm x 23cm)

Play Leads to Discovery

Occasionally you make an unexpected discovery while you're playing. The idea of painting a splashy rainbow with yellow and yellow-green on the ends, instead of red and violet, intrigued me. I rotated the piece and my landscape painter's eye saw a mountain and colorful woodland under a blazing sunset. A few brushstrokes made it so.

Spectral Fusion · Nita Leland · Watercolor · 12½" x 5" (32cm x 13cm)

Surface Treatment

Somehow you have to get that first mark on blank paper, wood panel or canvas. Begin by preparing your support, a creative experience in itself.

The support you work on must be compatible with your medium. Some possibilities are:

drawing paper • canvas and canvas board • fabric • illustration board • metal boxes or trays • pastel paper • printmaking paper • rice or mulberry paper • untempered Masonite • watercolor paper, board or canvas • wood panel • wooden boxes, toys and furniture

A prepared sheet is more inviting than a blank one. Using materials you already have, prepare surfaces for painting or drawing and set them aside until you're ready to use them.

☞ *Activity* ☜
Prep Supports for Later

Here are some ways to prepare paper, board or canvas for later use. Make several supports and start your next project with one of them. Invent other prepared supports to make ready for painting days.

❋ Make rubbings on paper or unstretched canvas from textured surfaces: string, leaves, weeds, coins, fabric or screen. Scribble random marks and graffiti in light pencil. Or use white crayon or paraffin to make invisible marks that resist watermedia. Scratch, crumple, fold, bend, scribble, tear or patch the surface of the supports.

❋ Glue layers of rice paper, wrapping tissue, torn drawings or watercolors onto paper, illustration board or canvas using white glue, acrylic matte medium or soft gel.

❋ Squeeze, drip, spatter or paint gesso with a brush or brayer on heavy paper, board or canvas. Establish a dominant line, direction or pattern. Sprinkle sand in it. Drag a comb through it.

❋ Stain paper or canvas with thin washes of light-fast inks, acrylic or watercolor. Use this as a toned support, as the beginning of a color design, or for collage papers.

RICE PAPER OVERLAYS

RUBBINGS

DRIPPED GESSO

Yupo

This synthetic support has a surface slipperier than even the smoothest hot-press watercolor paper. Paint slips, slides, lifts and blossoms, creating fascinating accidental effects. It takes patience and persistence to work with, but some spectacular results are possible.

Mystic Sea • Maureen E. Kerstein • Watercolor on Yupo • 40" x 26" (102cm x 66cm)

Exploring Media and Techniques

The lines between painting, drawing, printmaking and crafts are blurred in experimental work. Some projects incorporate more than one technique in the same piece. A lot of latitude is permitted in the combinations of media, as long as the materials you use won't make the work self-destruct. You can find plenty of information covering compatibility and safe use of art materials at your local library, arts-and-crafts store, bookstore or online, so when in doubt, look it up.

SO MANY OPTIONS…

The variety of art materials is awe-inspiring—and so is the cost. Don't change too many things at once or you'll be in a constant state of sticker shock. Start with materials you have or can easily acquire and see how far you can go with them. Trade a few supplies with artist friends; dust off those items you bought for a workshop and never used. Or buy just three new tubes of paint, six pastel sticks, three sheets of paper you haven't tried.

Here are some media and techniques to try for arts or crafts activities in this chapter and beyond:

acrylics • alkyds • casein • charcoal • collage • Conté crayon • crayons • digital printing • egg tempera • fabrics • fibers • finger paints • inks (lightfast) • gouache • graphite • markers • monotype • oil paint • oil pastels • papermaking • pencils • chalk pastels • printing • rubber stamps • transfer • stencils • watercolor

Activity
Finger Painting

Finger painting isn't just for kids. It's a great way to loosen up and play with paint and color. Buy finger paint in an art or school supply store or search for a recipe online to make your own. Put a couple of blobs of paint on a smooth support. Finger-painting paper is specially treated, but you can also use smooth cardboard, newsprint, illustration board or hot-press watercolor paper. Spread the paint with your hands, a palette knife, a spatula or credit card. Make marks with your fingers, your palm, a comb or a sponge. Draw in the paint with a brush handle, a butter knife or a cotton swab. Drop a sheet of paper on top of your finger painting and rub the back, then pull it off and you'll have a print. Save these masterpieces in your collage box. Some may even be good enough for framing.

On the following pages we'll explore several of these options in detail. Add your own creative ideas. Brainstorm new combinations of media. Keep your sketchbook up to date, describing media and techniques as you try them and listing ideas to try sometime. Make lots of sample sheets with the new techniques. Label them and describe the method you used. Then incorporate them in your artwork.

Medium Choice Affects Design Emphasis

When you change your medium or the way you handle materials, your design emphasis alters as well. When you put down your pencil or craft tool and pick up a brush, movement and color come to the fore. When you experiment with collage, shapes and pattern dominate. Every medium or tool makes a unique mark, which becomes evident in the hands of different artists. As you experiment, refer often to design fundamentals.

Drawing Media

In chapter three we used mostly traditional drawing media like graphite and charcoal. If drawing is your first love, go beyond line and tone. Contemporary artists use expressive gesture and color in drawings. Use the underappreciated wax crayon or try watercolor crayons. Watercolor crayons are one of the best-kept secrets in art media. They come in sticks instead of pencils and make a broader mark. Unlike regular wax crayons, these can be moistened to create a watercolor wash.

Make a drawing with brush and watercolors, oils or acrylics. Resist and transfer drawing are intriguing variations of drawing techniques. Mixing media is creative and fun, so give it a try.

Drawing Over a Transfer

Shunk soaks a picture from an old magazine or newspaper in lacquer thinner, places it on his paper, and rubs the back with a spoon or burnishing tool to transfer the image. Experiment to find the right combination of materials. Some inks and solvents don't work as well as others. (If you use solvents, properly ventilate your workplace.) Once you've completed the transfer, develop a balanced composition by incorporating other drawing techniques and media.

Cézanne's Apples · Hal Shunk · Transfer drawing with pastel · 30" x 22" (76cm x 56cm)

☞ *Activity* ☜
Play With Wet and Dry Media

Draw with watercolor pencils or water-soluble crayons on damp heavy paper or illustration board to produce blurred lines and tints. Add watercolor washes. Or combine wet and dry drawing media by creating a crayon-resist drawing, applying watercolor washes over the crayon, and adding colored pencil or pastel after the washes have dried.

My Combination Drawing

This quick 10" x 8" (25cm x 20cm) drawing, made with Caran d'Ache watercolor pencils, was done on partially dampened watercolor paper. I picked up some of the color on a watercolor brush to make the tinted wash on the pitcher.

Pastels and Colored Pencils

Pastels, which come in hard and soft sticks, are the closest thing to painting with pure pigment, having just enough binder to hold the pigment particles together. Some newer products are water-mixable. The colors are intense and velvety. Pastels make gorgeous drawings or paintings and provide brilliant accents on watercolors or acrylics.

When working with pastels, layer one color over another for richer effects. Use any paper with tooth, including charcoal, pastel, watercolor or specially prepared sand-finished papers. Apply light pastel over dark with or without blending. Add lines with vine charcoal or ink. Use pastel to add surface patterns to mixed-media paintings. Research and use proper finishing and framing methods so your pastel work will last.

Wax-bound colored pencils have several benefits. They are a highly portable, dust-free sketching medium. Colored pencils are controllable on a support, unlike the splash-and-dash of watermedia. If you enjoy drawing and coloring and don't like the mess of paints and diluents, colored pencil may be for you. This medium gives you creative control, but first you must learn the tricks of the trade. Patience is a virtue in colored pencil.

☞ *Activity* ☜
Redo Drawing Exercise in Color

You don't need a big investment to experiment with pastels or colored pencils. Purchase a small starter set of Nupastel hard pastels or Prismacolor wax-based color pencils. Go back to chapter three and try them out in your sketchbook with the drawing activities.

Light on Dark

Pastel captures soft ambient light in a rural landscape. Because light colors can be applied on top of darker areas with pastel, flickering touches of color catch the eye and keep it moving over the surface.

Clermont Barn · Barbara Livingston · Pastel on sanded paper · 8" x 10" (20cm x 25cm) · Collection of Mr. and Mrs. Richard Wenstrup

The Capabilities of Colored Pencil

While colored pencil isn't as spontaneous as many other media, in the hands of an experienced artist, the results are awesome. Gildow used pastel as an underpainting for her colored pencil work, giving a base tone to the black Letramax support. Difficult textures such as metals, glass and fabrics are particularly effective when done with colored pencil by a master artist.

Variations · Janie Gildow · Colored pencil and pastel · 12" x 16" (30cm x 41cm)

Oils and Oil Pastels

Oil painting is a perennial favorite with many creative artists. The paint stays workable throughout the session, unlike quicker-drying acrylics and watercolors. Oil-based media are less compatible with mixed media than water-based paints, but still have many creative possibilities for fine art and decorative painters.

You may choose to paint with a brush or spread your oil paints with a palette knife. Experiment with both to see what textural effects you can make. Many different surfaces accept oils—canvas, wood, Masonite, tin—but most need some kind of preparation. When you work with oils, apply thinner layers underneath, building to thicker layers on top, to avoid uneven drying. Consider using water-mixable oils for easy cleanup and to avoid strong odors in your workplace.

Oil pastels and paint sticks have a heavy binder soluble in mineral spirits.

Apply them directly to the surface like crayons. Artists' oil pastels are more richly pigmented than ordinary wax crayons. Blend oil pastels with brush and solvent for a painterly handling, or dampen the support with spirits and draw directly on the damp surface. Use oil pastels on dry oil paintings, adding line and pattern. Or try oil pastels as a resist, drawing on watercolor paper and painting with transparent watercolors or fluid acrylics.

Oil Painting With an Attitude

Pendleton paints plein air with a traditional palette, using bold strokes and rich color. Her emphasis is on the changing colors of light.

Marin County Morning · Elin Pendleton · Oil · 24" x 30" (61cm x 76cm)

Drawing With Oil Pastel

Oil pastel is a rich painting medium in Davis's hands; at the same time his gestural line retains the quality of a drawing. He combines both techniques in this powerful painting. Oil pastels make a vibrant affirmation of Davis's proud commitment to the theme of his ancestral heritage.

Ancestral Spirit Dance #115 · Willis Bing Davis · Oil pastel · 40" x 64" (102cm x 163cm) · Collection of Bill and Camille Cosby

Activity
Test the Versatility of Oils

Oil colors can be thinned, poured and glazed like acrylics and watercolors. Coat watercolor paper or raw canvas with a thin protective layer of acrylic matte medium or white gesso. Stain your support with transparent oil washes, flowing or pouring oil paint thinned with odorless mineral spirits. Overlap or glaze colors in layers. Enhance with oil pastel or draw upon the surface with wax-based colored pencils.

Watercolor, Gouache and Casein

Flowing paint and gleaming white paper seen through transparent washes are characteristics unique to transparent watercolor. A purist relies on design and creative color schemes rather than experimental techniques, but if you have a mind to play with watercolor, almost anything goes.

Every artist has a few tricks of the trade. Watercolor artists use masking, texture and lifting techniques to enhance their basic repertoire of wash, drybrush and wet-into-wet painting. For different effects, combine watercolor with drawing and water-based media. Apply watercolor to a variety of surfaces besides traditional watercolor papers; for example, watercolor canvas, Yupo (a synthetic "paper" with a slick surface), Claybord or your own gesso-coated surfaces. Find new ways to work with resists, prints and stencils. Try some of the texture techniques on the next page to enhance the surface if you like.

Gouache and casein are opaque watercolors compatible with other water-based media. Unlike watercolor and gouache, casein dries to a hard film. Opaque colors are applied light over dark because of their density and covering power. Gouache and casein make elegant, translucent glazes. The dense pigments also work well in monoprinting.

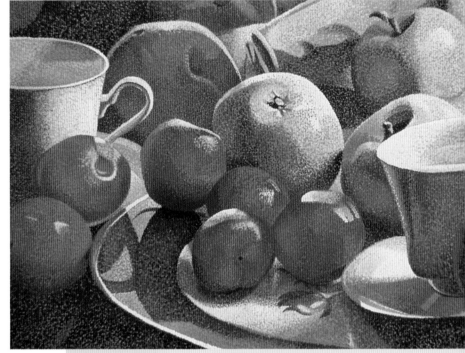

Choosing a Medium Befitting the Technique

Gouache is well suited to a controlled pointillist technique. Cain uses dots of pure color that appear to blend when the viewer stands back from the painting.

Red Plums · Karen Cain · Acrylic gouache · 18" x 24" (46cm x 61cm)

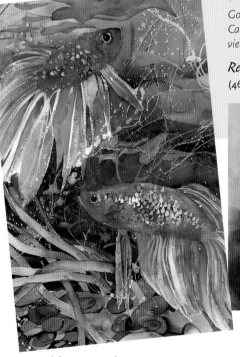

Bold Watercolor

You can be just as bold with watercolors as with oils or acrylics. Dazzling color in pure transparent watercolor is this artist's specialty. His large-format paintings are primarily nature-based.

Bettas · David R. Daniels · Watercolor · 52" x 48" (132cm x 122cm)

Plastic Wrap Printing

Printing on wet media with plastic wrap has been around for awhile, but it never seems to lose its fascination. Applying saturated colors to wet paper is easy. The trick is to manipulate the plastic wrap so the textures make an interesting image or background. Leave it on until the surface is almost dry to get the best print.

Hot Wings · Patricia M. Michael · Watercolor · 15" x 21" (38cm x 53cm)

☞ *Activity* ☜
Test the Flexibility of Watercolor

✳ Touch and spatter slightly diluted white gouache into a damp watercolor wash. The paint crawls and makes interesting feathery edges. Use a hair dryer to stop the action if you see something you like happening on the surface. When the paint is dry, work back into it to bring out an image or design.

✳ Test different kinds of resists with watercolor washes. These resists can be applied to reserve white areas or to texturize. Apply liquid masking or acid-free rubber cement and let it dry, then apply watercolor washes. Rub off the masking or rubber cement, then add glazes or emphasize white areas with dark lines. For hard-edge designs, try masking tape and stickers. See my sample sheet below for more possibilities. Make a test sheet of your own.

✳ Paint a leaf with gouache or casein mixed with watercolor. Place the leaf on paper, painted side down, and lay another sheet of paper on top. Roll a brayer over this sandwich to print the leaf. Make a sample sheet of printed textures like the one shown and incorporate some of them in a composition.

✳ Use stencils to create unity and rhythm through repetition of a shape. Vary the shape occasionally, changing its size and the spaces between the shapes. Cut stencils representing figures, flowers, leaves or geometric shapes from heavy paper. (I use old file folders.) Sponge out areas of a watercolor using a stencil pattern, or paint and spatter into the stencil design.

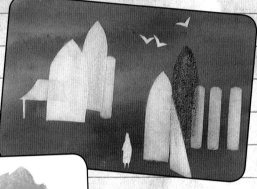

STENCILS WIPED OUT AND PAINTED THROUGH

WHITE GOUACHE ON WET WATERCOLOR

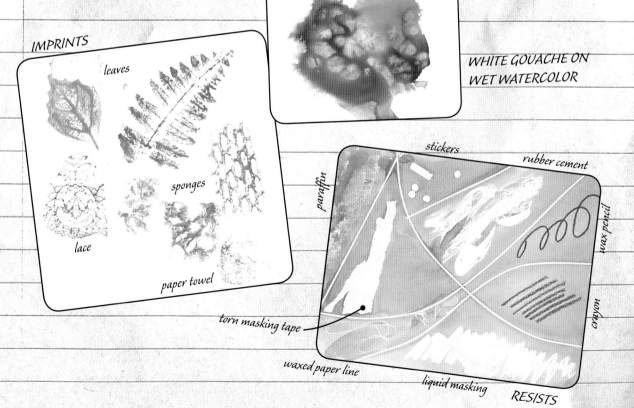

IMPRINTS

leaves

sponges

lace

paper towel

stickers

rubber cement

paraffin

wax pencil

crayon

torn masking tape

waxed paper line

liquid masking

RESISTS

Acrylics

Acrylics are the answer to combining many elements in experimental painting and crafts. Layers dry quickly, the medium adheres solidly, tools clean up easily in water, and many other media are compatible with acrylics. Just remember that once the color is dry, it is permanently bonded to the surface and can't be lifted like other watermedia.

Water-based acrylic paints work well for both transparent and opaque techniques. They adhere to almost any clean, non-oily surface, including fabric, and may be used as an under-painting for oils. (However, don't try to paint *over* oils with acrylics.) Use canvas, watercolor paper or illustration board or fabrics as your support, with or without gesso coating.

Change the viscosity of the paint by thinning it with liquid acrylic medium so it will flow freely. Add gel medium to thicken it and make it more transparent. Or mix the acrylic paint with modeling paste for a sculptural quality. Control the finish by glazing with gloss or matte mediums. Use iridescent acrylic colors for subtle color effects.

Because acrylics dry quickly, you can paint without interrupting your creative flow. Squeeze tube acrylics onto a dampened, folded paper towel on your palette and spritz occasionally with water to keep them workable longer. Place a damp sponge inside your covered palette to keep paints workable overnight.

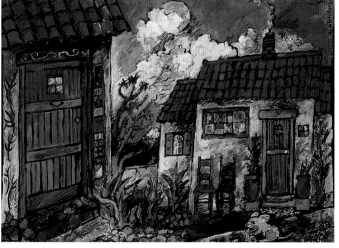

Layering On the Details

Vierow is deft with detail in acrylics on a small format. Most people can't distinguish watercolor or gouache on paper from acrylic. In practice the difference is a big one, because acrylics can't be lifted, but they can be painted over.

Village · Judith Vierow · Acrylic on paper · 9" x 12" (23cm x 30cm)

☞ Activity ☜
Play Around With Acrylics

✱ Pour a creamy layer of acrylic soft gel or gloss medium mixed half-and-half with gel medium onto a piece of wax- or plastic-coated freezer paper (shiny-side up). Coax the medium into an organic shape. Drop colored acrylic inks or fluid acrylics into the wet medium and lightly stir the color with a toothpick. When the medium dries clear (this may take several days), peel it off and adhere it to a white support with acrylic medium. Make several of these free-forms, assemble them and paint black lines between the colored panels for a stained-glass effect.

✱ Pour three or four fluid acrylic paints on a sheet of heavy watercolor paper or illustration board. Onto the wet paint press textured sponges, cutouts, corrugated cardboard, cheesecloth, leaves, string—anything that makes an imprint. Allow the support to dry partially, then remove the objects. Come up with a concept and design for a painting, then add collage or paint acrylics on the textured surface to finish.

POUR-AND-PEEL ACRYLIC

AN IMPRINTED-ACRYLIC

Monotype

Monotype is an easy way to produce a single stand-alone image or one that can be incorporated into other artwork. A *monotype* is a single image printed from a flat, painted-surface plate. This differs from a *monoprint*, which is a single image incorporating one or more additional printmaking processes. A monotype has a delightfully different look and feel from a painting. When the image is pulled from the plate, painted edges blur slightly and ripples occur in the paint to enhance the surface texture. Note that all prints are reversed from your original painting. Words and numbers read backwards.

Use this technique with oils, acrylics or watercolors. After you print your monotype, mat and frame it as is or embellish it with additional drawing and painting. Monotypes make unique backgrounds for paintings and collages. If enough paint remains on the plate after making an image, pull additional "ghost prints," which will be lighter each time and may show only parts of the image. Keep everything you print and use your monotype papers for collage.

A Painting Might Make a Better Print

I painted the orchid with oil paints on a heavy glass printing plate and pulled a single print of the image. The wet paint blended slightly as I pulled the print, creating subtle edges and mixtures. I preferred the print to the original painting on glass.

Orchid · Nita Leland ·
Oil monotype on paper ·
12" x 9" (30cm x 23cm) ·
Private collection

☞ Activity ☜
Make a Monotype

✱ Lay a thin film of gum arabic or diluted dishwashing detergent on a sheet of glass, Plexiglas or Mylar drafting film. Let the plate dry. This is your printing plate. If you have a preparatory sketch, place it under the plate as a guide. Paint your image or design on the plate. Lay a slightly damp sheet of paper on top of the painted image. (Tip: Hold the paper at diagonal corners. Put the near corner on the plate and roll the paper to the far corner to avoid trapping air bubbles.) Pat gently or roll with a brayer if the paint isn't too thick. Pull the print.

Note: To print on paper with oils, apply a thin coat of acrylic matte medium on your paper before printing to protect the paper from deterioration. For watermedia, use anything from rice paper to lightweight watercolor paper. No coating is necessary for acid-free media.

✱ For a different effect, squeeze paint directly from the tube onto the plate. Roll the paint with a brayer. Scrape your drawing into the wet paint with a single-edge razor blade, palette knife or brush handle, then make your print from the plate.

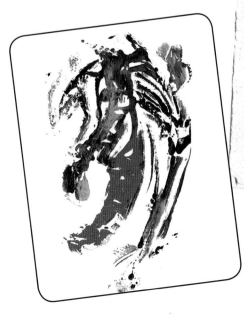

My Scraped Monotype

I worked a small amount of Winsor & Newton Aquapasto medium into undiluted watercolor for a slightly thicker consistency. Then I painted the hot pepper with impasto on the plate instead of washes. The Aquapasto gives the paint more body and flexibility so it won't crack when dry.

151

Inks

Colored inks are brilliant, transparent and easy to use. Make certain your inks are labeled as lightfast, because some colored inks fade quickly. Squirt inks from plastic-tipped squeeze bottles or pour onto wet or dry paper. Spatter, drip, layer, airbrush, paint, print and glaze with this versatile medium.

Unlike traditional acrylic paints, most inks are thin and highly transparent. Inks spread rapidly on damp surfaces—tending to creep and crawl with unpredictable results—so be ready. They are permanently staining and cannot, as a rule, be lifted once they are put down. They retain their brilliant colors, instead of drying lighter, as watercolors often do.

☞ *Activity* ☜
Investigate With Ink

Explore the potential of ink. Look for an accidental abstract design or a suggestion of a realistic image in the random ink lines and shapes created, and develop them by adding more lines and shapes or by covering selected areas with opaque white. Save these experiments for your collage box.

* *Dip a piece of damp twine in India ink and noodle it around or drop it on a sheet of paper. Extend the linear design with pen or brush, or delete some lines with opaque white. Create shapes where the lines suggest them.*

* *Spatter a few drops of ink on paper or cardboard. Blow through a drinking straw to move the ink around, turning the paper as you blow.*

* *Dampen or spatter clean water on smooth, medium-weight paper. Drop or spatter ink on the damp sheet and let it spread. Draw through the wet areas with a stick or brush dipped in ink. Add shapes and lines to make an abstract design and connect some areas to the edges. If you see a realistic image, develop it.*

* *Flow ink with an eyedropper or a brush, and expect the unexpected. Pour and spatter areas of colored inks on a piece of medium-weight paper that you have dampened slightly in a few areas. Start with an abstract design in your sketchbook, but go with the flow of the ink, working into the wet ink with a stick, pen, brush or water-filled spray bottle.*

Ink dropped onto wet paper

Ink flowed onto wet-and-dry paper

Ink applied with twine

Ink spattered and blown on dry paper

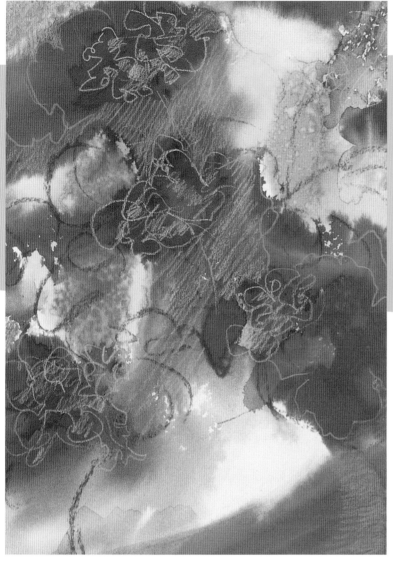

Poured Beginnings

Pour inks just as you do fluid acrylics, and combine them freely with other media. Establish a color scheme and dominance while pouring to help develop your composition later. Be flexible. I was thinking "flowers" when I poured this piece, but it might have turned out to be a figure or landscape when the inks were dry. As it happened, the white area was in just the right place for a vase, so I completed it with other media to make a floral arrangement.

Bouquet · Nita Leland · Acrylic inks, charcoal, colored pencil and pastel on illustration board · 10" x 8" (25cm x 20cm) · Private collection

☞ *Activity* ☜
Texturize Ink With Overlays

Use waxed paper, burlap or other materials to create textures like these with colored inks. Start with small amounts of color. Let the inks blend freely. Lay waxed paper, plastic wrap, cheesecloth or burlap on the wet ink. When the ink is almost dry, peel off the overlays. Make small samples of different texture effects, noting on the back of each what you used to create the texture.

Go With the Flow

As you have seen in this chapter, fluid media of all kinds lends itself to spontaneous artwork. Experiment with liquid watercolors, thinned acrylics, acrylic inks and other flowing media to see what interesting effects you can make.

PLASTIC WRAP

WAXED PAPER

CHEESECLOTH

153

Collage and Assemblage

Collage is exciting because of the versatility and durability of acrylic mediums and paints. Many crafts cross over into collage materials and applications. The popularity of scrapbooking, a form of collage, has resulted in the availability of numerous archival materials collage artists enjoy using, such as dry-mount adhesives and sticker-making machines. The materials used are virtually unlimited, with one caution: The support must be heavy enough to bear the weight of the collage material. Every effort must be made to protect materials from degradation.

Supports may be canvas, untempered Masonite, watercolor paper and board or illustration board. Collage materials include papers of all weights, shapes, textures and colors; found papers, such as tickets, candy wrappers, cancelled stamps, posters; silk-screened papers; marbled papers; metallic foils; newspapers; photos; string; fabrics; wire; mirrors—anything your imagination can conjure and your ingenuity can unearth. You may also paint on your collage if you wish.

Tear, cut, crumple, tangle or mash your materials to create either a flat or low-relief collage. Use acrylic mediums and gels to adhere papers and small objects to your support. For assemblage, spread heavy gel or modeling paste on three-dimensional objects and embed them in wet medium applied to the support. Extremely heavy pieces require epoxy glue on a rigid support.

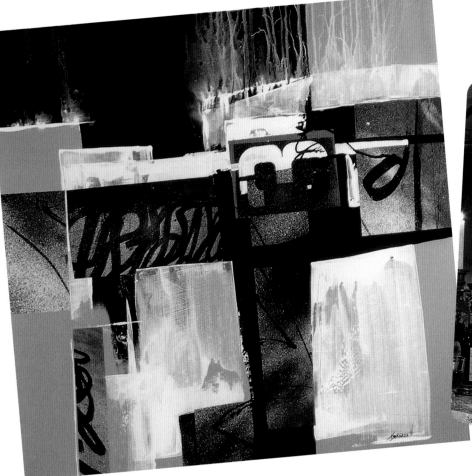

An Intuitive Start Leading to a Focused Concept

Benedetti paints and marbleizes papers, then cuts and tears them to be reconstituted on a new painting surface. She arranges and rearranges the shapes and uses paint to create unity over the surface. Sometimes figure shapes appear. Her process is more intuitive than planned at the beginning, but at some point concept and design kick in to tie everything together.

Alaskan Odyssey · Karen Becker Benedetti · Fluid acrylic and collage · 30" x 30" (76cm x 76cm)

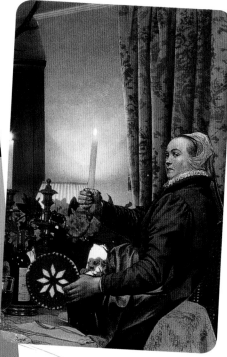

Collaged Cards

Gistrak created a deck of tarot cards using magazine paper collage. Each is a miniature gem of symbolic imagery.

Three of Pentacles · Jennifer Gistrak · Paper collage Tarot card · 5" x 3" (13cm x 8cm)

154

NO EXPERIENCE IS NECESSARY

Paper collage is the easiest way to get started in this versatile medium. Everything from magazine and newspaper clippings to concert programs and photos is fair game. Beyond that you can make your own papers and combine readymade papers with paints. Explore some of the collage activities shown. See my book *Creative Collage Techniques* and others for more information on collage design and techniques.

Built to Last

If you want your art to last, you must use materials that won't degrade. Art supply and scrapbooking stores are good resources for archival materials. Look for acid-free and pH neutral papers and lightfast paints, pens and markers. One handy tool is a pH-testing pen to use on items not labeled acid-free. Krylon makes Acid-Free spray to neutralize acidity in scrapbook and art papers and Preserve-It spray for UV protection of finished work.

☞ *Activity* ☜
Unleash Creativity With Collage

If you have doubts about your creativity, try collage. This fun technique seems to unleash a creative spirit.

✳ *Set up a greeting card workshop with your treasure chest and scrap box from page 12 handy. Keep your supplies simple: white glue or medium, a small brush, perhaps a few watercolor pencils. Make small collage designs on folded medium-weight watercolor paper or cardstock. Your family and friends will love—and collect—your handmade cards. Be sure to sign these miniature artworks with your name or initials, so people will know they're originals.*

✳ *Start with a color idea—an expressive, unique color combination. Tint several pieces of heavy paper with colored ink, watercolor or acrylic washes, using the colors you've chosen. Tear your papers into interesting shapes and arrange them in a composition, using some of the torn edges as white lines between the shapes. Add other papers from your scrap box or tinted rice papers for pattern and contrast. Adhere the papers with acrylic medium or gel.*

✳ *Paint an abstract design in ink, watercolor or acrylic on canvas or paper. You might begin with a viewfinder design. Layer torn rice paper or white wrapping tissue to glaze some areas, adhering it with acrylic medium or gel. Glaze and layer with paint and tissue alternately to complete your collage. If you don't like what you see, simply add another layer.*

TORN-PAPER COLLAGE

COLLAGED GREETING CARD

Synthesis · Nita Leland · Acrylic and rice-paper collage on illustration board · 10" x 11" (25cm x 28cm) · Private collection

155

Let your dreams
run wild and free
and always,
always follow
where they lead

8 ADVENTURE:
Developing Your Creative Spirit

Involution/Evolution ·
Ardis Macaulay · Oil on canvas
· 34" x 34" (86cm x 86cm)

The more interest and effort you put into your art or craft, the better your work will be. It's as simple as that. Recite the "P" words to help you reach your goals: passion, possibilities, positive thinking, priorities, permission to play, process not product, and—above all—patience, practice and perseverance.

Know that you're not alone. Every artist has bouts of uncertainty. Conquer self-doubt by practicing your skills to gain confidence. The less you need to worry about technique, the more expressive your art becomes.

Is there a definitive key to creativity? No, just different avenues to explore. To develop your creativity, commit to nurturing your creative spirit, acquiring knowledge and listening to your inner voice. Set goals, but stay open to change. Be true to your artistic vision, but respect the work of others. Learn to analyze your work. Let your personal style evolve.

Choose to be creative.

*"When the artist is alive in any person…
he becomes an inventive, searching, daring,
self-expressing creature. He becomes
interesting to other people. He disturbs,
upsets, enlightens, and he opens ways for
a better understanding."*

Robert Henri,
The Art Spirit

Shades of Summer · Lynn Lawson Pajunen · Mixed-media collage · 21½" x 15½" (55cm x 39cm)

Commit for the Long Haul

Take time to develop skills and awareness. As the old saying suggests, this is a marathon, not a sprint. A student watching the then 82-year-old Ed Whitney demonstrate his watercolor skills whined, "Why can't I do it as easily as you?" Whitney scowled at her and growled, "When you've been doing it for sixty years, maybe you will!" It may not take you sixty years—but it will take time.

Be patient. French writer Gustave Flaubert said, "Talent is long patience." That's exactly what it takes to make art.

Making art is a wonderful experience, but don't expect it to be easy. You won't make a winner every time. That's okay. Sometimes your best work comes out of a battle with a concept or an encounter with materials. Don't avoid the struggle that produces meaningful art.

Expect to have plateaus. Don't be discouraged when they occur. When you're stuck, concentrate on refining your skills at that level. As your skills improve, introduce small changes— a new tool, a different pencil, an unusual color, an unexpected texture. Use this book for ideas to get you started again. Keep moving and you will rise above that plateau.

Nobody gets stuck forever.

Give It Time

Your progress in art or craft is in direct ratio to the time you spend making art. Your temperament determines to a great extent how quickly you advance. I've had students who painted every day between class sessions. Many of them are now professional artists. Others only painted in class—they're still taking classes. The individuals in both groups have chosen the path that best nurtures their creative spirit. Their joy is in the doing.

Simple Yet Skillful

This delightful watercolor is deceptively simple. The technique is traditional watercolor. Canada has included the following in her piece: good drawing, interesting shapes, exciting color, a composition that works and textures around the edges. Her painting is unique and creative.

Chapel at San Xavier · Ruth Canada · Watercolor · 21" x 14" (53cm x 36cm)

A Talent for Tailoring

Turner makes creative dolls from authentic patterned fabrics imported from South Africa. Traditional colors and symbols decorate the costumes. Turner's art dolls are prized by collectors.

Masai Dancer · Frances Turner · Fabrics imported from South Africa · 14" x 8½" (36cm x 22cm)

Make the Most of Change

*I*f I had to summarize in one word how to stimulate creativity, the word would be *change*. Creativity thrives on change. But you don't have to change everything. If you change one thing, everything looks different, heightening your awareness and stimulating your creativity. The quest for creativity begins with risk-taking. Give yourself permission to change.

If you're struggling, change something. Change the size or shape of your artwork. Change your palette of colors. Change the type of subject or the medium you use. Do whatever it takes to give yourself a fresh start. Switch media, tools or techniques. Indulge yourself in a new craft. Allow yourself to play. Go outside to paint. Do your work at a different time of day.

It isn't a sin to stay in your comfort zone when you're confused about what your next step should be. Just don't get too comfortable there. Challenge yourself occasionally to see if you're ready for something new.

Use the list below for inspiration when you begin a new project. Copy this list of modifiers in your sketchbook-journal and add some words of your own. Modify your artwork's content using one or more of the words in the list:

add • combine • crop • curve • decorate • distort • divide • energize • exaggerate • fade • fracture • grid • magnify • multiply • reduce • reverse • sharpen • soften • stretch • substitute • subtract

Invite creativity in other ways as well. For example, rearrange the furniture in your art space, so you're facing a different direction. Instead of sitting down to work, stand up. Work with a group, instead of alone. Bring change into your everyday life and cultivate your creative spirit. Whatever you're doing now, consider how you might do it differently. Habit stifles and distorts artistic impulses.

> *"What the caterpillar calls the end of the world, the Master calls a butterfly."*
>
> Richard Bach,
> **Illusions**

Expand Horizons With an Unfamiliar Medium

I've been a watercolor painter for more than thirty years, but I've experimented with a lot of different media. My latest foray into the wonders of art materials is water-mixable oil paint. I've a long way to go to master the medium, but it has been fun trying something new.

Leaning Tree • Nita Leland • Oil on canvas • 16" x 20" (41cm x 51cm)

☞ *Activity* ☜
Tackle a Boring Subject

What is the most boring subject cliché you can think of? I won't give you a hint, because your idea may be different from mine. Make the subject exciting by applying the elements and principles of design to make your statement.

Set Specific, Reachable Goals

*I*f you don't know where you're going, how will you know when you get there? There's a familiar line in the musical *South Pacific*: "You've got to have a dream; if you don't have a dream, how you gonna have a dream come true?" Motivational author Napoleon Hill said, "A goal is a dream with a deadline."

What, exactly, is a goal for a creative artist? American author Jack London said it best: "What every (artist) needs is a technique, experience, and a philosophical position." In other words, master your medium, practice, and have something to say. What could be clearer than that?

Be specific about your goals. Don't say you want to be a better watercolorist or quilter. State that you want to improve your watercolor washes or your appliqué techniques. Break down your goal into small steps and write them in your sketchbook. Start with hiring a babysitter so you can take a class. Make a date with yourself to work at your art or craft for a specific time every day or once a week on a certain day. Make that date a top priority on your calendar.

Be realistic about your goals. Don't set yourself up for failure. Robert Fritz said, "The human spirit will not invest itself in a compromise." Be honest with yourself and make your goal a doable one.

Visualize yourself taking each step necessary to reach your goal. Focus on that goal. Relax and let yourself dream about it. Allow yourself to feel the joy you'll experience when you arrive at your goal. Don't become distracted from your goal or you're sure to see obstacles in your way. Concentrating on your goal will help you overcome those obstacles.

For more than four years I wanted to manufacture a color selection wheel for my "Exploring Color" workshops, but I never started because the project seemed overwhelming. I sat down one day and listed the steps needed to get my project going. The first was to find a die cutter. I went to the phone book, made three calls and struck gold. The toolmaker I spoke with referred me to a reliable company and at the same time recommended several intermediate steps to take. Within six months my color wheel was a reality. This never would have happened if I hadn't taken that first step.

A Common

Quest for the Uncommon

Like the figures in Benedetti's collage, we often feel alone in our quest for creativity, yet some mysterious force is moving us in the same direction—toward freeing our creative spirit.

Seeking One Goal · Karen Becker Benedetti · Fluid acrylic and collage · 30" x 22" (76cm x 56cm)

Choose Concepts You Connect With

*C*oncept draws a line between what you know and what you feel. The best art is a combination of both. When you're searching for a subject, don't settle on something you're familiar with until you ask yourself what you know about it and how it makes you feel. Subjects beyond your realm of experience are also beyond your capability of finest expression in art.

I was once taken to task by an artist for rejecting her large, meticulously rendered oil painting of the Alps. She didn't understand why I gave an award to her small watercolor of muddy garden gloves and digging tools. I told her that she conveyed how much she loved her garden in the small picture, but I suspected (and she admitted) that she had never been to the Swiss Alps.

Tell your own story—your way. Painting, drawing and many craft arts are like disclosing your secrets to a friend. Share your unique insights with your friend, the viewer. Let the viewer participate in the work and be your collaborator. Tell something only you can tell.

Even as you practice your skills, remember that art is more than virtuosity. Russian-born expressionist painter Kandinsky wrote: "The artist must have something to say, for mastery over form is not his goal but rather the adapting of form to its inner meaning…. That is beautiful which is produced by the inner need, which springs from the soul."

> *"Every art expression is rooted fundamentally in the personality and in the temperament of the artist…. When he is of a more lyrical nature his work will have a more lyrical and poetical quality; when he is of a more violent nature his work will express this in a more dramatic sense."*
>
> *Hans Hofmann*

A Common Event Your Audience Can Relate To

Every viewer feels the expressive content of this painting: a young girl dreaming as she basks in sunlight. Hodges has emphasized her point with a strong, simple background design and her mastery of painting light.

Opening a Window · Gwen Talbot Hodges · Watercolor · 20" x 30" (51cm x 76cm)

Integrate What You Know With What You Feel

Knowledge and intuition have parallel functions in the development of a fully realized concept. This chart shows the direct relationship between them that comes into play during the creation of your art or craft.

KNOWLEDGE	INTUITION
Awareness of the facts of the subject	Awareness of your ideas and feelings
Knowledge of materials	Personal selection of specific materials
Mastery of techniques	Your method of handling materials
Knowledge of color and design	Your choices in color and design

Be True to Yourself and Your Art

There ought to be a truth-in-art law, just as there is a requirement for truth in advertising. If there were, artists might be more tolerant of others' efforts to express what they believe to be true in their art. This law shouldn't establish standards for truth, but it should allow free rein to whatever the artist says, as long as it is sincerely and honestly felt. Trust your instincts above the advice or criticism of others—especially when you feel you've expressed the truth in your art.

Georgia O'Keeffe wrote to her friend Anita Pollitzer, "I don't see why we ever think of what others think of what we do—no matter who they are. Isn't it enough just to express yourself?"

Artist and author Ben Shahn also questioned himself. "This may be art, but is it my own art?" He went on to say, "...I began to realize that however professional my work might appear, even however original it might be, it still did not contain the central person which, for good or ill, was myself." Finding the central person who is yourself is a worthwhile and necessary objective for every creative artist.

How does it happen that you occasionally do an artwork beyond your present skill level? This is a clue to your true potential. You were so absorbed in your process that you overcame your self-consciousness as you worked, automatically shifting from your critical, left-brain thinking mode to a relaxed concentration, allowing your unconscious full access to your knowledge and experience.

You really *are* that good. You can continue to be as good as the best piece you have ever done. Be patient and practice, and you will persevere.

Believe in Your Vision

Huart came to my beginning watercolor class many years ago. She showed me tiny fragments of handmade paper that looked like pretty little bits of nothing, touching them as though they were great treasures. In time she mastered the ancient art of papermaking. Now she stirs her creative spirit into every batch of paper pulp and incorporates calligraphy and mixed media in her artwork.

Power of Words · Rosemarie Huart · Handmade paper, calligraphicmarks and gold leaf · 7" x 7" (18cm x 18cm)

☞ Activity ☜
Seek the Truth in Others' Art

Art doesn't have to be beautiful, as long as it's truthful to the artist's understanding of and feelings about the world. A pretty image may express one kind of truth for you, but that isn't the only truth. A picture may be a wrenching representation of human cruelty—a masterwork of artistic elements intelligently organized to express a terrible reality.

The next time you visit an art gallery or museum, instead of looking for pretty pictures, search out some you haven't examined before and see if you can discern some truth that the artist is communicating. Every artist speaks his own truth.

Critique Your Own Work

Sooner or later you will evaluate your own work. Self-critique is instructive if you approach it right. Use self-critique as a means of understanding rather than an opportunity for finding fault.

There are many good things in everything you make, so begin by looking for them. Each time you critique your work, answer these questions:

What is the best part of this picture or project?

Have I said what I intended to say?

Did I simplify the shapes?

Is the value key emphatic?

Is the color expressive?

Is there enough tension/energy in the design?

Add your own questions to this list each time you critique your art. Establish your criteria to fulfill your artistic purpose and suit your mode of working. As your objectives change, modify your criteria. Keep your list going as an indicator of your growth and development.

SELF-CRITIQUE UNDER THE RIGHT CIRCUMSTANCES

To get the most benefit from your self-critique, use a little "attitude adjustment."

Ignore your inner critic when your creative juices are flowing. Don't stop constantly to critique when you're on a roll. The time to step back and look at your progress is when you find yourself slowing down.

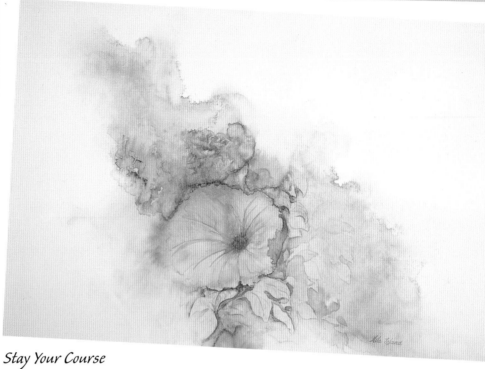

Stay Your Course

In my early painting days, I took a workshop hoping to learn experimental techniques, but the instructor didn't demonstrate so I didn't know where to begin. I was surrounded by apparently insane artists who were crumbling dirt, sand and leaves onto enormous watercolor boards and pouring, spattering and throwing paint and glue every which way. I cowered in the corner, totally intimidated. The instructor said, "Do what you feel comfortable with." So I stayed with watercolor during the workshop and worked with spontaneous washes and negative painting. I understood that I wasn't ready for a major metamorphosis. I did this painting in the workshop and was pleased with its freshness and simplicity.

Summer Glow · Nita Leland · Watercolor · 22" x 30" (56cm x 76cm) · Collection of Dr. and Mrs. Thomas J. Thomas

When the work is finished, give it time to grow on you. Don't judge it too soon. Examine the piece from a different perspective. Walk away from it for a while and come back with a fresh eye.

When you critique, take a positive approach. List all the things you like about the piece. In your next experiment, use the things that worked.

Appreciate your own best efforts. Don't compare yourself to others. This is hard to do, especially in a class situation where people with widely differing backgrounds and skills are thrown together. Most people aren't able to do their best work under these circumstances. Tune out distractions by concentrating on your own work and ignoring what others are doing, unless you feel you can learn something from what is going on.

Zero In on Concept, Design, Technique

A strong piece of work withstands serious critique. Nevertheless, judging art is subjective, so how can one conclude what is good art? This is a tough question. Here are some guidelines to help you establish an objective basis for evaluating your artwork and the work of others. Having guidelines helps you to be fair and more aware of the intent in an artist's work. If you're ever called upon to judge an art exhibition, keep these points in mind.

CONCEPT

What is the concept or idea revealed in the piece?

Has this idea been expressed dynamically?

Is this an interesting problem with a unique solution?

Is there wit and character in the interpretation?

What is the artist telling you about himself or herself?

DESIGN

How has the artist used design to express the concept?

Are interesting shapes arranged dynamically?

Is dominance used effectively to support the concept?

Is there a feeling nothing can be added or subtracted without impairing the unity of the piece?

TECHNIQUE

How effectively has the artist used his or her skill?

Is the artist working with conviction?

Are techniques well-integrated or just surface tricks?

Does expertise overshadow meaning?

☞ Activity ☜
Play Art Critic

Examine the content, design and technique in these two paintings and other art throughout this book. Use the same criteria for realistic and abstract art, as well as crafts. Compare two other pictures in this book—one you especially like and one you don't. Be as open-minded and objective as possible. Assume that the artists are sincere in their art, even though you may not agree with what they've done. See if you can try to understand why they have used a certain technique, subject or color. What would you have done with the same subject?

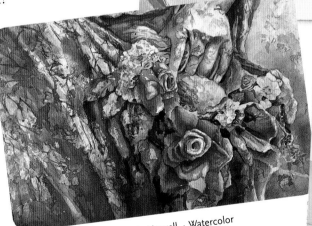

Spring Bouquet · Mary L. Norvell · Watercolor on tissue collage · 24" x 28" (61cm x 71cm) · Private collection

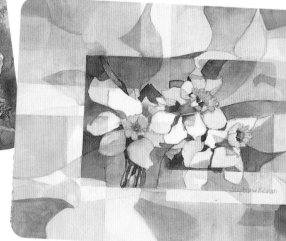

Fractured Flowers · Stephanie H. Kolman · Watercolor · 11½" x 15" (29cm x 38cm)

Have Faith in Yourself—and You Can Do It

*B*eing an artist would be a lot easier if you weren't so hard on yourself. You are your own worst critic. When I critique student work in my classes, a few students always say, "Tear this apart—tell me everything wrong with it. I can take it." I feel it's more productive to look first at what you're doing right, where your strength lies. Yes, I believe you benefit from your mistakes. But learn from them and move on.

Maintain a positive attitude about your art. Here are several strategies to help sustain your confidence in your work.

Build on your strengths. Study the things you do right. Find the parts of the picture that work. Keep doing these things. You resolve your problems as you work. You improve every time you exercise your skill. The secret is to keep doing it as often as you can.

Avoid negative influences. Learn not to be intimidated by the criticism of others. When you need a second opinion, find someone whose judgment you value, who will give you an honest critique.

Trust your instincts. Your unconscious makes valid contributions to your art. Allow accidents to stimulate creativity. Author Henry Miller was a prolific painter in his spare time. He said: "There is something else to be said about this immediate, spontaneous way of working, and that is this: in such moments, one is playing at the game of creation." There is no greater game to play.

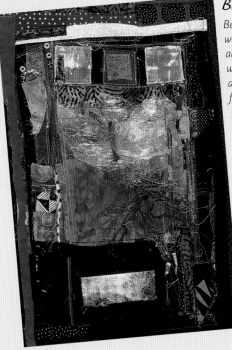

Be Open to New Vehicles of Expression

Believe in yourself, but be open to change. Experiment with a variety of arts and crafts. Everything you do adds to your knowledge and skills. Artisans like Jeffers, who work with design and color to create striking artwork, have elevated domestic arts like quilting to fine art status.

The Touch · Cathy Jeffers · Mixed fibers and quilting · 18" x 12" (46cm x 30cm)

Believe and You Will Do

When I met Dave Daniels some twenty or so years ago he was hooked on color and nature painting. In the interim his work has grown increasingly colorful and grander in scale. His subject matter continues to be the small things most people don't see. He's firm in his purpose and his work reflects his practice, patience and perseverance. He believes in himself. You must believe in yourself as a creative artist.

Grasshopper · David R. Daniels · Watercolor · 60" x 40" (152cm x 102cm)

Resist the impulse to correct an inadvertent change or small mistake. An incorrect line, shape or color may energize the piece. Make this work for you or ignore it. Attempts to correct a minor flaw may only call attention to it.

Learn to handle criticism regardless of the source. Most judges and critics try to be fair, but they're human. They have personal biases. A rejection doesn't necessarily indicate a piece is bad, only that the standards used for evaluating the work are different from yours. Remember, today's reject could be tomorrow's best of show.

Cultivate Your Personal Style

Style is the imprint of your personality on your art. The way you look at your subject, how you relate it to your experience, which materials you choose, and your manner of handling them all influence your style.

Don't force style or you'll never cultivate one. You may be tempted to fit bits and pieces of style from other artists into your artwork, but it won't work. You have influences, of course, but your own, distinctive style will assert itself in time. When you become deeply involved with the content of your work and throw yourself vigorously into it, style will take care of itself.

Begin by trying everything. Take risks. Artist/author Mary Carroll Nelson wrote in *Connecting: The Art of Beth Ames Swartz*, "Every artist who evolves a style does so from illusive elements that inhabit his or her visual storehouse, but the actual breakthrough in the privacy of the studio, when one dares to apply paint in a new manner, is a solitary thrill, dependent upon no one else. It is the individual artist who must act courageously in an effort to grow."

You will never know that thrill unless you dare to try.

YOU'RE IN THE DRIVER'S SEAT

You probably already have the beginning of a style. Many artists lament their lack of recognizable style, yet their work can be easily identified when it hangs with other artists' work. Emphasize your themes—the distinctive elements, symbols or features that appear in your work. You're drawn to things that reflect yourself—certain subjects, specific colors, your personal way of handling a medium.

Let your style evolve. Make choices independently. Your selection of a subject, your materials and the way you handle them are your style. Your choices of the dominant elements in your art and the way you arrange them are your style.

Every choice you make is a revelation of yourself and your personal style. Don't rely on imitation. Trust yourself. Your creativity is displayed through the smallest personal touch or revelation of wit.

These are your resources for style: your direct impressions of nature, your inner self and your materials. The more skilled you are with your

Components of Your Style

* *What techniques and media please you the most?*
* *Do you find elements that appear in your work in spite of yourself?*
* *What symbols or themes do you find most often in your work?*
* *Do you try to expand these themes in your work?*
* *Are these symbols, themes and techniques an essential part of your personal expression?*

Unlimited Color

Williams is an outdoorsman whose love of nature and careful observation are apparent in his artwork. His style has evolved from a literal interpretation of local color to a glorious praise of the landscape in color.

Another Day Passes · Leonard Williams · Acrylic gouache · 23" x 33" (58cm x 84cm)

medium, the more effective your message will be. Improve your self-confidence by sharpening your skills and mastering techniques.

A solid foundation of knowledge and skills enables you to work with conviction, to be persuasive in revealing your truth. Practice your skills. They get rusty when you don't use them. Strengthen them through exercise, like athletes strengthen their bodies for competition.

☞ *Activity* ☜
Walk a Subject From Realistic to Abstract

Whether you're a realist or abstract artist, do this activity and see for yourself how you can create different design treatments for a single subject. Select a subject and make three different plans for it:

❋ *Do a realistic rendering with an expressive dominant element. For example, I designed a picture of two parrots using dominant color intensity and temperature contrast to suggest their three-dimensional form.*

❋ *Stylize the same subject with simplified flat shapes, clearly not representative of three dimensions. I eliminated values and concentrated on simple shapes in bold, flat color, adding to the dominant red hue a black-line accent similar to stained glass.*

❋ *Make an abstraction from some part of the image, rearranging and further simplifying shapes to create an abstract design without regard for realism. I isolated the wing and shoulder feathers and changed their relationships on the page into a geometric design not recognizable as two parrots.*

Two Parrots · Nita Leland · Watercolor · 16" x 12" (41cm x 30cm)

Two More Parrots · Nita Leland · Watercolor · 16" x 12" (41cm x 30cm)

Wings · Nita Leland · Watercolor · 16" x 12" (41cm x 30cm)

167

And the Greatest of These Is... Enjoy!

A creative artist must make many decisions. Let's review the major ones involved in creating art and fine crafts:

1 Identify your concept. What do you want to say? You're making visible something that can't be verbalized. Be aware of symbols that recur in your work.

2 Plan your composition. Use the elements and principles of design to reveal your concept. Find the best way to say what you want to say. Select the format that expresses your idea. Choose your color scheme for creative expression.

3 Refine your technique. Master your skills and materials so you can say what you want to say beautifully. Great technique won't make good art if you have nothing to say.

4 Create your artwork. Try several ways to develop your concept. Take your time. Reserve judgment. Experiment, but don't depend on fancy footwork to make your statement.

5 Enjoy yourself. Value the experience of making art, of learning about yourself and your world. The art is important, but not as important as how you feel about making it. By appreciating the experience, you make the result a thing of value.

A Musical Composition

This is just one of many pieces based on music that Pippenger created for a group gallery show. Each artist who participated in the show was deeply inspired in her own way by the powerful music theme.

Wanderin' · Marsha Monroe Pippenger · Mixed-media collage · 18" x 24" x 1½" (46cm x 61cm x 4cm)

A Creative Departure

Canada departs from her luminous southwestern landscapes and gives us a frog among the rushes, begging to be turned into a prince. Everything is different from her landscapes, from the subject to the color scheme. Notice she has retained the interesting treatment of the edges around the subject.

Just One Kiss · Ruth Canada · Mixed media · 23" x 19" (58cm x 48cm)

This Is Just the Beginning

The road to creativity has many ups and downs. Progress comes with patience, practice and perseverance. Continuous growth takes place every time you make your art, but you're seldom aware of it. Don't fear to fail. Even a disaster teaches you something.

Every artist and craftsman, no matter what level of skill or experience, has to decide again and again, "What shall I paint or draw or build?" Ben Shahn wrote, "The answer is a pretty obvious one, 'Paint what you are, paint what you believe, paint what you feel.'" Try anything and everything.

When do you stop being an art student and become a real artist? You're an artist when you realize that your art education never ends. There are no limits to what you can learn about yourself and your world through art. You create order out of chaos, finding meanings. As your creative spirit develops, your background, experience, education and environment are major influences. These comprise your art education. The more you experience new things in life and art, the richer your resources for art.

Explore, experiment and expand. Free your creative spirit.

Creativity allows you to function at the height of your potential as a human being. Tune in to your environment, personal relationships and cosmic forces. Your creative work of art shapes the intangible—your idea, concept or feeling—into a tangible form that affects its viewers as long as it lasts. Discover the images that inhabit your mind and give them material form. Share your vision with the world. Let your creative spirit soar.

You dream of being an artist.
You *are* an artist.
BEGIN.

> " Don't ever begin to believe that when you get to a certain point, you're there.
> Don't ever put a limit to what you want to be, because when you get to that place, you're nowhere.
> Don't ever set yourself a stopping place, because maybe that is just the beginning."
>
> *John Held, Jr.*

The Journey That Never Ends
Learning and growing: just like children, that's what creative artists do.

Dream On · Nita Leland · Watercolor · 9" x 6"
(23cm x 15cm)

Selected Bibliography

CREATIVITY & MOTIVATION

Arrien, Angeles. *Signs of Life*. New York: Jeremy P. Tarcher/Putnam, 1998.

Barron, Frank, et al. *Creators on Creating*. New York: Jeremy P. Tarcher/Putnam, 1997.

Bayles, David and Ted Orland. *Art & Fear*. Santa Cruz, California: Image Continuum Press, 2001.

Benzel, Rick. *Inspiring Creativity*. Los Angeles: Creativity Coaching Association, 2005.

Briggs, John. *Fire in the Crucible: The Alchemy of Creative Genius*. New York: St. Martin's, 1998.

Cassou, Michele and Stewart Cubley. *Life, Paint and Passion*. New York: Jeremy P. Tarcher, 1996.

John-Steiner, Vera. *Notebooks of the Mind: Explorations of Thinking*. New York: Oxford University Press, 1997.

Koestler, Arthur. *The Act of Creation*. New York: Penguin Group, 1990.

Leland, Kurt. *Music and the Soul: A Listener's Guide to Transcendent Musical Experiences*. Charlottesville, Virginia: Hampton Roads Publishing Company, 2005.

London, Peter. *No More Secondhand Art*. Boston: Shambhala, 1989.

Loori, John Daido. *The Zen of Creativity*. New York: Ballantine Books, 2004.

Maisel, Eric. *Affirmations for Artists*. New York: Tarcher, 1996. *Coaching the Artist Within: Advice for Writers, Actors, Visual Artists and Musicians from America's Foremost Creativity Coach*. Novato, California: New World Library, 2005.

Maslow, A.H. *The Farther Reaches of Human Nature*. New York: Penguin Group, 1993.

May, Rollo. *The Courage to Create*. New York: W. W. Norton and Company, 1994.

McKim, Robert. *Thinking Visually*. Boston: Addison Wesley Publishing Company, 1980.

Oech, Roger von. *A Whack on the Side of the Head, Revised Edition*. New York: Warner Business Books, 1998.

Perkins, D. N. *The Mind's Best Work*. Cambridge, Massachusetts: Harvard University Press, 1981.

Root-Bernstein, Robert and Michèle. *Sparks of Genius*. New York: Mariner/Houghton Mifflin Company, 2001.

Sark's Journal and Playbook. Berkeley, California: Celestial Arts, 1993.

Shuman, Sandra G. *Source Imagery*. New York: Doubleday, 1989.

ARTISTS AND PHILOSOPHY

Chopra, Deepak, *The Seven Spiritual Laws of Success*. Novato, California: New World Library, 1995.

Flam, Jack D. *Matisse on Art*. New York: E. P. Dutton, 1978.

Goodman, Cynthia. *Hans Hofmann*. New York: Abbeville Press, 1986.

Hartley, Ann, ed. *Bridging Time and Space*. Maui: Markowitz Publishers, 1998.

Henri, Robert. *The Art Spirit*. New York: Harper Collins Publishers, 1984.

Hofmann, Hans. *Search for the Real*. Cambridge, Massachusetts: The MIT Press, 1967.

Kandinsky, Wassily. *Concerning the Spiritual in Art*. New York: Dover Publications, 1977.

Miller, Henry. ed. Noel Young. *The Paintings of Henry Miller*. San Francisco: Chronicle Books, 1982.

Nelson, Mary Carroll. *Connecting: The Art of Beth Ames Swartz*. Flagstaff, Arizona: Northland Publishing, 1984.

Shahn, Ben. *The Shape of Content*. Cambridge, Massachusetts: Harvard University Press, 1957.

Vitale, Joe. *The Attractor Factor*. Hoboken, New Jersey: John Wiley and Sons, 2005.

DESIGN

Abbey, Rita Deanin and G. William Fiero. *Art and Geology*. Layton, Utah: Gibbs M. Smith, Inc., 1986.

Brooks, Leonard. *Painting and Understanding Abstract Art*. New York: Van Nostrand Reinhold, 1980.

Collier, Graham. *Form, Space and Vision*. Englewood Cliffs, New Jersey: Prenctice-Hall, 1984.

Graves, Maitland. *The Art of Color and Design*. New York: McGraw-Hill, 1951.

Hale, Nathon Cabot. *Abstraction in Art and Nature*. New York: Dover Publications, 1993.

Hanks, Kurt, et al. *Design Yourself!* Los Altos, California: CrispLearning, 1977.

Jameson, Kenneth. *Starting with Abstract Painting*. New York: Watson Guptill, 1970.

Leland, Nita. *Exploring Color, Revised*. Cincinnati: North Light Books, 1998.

Prohaska, Ray. *A Basic Course in Design*. Westport, Connecticut: North Light Books, 1980.

Whitney, Edgar A. *A Complete Guide to Watercolor Painting*. New York: Dover Publications, 2001.

Wong, Wucius. *The Principles of Color Design, Second Edition*. Hoboken, New Jersey: John Wiley & Sons, 1996.

DRAWING

Albert, Calvin and Dorothy Gees Seckler. *Calvin Albert's Figure Drawing Comes to Life*. Englewood Cliffs, New Jersey: Prentice Hall, 1987.

Arnheim, Rudolf. *Art and Visual Perception*. Los Angeles: University of California Press, 2004.

Betti, Claudia and Teel Sale. *Drawing: A Contemporary Approach*. Belmont, California: Wadsworth Publishing Company, 1996.

D'Amelia, Joseph. *Perspective Drawing Handbook*. New York: Dover Publications, 2004.

Dodson, Bert. *Keys to Drawing*. Cincinnati: North Light Books, 1990.

Dvorák, Robert. *Drawing Without Fear*. Montara, California: Inkwell Press, 1997.

Edwards, Betty. *The New Drawing on the Right Side of the Brain*. Los Angeles: J. P. Tarcher, 1999.

Franck, Frederick. *The Zen of Seeing/Drawing*. New York: Bantam Books, 1993.

Hoddinott, Brenda. *The Complete Idiot's Guide to Drawing People*. Indianapolis: Alpha, 2004.

Kaupelis, Robert. *Experimenetal Drawing*. New York: Watson Guptill, 1992.

Nicolaides, Kimon. *The Natural Way to Draw*. Boston: Houghton Mifflin, 1990.

TECHNIQUES

Ayres, Julia. *Monotype*. New York: Watson Guptill, 2001.

Beam, Mary. *Celebrate Your Creative Self*. Cincinnati: North Light Books, 2001.

Betts, Edward. *Master Class in Watermedia*. New York: Watson Guptill, 1993.

Brommer, Gerald. *Creative Collage*. New York: Watson Guptill, 1995. *Watercolor and Collage Workshop*. New York: Watson Guptill, 1997.

Brommer, Gerald and Nancy Kinne. *Exploring Painting*. Worcester, Massachusetts: Davis Publications, 1995.

Dews, Pat. *Creative Discoveries in Watermedia*. Cincinnati: North Light Books, 1998.

Gildow, Janie. *Colored Pencil Explorations*. Cincinnati, North Light Books, 2002.

Goldsmith, Lawrence. *Watercolor Bold and Free*. New York: Watson Guptill, 2000.

Harris, David. *The Calligrapher's Bible*. New York: Barron's Educational Series, 2003.

Heller, Jules. *Papermaking*. New York: Watson Guptill, 1997.

Kanter, Dory. *Art Escapes*. Cincinnati: North Light Books, 2003.

Leland, Nita and Virginia Lee Williams. *Creative Collage Techniques*. Cincinnati: North Light Books, 1994.

Leslie, Kenneth. *Oil Pastel*. New York: Watson Guptill, 1990.

MacPherson, Kevin. *Fill Your Oil Paintings with Light and Color*. Cincinnati, North Light Books, 2000.

Masterfield, Maxine. *Painting the Spirit of Nature*. New York: Watson Guptill, 1996.

Maurer-Mathison, Diane. *The Ultimate Marbling Handbook*. New York: Watson Guptill, 1999.

Mayer, Ralph. *The Artist's Handbook of Materials and Techniques*. New York: Viking, 1991.

Mowry, Elizabeth. *The Poetic Landscape*. New York: Watson Guptill, 2000.

Patterson, Freeman. *Photography and the Art of Seeing*. Toronto: Key Porter Books, 2004.

Quiller, Stephen and Barbara Whipple. *WaterMedia: Processes and Possibilities*. New York: Watson Guptill, 1986.

Rae, Nan. *The Ch'i of the Brush*. New York: Watson Guptill, 2003.

Roukes, Nicholas. *Acrylics Bold and New*. New York: Watson Guptill, 1986.

Schmid, Richard. *Alla Prima: Everything I Know About Painting*. South Burlington, Vermont: Stove Prairie Press, 2004.

Shafer, Jeremy. *Origami to Astonish and Amuse*. New York: St. Martin's Griffin, 2001.

Shaw, Jackie. *The Big Book of Decorative Painting*. New York: Watson Guptill, 1994.

Stroud, Betsy Dillard. *Painting From the Inside Out*. Cincinnati, North Light Books, 2002.

Westerman, Arne. *Paint Watercolors Filled with Light and Energy*. Cincinnati: North Light Books, 1994.

Wignall, Jeff. *The Joy of Digital Photography*. Asheville, North Carolina: Lark Books, 2005.

Wolfram, Joen. *The Visual Dance: Creating Spectacular Quilts*. New York: Watson Guptill, 1995.

Contributing Artists

ANN BAIN
Dedication calligraphy, 5

CURTIS BARNES
Backyard, 104; 64 Squares, 137 © Curtis Barnes

ROBERT L. BARNUM
J.D.'s, 90; Road Trip, 16 © Robert L. Barnum

A. JOSEPH BARRISH, S.M.
Boothbay Harbor, Maine, 54; Harbor Scene, Boothbay, Maine, 35; York Harbor, Maine, 116 © A. Joseph Barrish

DONNA BASPALY
Keeping All the Balls in the Air, 88; The Tuesday Group's Interpretive Dance Class, 36 © Donna Baspaly

MARY TODD BEAM
Sacred Circuit, 96 © Mary Todd Beam

KAREN BECKER BENEDETTI
Alaskan Odyssey, 154; Harmony in Spirit, 56; Seeking One Goal, 160 © Karen Becker Benedetti

KATHLEEN M. BERTOLONE
St. Paul de Vence, 52; Still Life With Apples and Pears, 100; Tall Vase With Flowers, 33 © Kathleen M. Bertolone

EDWARD BETTS
Northcoast, 125 © Edward Betts

JUDI BETTS
Lucky Bounce, 40; Swirl Pools, 21 © Judi Betts

GLENN R. BRADSHAW
Tracks and Traces, 133 © Glenn R. Bradshaw

SUE BREZINE
Deep Down Things, 70 © Sue Brezine

JILL BROWN AND SHAYNA SCHROEDER
The Day Academy Tenth Anniversary Quilt, 47 © Jill Brown and Shayna Schroeder

BILL BRYANT
Chama Starlight, 31; Urban Cow, 53 © Bill Bryant

KAREN CAIN
Red Plums, 148 © Karen Cain

RUTH CANADA
Chapel at San Xavier, 158; Just One Kiss, 168 © Ruth Canada

ANGELA CHANG
Light, 95 © Angela Chang

DAVID R. DANIELS
Bettas, 148; Grasshopper, 165; Sondra's Window, 109; Winter Beech, 18 © David R. Daniels

WILLIS BING DAVIS
African Rain Forest #2, 136; Ancestral Spirit Dance #115, 147 © Willis Bing Davis

CHRISTOPHER DODDS
Careless Smoking: Southern California 2003, 134 © Christopher Dodds

CHRISTINE DUGAN
Roots, 49 © Christine Dugan

ROBERT FRANK
January Shadows, 105 © Robert Frank

CAROL FREAS
And the Dish Ran Away, 89; The Artists Paint Barnegat Light, 116 © Carol Freas

JANIE GILDOW
Variations, 146 © Janie Gildow

JENNIFER GISTRAK
Three of Pentacles, 154 © Jennifer Gistrak

SANDRA GOLDMAN
Passages, 48 © Sandra Goldman

R. C. GORMAN
Barefoot Lady, 84 © R. C. Gorman

DONNA M. GRACE
Sleeping Beauty, 67 © Donna M. Grace

ESTHER R. GRIMM
Aztec Autumn, 139; Tchaikovsky's Waltz of the Flowers, 42 © Esther R. Grimm

LINDA HAMMOND
Beach Nest II, 92 © Linda Hammond

KAREN HARRINGTON
Dancing Violins, 93; The Look, 115 © Karen Harrington

GWEN TALBOT HODGES
Opening a Window, 161 © Gwen Talbot Hodges

SERGE HOLLERBACH
Street Scene in Upper Manhattan, 107 © Serge Hollerbach

JUDY HORNE
On the Wagon, 87 © Judy Horne

ROSEMARIE HUART
Paper, Lace and Pearls, 42; Power of Words, 162 © Rosemarie Huart

MARY SORROWS HUGHES
Galveston Curbside, 114 © Mary Sorrows Hughes

LOUISE JACKSON
decorative painting on wood, 46 © Louise Jackson

CATHY JEFFERS
Lexis at 13, 17; The Touch, 165 © Cathy Jeffers

MELODY JOHNSON
Lollipops #1, 47 © Melody Johnson

EMILY KARAFFA
Cat Slumber, 126 © Emily Karaffa

ELLEN KAY
Too Many Cats, 49, vest © Ellen Kay; design © Debora Konchinsky

ALAN R. KELCHNER
Metaphor for the Soul, 38 © Alan R. Kelchner

MAUREEN E. KERSTEIN
Mystic Sea, 143 © Maureen E. Kerstein

STEPHANIE H. KOLMAN
Fractured Flowers, 164; Grandmere, 37 © Stephanie H. Kolman

MARIE DOLMAS LEKORENOS
Rage, 128 © Marie Dolmas Lekorenos

KURT LELAND
Pure Contour Drawing, 64; controlled contour drawing, 65; Sculpture Study #2 (Torso), 68 © Kurt Leland

NITA LELAND
Autograph, 12; Bamboo, 45; Bouquet, 153; Cross-Section Green, 29; Dream Catcher, 141; Dream On, 169; Focus, 86; Georgia on My Mind, 127; Guardians of the Gold, 43; The Haber Boys, 25; Home on the Range, 88; Iris, 45; Leaning Tree, 159; Lost and Found, 132; Lunarscape, 25; Moonshadows, 142; New Mexico Cemetery, 83; Orchid, 151; The Rats Are Winning, 26; Red Tiger, 112; Remnants of Autumn, 83; Rushing Wings, 89; Self-Portrait, 72; Splash, 2; Splendid Spirit, 127; Spectral Fusion, 142; Summer Glow, 163; Synthesis, 155; Tidal Surge, 140; Two More Parrots, 167; Two Parrots, 167; Wings, 167 © Nita Leland

BONNY LHOTKA
Sundial, 120 © Bonny Lhotka

BARBARA LIVINGSTON
Cincinnati, Inc., 41; Clermont Barn, 146; Spring Orchard, 41 © Barbara Livingston

SHERRY LOEHR
Golden Lemons, 98; Pomegranates and Rice Basket, 79; Resolution, 83 © Sherry Loehr

Index

Unlock creativity and sharpen your skills
with these other fine North Light Books!

Beautiful color is no happy accident. Here, Nita Leland illustrates color principles with 87 exercises that will teach you how to strengthen your compositions, express powerful emotions, create striking color harmonies and more!

ISBN-13: 978-0-89134-846-7
ISBN-10: 0-89134-846-8
Paperback, 144 pages, #31194

Learn the fine art of paper and shape, color and texture, imagination and vision, with Nita Leland's Creative Collage Techniques. Magnificent collages and nearly 50 step-by-step projects will challenge you to do your most creative work.

ISBN-13: 978-1-58180-098-2
ISBN-10: 1-58180-098-3
Paperback, 144 pages, #31754

Maximize the power of your artistic brain and overcome roadblocks to creative success! This book shows you how to trust your eyes and portray even the most complex subject by focusing on what you really see—not what you think you see.

ISBN-13: 978-1-58180-993-0
ISBN-10: 1-58180-993-x
Paperback, 128 pages, #Z0942

Kick-start your creativity and make better paintings with Creative Watercolor Workshop! Inside you'll find 25 energizing demonstrations, new ways of applying watercolor, and tips for breaking out of creative block.

ISBN-13: 978-1-58180-532-1
ISBN-10: 1-58180-532-2
Hardcover with wire-o binding, 128 pages, #32886

The Drawing Bible is the definitive drawing resource for all artists! Learn basic drawing principles and techniques for a wide variety of drawing mediums. Step-by-step demonstrations and beautiful finished art throughout will instruct and inspire you.

ISBN-13: 978-1-58180-620-5
ISBN-10: 1-58180-620-5
Hardcover with wire-o binding, 304 pages, #33191

A must-have for your watercolor tool kit, The Watercolor Bible gives you inspiring artwork, comprehensive instruction and indispensable advice for nearly every aspect of watercolor painting.

ISBN-13: 978-1-58180-648-9
ISBN-10: 1-58180-648-5
Hardcover with wire-o binding, 304 pages, #33237

These books and other fine North Light titles are available at your local fine art retailer or bookstore or from online suppliers.